AMBROISE VOLLARD, EDITEUR

Prints · Books · Bronzes

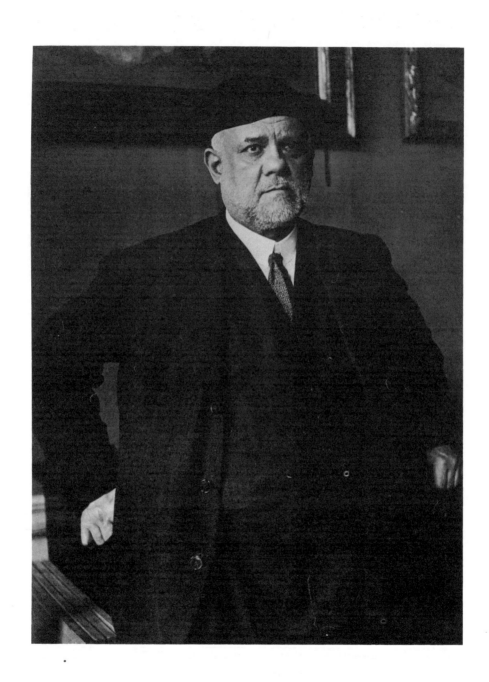

AMBROISE VOLLARD, EDITEUR

Prints · Books · Bronzes

UNA E. JOHNSON

The Museum of Modern Art, New York

Designed by James M. Eng
Type set by Custom Composition Inc., York, Pa.
Printed by General Offset Inc., New York (text)
 Eastern Press Inc., New Haven, Conn. (plates)
Bound by Sendor Bindery Inc., N.Y.

The Museum of Modern Art
11 West 53 Street, New York, New York 10019
Printed in the United States of America

Frontispiece: Brassaï (Gyula Halász). *Portrait of Ambroise Vollard*, ca. 1932–33. Photograph, 15¼ x 11½″.
The Museum of Modern Art, David H. McAlpin Fund

Photo Credits
Oliver Baker: 80; *Geoffrey Clements:* 93; *Kate Keller:* 53, 54, 56, 59, 62, 69, 72, 73, 75, 81, 85, 90, 96, 97, 98, 99, 100, 108, 109, 110, 115, 117, 118, 119, 120, 121, 124; *James Mathews:* 60, 65, 70, 82, 89, 103; *Rolf Petersen:* 61; *Adolph Studly:* 51, 87; *Soichi Sunami:* 57, 63, 64, 66, 67, 68, 76, 77, 84, 92, 95, 102, 104, 106, 107, 111, 112, 113, 114

TRUSTEES OF THE MUSEUM OF MODERN ART

To the memory of
George Wittenborn and Heinz Schultz,
who published the first edition
of this work in 1944

———————

This book and the exhibition it accompanies
have been made possible by generous grants
from Exxon Corporation and the National Endowment
for the Arts in Washington, D.C.

ACKNOWLEDGMENTS

SPECIAL ACKNOWLEDGMENTS are made to Miss Riva Castleman, Director of the Department of Prints and Illustrated Books of The Museum of Modern Art for her perceptive observations and for access to the Museum's splendid collection of prints and illustrated books in the period covering the Vollard publications. A debt of gratitude is also owed to the following people: to M. Jacques Guignard, Conservateur en chef, Bibliothèque de l'Arsenal and to M. Jean Adhémar, Conservateur, Cabinet des Estampes, Bibliothèque Nationale in Paris for their help in providing information concerning their vast and important collections; to Mme Marguerite Lacourière, who permitted me to study the unique archives of the Lacourière collection, and to Mlle Isabelle Rouault for her patience in helping to solve some of the problems involved in the Georges Rouault prints and illustrated books published by Vollard; to Mr. Harold Joachim, Curator of Prints and Drawings at the Art Institute of Chicago, who made available information relating to the Institute's rewarding collection of late 19th- and 20th-century French prints; to Mr. Lessing J. Rosenwald, who generously permitted me to work in his fine library of *éditions de luxe* and in his collection of prints at the Alverthorpe Gallery in Jenkintown, Pa.; to Mr. Rudolf Koella, Curator of the Kunstmuseum, Winterthur, for making available the Vollard archives in the Museum's collection; to Susan Weiley, whose extraordinary patience and editorial skills are highly appreciated.

Many others have contributed, in no small way, to the clarification of the scattered and sometimes contradictory legend of Ambroise Vollard as éditeur and entrepreneur. Thus acknowledgments are gratefully extended to the following individuals, museums, and libraries: Achenbach Foundation for Graphic Arts, Palace of the Legion of Honor, San Francisco, Calif.; Mr. Clifford S. Ackeley, Associate Curator, Museum of Fine Arts, Boston, Mass.; Mr. Maurice Bloch, Curator, Grunwald Center for the Graphic Arts, University of California, Los Angeles, Calif.; Brooklyn Museum, Department of Prints and Drawings, Brooklyn, New York; Mr. Sylvan Cole, Director, The Associated American Artists Gallery, New York; Mrs. Gertrude Dennis, Director, Weyhe Gallery, New York; Mr. Douglas W. Druick, Curator, National Gallery of Canada, Ottawa, Canada; Mr. Alan Fern, Chief, Division of Prints and Photographs, Library of

Congress, Washington, D.C.; Mr. Rafael Fernandez, Curator, Department of Prints and Drawings, Sterling and Francine Clark Art Institute, Williamstown, Mass.; Mr. William J. Fletcher, Collector, Southport, Conn.; Miss Eleanor M. Garvey, Harvard College Library, Cambridge, Mass.; Mr. Lucien Goldschmidt, Director, Lucien Goldschmidt Ltd., New York; Miss Terry Haass, Artist and Printer, Paris; Mr. Sinclair Hitchings, Curator, Department of Prints, Boston Public Library, Boston, Mass.; Mrs. Colta Feller Ives, Curator, Department of Prints, Metropolitan Museum of Art, New York; H. P. Kraus Bookshop, New York; Miss Ruth Lehrer, Curator, Alverthorpe Gallery, Jenkintown, Pa.; Mr. William S. Lieberman, Director, Department of Drawings, The Museum of Modern Art, New York; Mr. Kneeland McNulty, Curator, Department of Prints, Philadelphia Museum of Art, Philadelphia, Pa.; New York Public Library, Spencer Collection and the Division of Rare Books, New York; The Polish Institute of Arts and Sciences in America, New York; Mrs. Susan Reed, Department of Prints, Museum of Fine Arts, Boston, Mass.; Mr. John Rewald, Scholar and Author, New York; Miss Elizabeth Roth, Keeper, Division of Prints, New York Public Library, New York; Mr. Lawrence Saphire, New York; William H. Schab Gallery, New York; Mrs. Margrette Schultz, Great Neck, New York; Mrs. Alexandra Schwartz, Department of Prints and Illustrated Books, The Museum of Modern Art, New York; Mr. James Thrall Soby, Collector, New Canaan, Conn.; Mrs. Carol Uht, Curator, The Nelson A. Rockefeller Collection, New York; Mrs. Peggy Zorach, Librarian, Brooklyn Museum, Brooklyn, New York; An Anonymous Collector and Dealer, Paris.

Appreciation is also expressed to those dealers in prints and in *éditions de luxe* in Europe and in the United States who, over many years, have contributed valuable information concerning the publications of Vollard in conversations and in well annotated catalogues.

Una E. Johnson

CONTENTS

LIST OF ILLUSTRATIONS

PREFACE
to the First Edition

AMBROISE VOLLARD was several kinds of genius. Most of them were concerned with the arts—if they be arts—of exploitation; and as the objects of his enterprise were invariably art, it might be just as well to concede that his work, too, was art. It was either that or science and though there was undoubtedly plenty of science in it, I still prefer to think of him as a genius-artist.

First, he was a genius in discovering geniuses. That is a talent in itself—and of the very first order. Emerson hints in one of his essays that the man who recognizes divinity in another raises himself to the same plane by such a discovery and Vollard is an admirable illustration of the theory. As an explorer he may have made some errors early in life of which I am unaware, but the astounding and long-continued rightness of his attitudes toward Cézanne and Rouault gradually bred the idea among his contemporaries that he could do no wrong. . . . This was partly because, in the beginning, none of them thought him right. It is one thing to see greatness in Cézanne now, but it was a totally different affair back in the period when all the influential part of the world considered him an imbecile. To charge at the stone wall of obstinate opinion that existed in those days, and to reduce it to nothingness required that something more than courage, which is called madness when it fails and genius when it succeeds. Vollard succeeded.

Granted that point, his manner of putting his great idea (Cézanne) before the world was even more striking than his original ability to believe in an artist so despised by "received opinion." It was equally inspired and creative. Instead of courting public approval he flouted it. Instead of the beguiling tones of the Pharisee he employed laughter. If he heard an insulting epithet applied to the work of his protegé, instead of hushing it up, he published it widely. People got into the habit of going to his little gallery on the rue Laffitte in order to be shocked, and—as a shock induces more outcries than satisfaction—it developed in a comparatively short time that the rue Laffitte outcries reverberated around the world. In the entire history of the art of picture-selling (a history not yet written) there never was such a comedy-with-a-happy-ending as this, for it all turned out exactly as the prestidigitator wished. Cézanne was acknowledged in the public places to be great, vast prices were put upon his productions, and Vollard became rich. To do him justice, I don't think he aimed at riches. The riches were incidental and merely valued as confirmation. He remained, as far as I could see, a *bon bourgeois* to the end of his life.

The tactics he used in regard to Rouault, his second great discovery, were similar, but much more easily applied since "the enemy" never reacquired confidence enough to attack him after the first defeat. In his comparative ease of mind after the launching of these two reputations, a third manifestation of his inner power came with the writing of his books. His accounts of his direct contacts with Cézanne and Renoir were not first thought to be literature, yet it is now reasonably sure that they will be read as long as interest persists in his protagonists, and, in such a case, the exact quality of the style is nothing to worry about. A book lasts only because there is some kind of life in it and, when it does last, the suspicion arises that there must be some kind of genius back of it.

Considering these things, every point in regard to such an irrepressible character becomes legitimate prey for the student and all of his activities bear being looked into; and, hence, Miss Johnson's inquiry into his work, in his later years, as a publisher of prints and illustrated books, awakens my deepest curiosity—and my gratitude.

HENRY McBRIDE

May 1943, New York

FOREWORD

THEY CALLED HIM many names behind his back and he was an enigma to nearly everyone. Even today, when those with whom he did business recall his appearance and temperament, they repeat their memories of him as if they were part of an age-old myth. His swarthiness led the French to characterize him, according to Lord Kenneth Clark, as the "black Lorenzo de Medici." Ambroise Vollard, that lazy mountain of art merchant, that clever impresario of modern art, was as sly and inquisitive as his favorite living being: the domesticated cat. Pretending to nap in his chair, behind his drowsy mien he acutely listened to every nuance of his artists' and clients' conversations and sensed every movement. He would jump at a new concept and insist upon knowing everything, but would himself tell little more than trivia.

Vollard reputedly followed his childhood sweetheart from La Réunion to France in 1890. In recalling his early years in France, where he abandoned his legal studies in order to become an art dealer, Vollard never mentioned Mme de Galea; yet it was at her home that he stayed during his early struggles in the art business, and after her husband's death in World War I, it was with her family that

he spent most of his leisure moments. Vollard remained unmarried, and when he died in 1939 his estate was divided between Mme de Galea and Vollard's brother, Lucien. The last Vollards in La Réunion, two sisters, presented some of their famous brother's collection to the Musée des Beaux Arts—Léon Dierx in the town of his birth, while Lucien donated many Vollard publications to the Kunstmuseum in Winterthur.

Vollard wrote several books about his artists and one about himself. His fame as an art dealer rests, for the most part, upon his presentation of Paul Cézanne; yet he also gave Pablo Picasso and Henri Matisse their first solo exhibitions. He was not the only art dealer in Paris at a time when art certainly flourished there, but he was quick to do better at ideas given less care by others. Like most successful dealers, he sold only what he wanted to sell and only when he felt the client was suitably prepared. He never fully satisfied any collector's appetite and he never seemed to run out of works of art with which to tempt each of them. He had less monetary success publishing prints, illustrated books, and bronzes, perhaps due to the impractical measure of love he had for this work. As a dealer, Vollard had

a memorable role that is noted in the biographies of his artists and collectors and in the provenances of their paintings and sculptures. As a commissioner and publisher of works of art, Ambroise Vollard is indelibly associated with the creation of the art itself.

This catalogue raisonné of the multiple works that Vollard commissioned and published is Una Johnson's second on the subject. The first, issued in 1944, could only hint at the vast legacy of unpublished prints and illustrated books that were left at Vollard's death. Some of the artists and a few other publishers took on the task of finishing and publishing most of these works, and the present catalogue contains entries for them, as well as for those that can never be completed. The informed print and illustrated book collector will recognize at once the impossibility of ever perfecting a catalogue of the projects envisioned by Vollard. Although he eagerly pounced upon idea after idea for albums of prints and books illustrated by his favorite artists, he was ponderously slow about completing them.

As commissioner, he was superb at beginning projects; as publisher, he was compulsive about perfecting them. Many prints were also left abandoned; although they were completed as editions, they were held because other prints were not ready for the albums in which they were to appear.

I am extremely grateful that Una Johnson, having continued to pursue her Vollard research for over three decades, has now allowed The Museum of Modern Art to have the honor of publishing it. Curator of Prints of the Brooklyn Museum from 1941 to 1969, Una Johnson was in charge of a collection that included many Vollard publications. Her own acknowledgement of the other collections she has consulted follows. The Museum of Modern Art was fortunate to have acquired over the years a substantial number of the works Vollard issued. These are not only noted herein, but also form the nucleus of an exhibition devoted to Vollard's editions that is concurrent with the publication of this catalogue raisonné.

RIVA CASTLEMAN
Director, Department of
Prints and Illustrated Books

INTRODUCTION

FROM LA RÉUNION, a small volcanic island in the Indian Ocean, the young French colonial Ambroise Vollard set out for France. His destination was Montpellier, his objective to study law, the time was 1890. In a kindred spirit of adventure, his father before him had forsaken the Ile de France for a tropical island off Madagascar and the fortunes of a minor government official. His mother's family originally came from Provence. The eldest of ten children, Vollard, at his father's urging, decided that the study of law in France might best equip him for earning a respectable livelihood.

It was after early studies in Montpellier that Vollard traveled north to Paris. There he enrolled in the Ecole de Droit where, sometime later, he was unsuccessful in his preliminary examinations for a doctorate in law. At the same time Vollard began his ceaseless explorations of the shops and bookstalls that lined the cramped streets of the Latin Quarter and the nearby quays. For a few francs each he acquired small drawings and engravings destined for the walls of his modest lodgings. These first acquisitions were undistinguished and remote from his first Cézannes, as Vollard later observed. Nonetheless they were tokens of his awakening taste for works of art. The satisfaction he gained through these early acquisitions and the tempting visions of treasures still to be discovered made short shrift of his career in law. As his possessions mounted, he began casting about for a way to gain experience in dealing in works of art. By chance he met the future director of the gallery L'Union Artistique, where he later served a brief but enlightening apprenticeship.

The Paris of the 1890s was rich, bourgeois, ebullient. The effects of the War of 1870 had been snuffed out in the glory of the Third Republic. Montmartre, engulfed by the sprawling city of Paris, was the home of French artists and the favored haven of their foreign counterparts. The shining dome of Sacré Coeur, irreverently called "Notre Dame de la Galette" by appreciative residents, crowned the hill of Montmartre. Below surged the life of the studios, cabarets, and small cafés. It was in Montmartre that Vollard began his career as a dealer in works of art. At the 1892 auction sale of the collection of Père Tanguy, well-known befriender of struggling artists, Vollard purchased five Cézanne paintings for less than 1000 francs. In 1893 he moved to a tiny shop on the rue Laffitte, known locally as the "rue des tableaux" since a number of important dealers had their

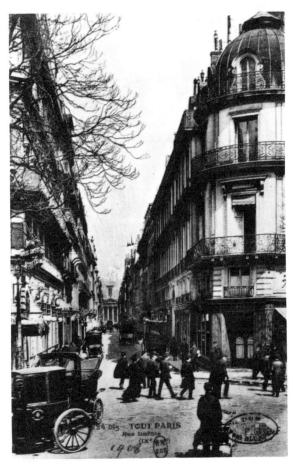

Rue Laffitte in 1908

17

shops there. Aggressive, enterprising, and uncommonly shrewd, Vollard soon managed to acquire a small but unusual stock of modern paintings and drawings and began offering them for sale at a good profit. Then in 1895, at the suggestion of Pissarro and Renoir, Vollard held the first exhibition of Cézanne's paintings. Vollard urged Cézanne, who had long been absent from the Paris art scene, to send some one hundred works to him—far more than could be accommodated in his gallery. In spite of the disapproval and disparagement voiced by the Academy and the critics, with this exhibition Cézanne's belated career was launched—and so was that of Ambroise Vollard. In addition, the prominent collectors Auguste Pellerin and Count Isaac de Camondo visited the Cézanne exhibition and were inspired to begin their own collections of modern art.

This venture was prophetic of Vollard's unique and eminent destiny in the art world of his time. His quarters became a rendezvous for the artists involved in the new art movements. Here Vollard listened intently to animated discussions and served his "créole dinners" to the very appreciative struggling artists. An amusing sketch by Bonnard depicts Vollard's shop. In this small caricature Degas, Renoir, Pissarro, and their friends stand about examining Vollard's stock of unframed pictures, which are scattered around the room in unceremonious rolls: on shelves, against walls, and across the floor. Vollard himself dominates the scene, holding in his hand a painting by Cézanne, while Bonnard enters with his latest creation.

The circle of artists continued to grow around their dauntless and eccentric defender. They often objected to the low prices he offered them, but at least Vollard exhibited and sold their work. His shop was seldom deserted. Cézanne himself rarely appeared at the Vollard gatherings, however. Extremely sensitive, he found the conversation there more painful than pleasurable. Gauguin came during his last fitful sojourns in Paris. Also among those who regularly visited the shop were Apollinaire, Bonnard, Vuillard, Max Jacob, young Picasso, and Alfred Jarry. Jarry's weird dramas and surrealist ideas shocked and intrigued Parisian au-

diences during the late 1890s. Several years later, when Vollard's exhibitions and stories of his sharp dealings and boorish manner became the talk of the Paris art world, his invitations to limited viewings of his collection and to his sumptuous dinners were much sought after. Such were the results of Vollard's carefully cultivated eccentricities.

Auguste Renoir often visited Vollard's shop as both artist and friend. His son Jean, who accompanied his father on some of these frequent visits, remembered Vollard's superbly tailored English tweed suits—their light brown tones accenting his dark, southern complexion. He also recalled that the walls of Vollard's gallery were painted a bright ocher, and later, a soft white.[1] Segonzac remembered, with some malice, the tall figure of Vollard standing in the doorway of his gallery, his arms upraised, his hands resting on the upper section of the door jamb, "looking very much like a giant ape." Bonnard painted Vollard holding his cat and Brassaï photographed him seated at his desk with his cat. Picasso remarked to Françoise Gilot: "The most beautiful woman who ever lived never had her portrait painted, drawn, or engraved more often than Vollard—by Cézanne, Renoir, Roussel, Bonnard, Forain, almost everybody, in fact. I think they all did him through a sense of competition, each one wanting to do him better than the others. He had the vanity of a woman, that man. Renoir did him as a toreador, stealing my stuff, really. But my Cubist portrait of him is the best one of them all."[2]

Marc Chagall called Vollard "a great precursor." Matisse recalled: "More than ten years ago, I met Vollard for the last time at Vittel. I reminded him of one of the old anecdotes he liked to bring out about female logic. Afterwards he said 'Monsieur Matisse is a very dangerous man because he has an excellent memory.'"[3] It also has been recounted that in his shop on the rue Laffitte, piled high with Cézanne's and van Gogh's paintings, Vollard used to light a lamp at dusk and pretend to sleep. He hoped to hear the opinions of possible collectors and passersby concerning the young painters whose works were hanging in the windows of his gallery and whose success he was anxious to share. When

an aspiring young art dealer asked his advice Vollard replied tersely, "You sleep a lot."

With shrewd judgment, Vollard had quietly acquired a magnificent collection of modern paintings. His policy of buying low and selling high inevitably brought results far exceeding even his own aspirations. He was willing to follow the advice of the artists who were forging a new vision but who were generally unaccepted by the Academy and ignored by many critics and dealers. He took the risks of dealing in their paintings, drawings, and prints, which were not then fashionable. With seldom-challenged authority and a gruff dignity, Vollard assumed his exceptional position in the art world of Paris. But to Vollard this early success was simply a stepping stone, a means to still another objective. It was on the publishing of fine prints, albums, and illustrated books that he proceeded to spend—and lavishly—the growing wealth that modern paintings had brought him. For nearly forty-five years his publishing ventures were to occupy his time, his thoughts, and his tireless energy. It was through them that he realized his desire for eminence as a publisher and entrepreneur.

Prints and Print Albums

Of his beginnings, Vollard remembered, "I was hardly settled in the rue Laffitte when I began to dream of publishing fine prints, but I felt they must be done by 'painter-printmakers!' My idea was to obtain works from artists who were not printmakers by profession."[4] Vollard's early undertakings were an album of miscellaneous prints and also an album of twelve lithographs in color, *Quelques Aspects de la vie de Paris* by Pierre Bonnard. Prophetic forerunner of many fine volumes to be illustrated by Bonnard, they were also symbolic of the rare judgment, intrinsic taste, and wholly French character of the Vollard publications.

It was understandable that he should have chosen Bonnard to illustrate a suite of Paris scenes. Bonnard's whimsical, anecdotal qualities appealed

to Vollard, who also knew and enjoyed this city of scintillating days, soft sunlight, and fleeting street scenes. Bonnard's prints and his paintings—lyrical, charming, and occasionally nostalgic—epitomize the close of a dazzling epoch. Bonnard's point of view was often experimental, and he brought to lithography a painter's sense of color. His prints reveal a fine discernment—subtle, urbane, and casual. He caught the infinite variety of moods and the pervasive ambience of Paris. He and his friend Vuillard, with whom he shared a studio in Montmartre, knew and loved the casual incident, the ever-changing scenes along the boulevards, the patterns of sunlight slanting across a street or through a window. The flower vendors, waifs, cabmen, nursemaids and their small charges—all were seen in an atmosphere that was youthful, often humorous, sometimes nostalgic, and essentially French. Despite Vollard's hopes, the series was not a success. Although Bonnard had completed his album in 1895, it was not exhibited in Vollard's gallery until 1899. Sometime later, a number of the individual titles were sold separately.

In 1896–97, Vollard issued two large albums of prints, mostly lithographs, by various artists then working in Paris. The first, entitled *L'Album des peintres-graveurs,* was published in 1896 in a limited edition of 100. It contained twenty-two prints by Bonnard, Denis, Fantin-Latour, Munch, Redon, Renoir, Vallotton, Vuillard, and others. The series received little or no recognition and was financially unsuccessful. In an attempt to entice the interest of more collectors, Vollard changed the title of his second series of prints. Mellerio notes that this series was exhibited as *L'Album d'estampes originales de la Galerie Vollard.* This title was only slightly different from the Marty album, *L'Estampe originale,* which was the more successful forerunner to the Vollard venture. The Marty album was composed of nine separately issued sections that totaled more than ninety prints.[5] Vollard issued each of his two albums as a complete publication. There were other practical reasons for a change in the Vollard title. The majority of print collectors were still more interested in the work of professional printmakers than in Vollard's preferences for the painter-print-

makers, whose names often were unknown to them. To further entice the special collector, Vollard added a number of trial proofs to several of his albums. These albums were offered at a much higher price than the regular edition. Although some dealers have referred to these special copies, none has been located. Another problem was the

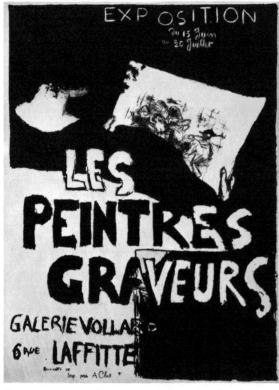

PIERRE BONNARD. *Les Peintres-Graveurs,* poster, 1896. Lithograph, 64 x 47 cm. (page).
The Museum of Modern Art, N.Y., Purchase Fund.
(Cat. no. 12)

fact that "Les Peintres-Graveurs" was also the general title of an annual exhibition of prints held at the Durand-Ruel Galleries since 1889. This confusion of names and events disturbed Vollard.

One version of Bonnard's cover for Vollard's second album still carried the title of *L'Album des peintres-graveurs.* However, other impressions of Bonnard's lithograph also have the new title: *6 rue*

Laffitte, 2^e année. Album d'estampes originales de la Galerie Vollard. In addition to artists whose prints appeared in the first album were Cézanne, Denis, Puvis de Chavannes, Rodin, Roussel, Sisley, Toulouse-Lautrec, and Whistler. Vollard once reminisced: "I can still see Lautrec, a bandy-legged little man, saying to me 'I will do you a *femme de maison.'* . . . In the end he decided upon *Partie de campagne,* which today is considered one of his masterpieces."[6] Whistler, then living in London, was represented by a lithograph, *La Conversation.* Some critics considered the lithographs of Cézanne, Forain, Leheutre, Rodin, and Sisley to be prints after drawings or paintings, something between a true lithograph and facsimile or commercial chromo.[7] Vollard brushed aside this criticism and continued his efforts to enlist painters for his publishing projects. He thought nothing of holding individual prints for such time as they might be fitted into an album. This practice is reflected in the extensive Vollard archives at Winterthur, which contain prints that were never published in editions.

Renoir's well-known *Baigneuse debout en pied* and *Enfant au biscuit* were destined for Vollard's third album. The projected cover for the album was a lithograph in five colors by Edouard Vuillard. It continued the title *L'Album d'estampes originales* and the notation "édité par A. Vollard, 6 rue Laffitte, Paris." It is known in three states but apparently no edition was printed (cat. no. 156). Finally, Vollard decided to discontinue his third album, not only because of the lack of success in the selling or distributing of his first two albums, but also because he had become much more interested in issuing albums containing the work of a single artist.

Nevertheless, Vollard's albums, along with the large series by Marty that immediately preceeded those of Vollard, form a veritable encyclopedia of French prints at the end of the nineteenth century. Vollard's ability to review a cross section of the graphic art of the time is evident in both his early albums and in the later ones that featured the prints of individual artists. The restless style of Art Nouveau is reflected in the prints of de Feure, Grasset, Munch, and Vallotton. The special imagery of Bonnard, Renoir, Signac, and Vuillard

retains a lingering charm of Impressionism. As for the Post-Impressionists, Cézanne, Redon, Toulouse-Lautrec, and others impart still a newer vision.

One of the artists who refused to work under the terms that Vollard proposed was Camille Pissarro. He explained:

> Vollard commissioned me to do a lithograph in color, a large plate, he would like a *Market*, he asked me what I would charge. I told him I would have to consider the matter. This blessed Vollard has grandiose ambitions, he wants to launch himself as a dealer in prints. All the dealers, Sagot, Dumont, etc., are waging war against him for he is upsetting their petty trade. He has talked a lot about books for you to do, but he is a real moth, I am afraid his fate will be the taper's flame! In any event there is no point in suffering disillusionment.[8]

In another letter Pissarro wrote:

> I went to see Vollard. We argued about the price of my lithograph in color; I had all I could do to get him to stick to the point. You won't believe what he proposed! Really, they think they can milk us! Drudge, work, they say. And we, we shall take it upon ourselves to make the money!

Arguing that Fantin-Latour sells his lithographs (the plates) at 100 francs, he proposed to give me 500 francs for 100 prints, the plate to be erased afterwards. Naturally I didn't accept. He said then: "All right, let's try this. Pull 100 proofs at your own expense, give them to me to sell at a commission . . ." If he thinks I'll agree to that, he is mistaken. I will make the plate and then consider what to do . . .[9]

Vollard had been attracted to Gauguin's Brittany lithographs printed on canary-yellow papers. He obtained the zinc plates and published them in 1894. In 1896, perhaps at Degas's suggestion, Vollard had contracted to buy all of Gauguin's paintings that were in the artist's studio. He also agreed to send Gauguin the materials he required; however, he sometimes neglected to carry out the agreement. In Gauguin's letters to Vollard he often asks for canvas, paper, paints, and inks. Vollard's carelessness in complying was a constant source of irritation if not outright despair to Gauguin.[10] Vollard did sell some of Gauguin's paintings but, unfortunately, had no interest in his woodcuts. When

Vollard's letterhead and a note to Gauguin

he received a sheaf of them he merely turned them over to Gauguin's friend, Daniel de Monfreid. Vollard may have felt that the exotic subjects and Gauguin's unconventional approach to the woodcut medium would not be accepted by the print connoisseurs of the time. Furthermore, his own taste was inclined toward the more rugged manner of Emile Bernard. In any case, Vollard misjudged Paul Gauguin's graphic work. The prints that Vollard chose to publish reflect his interests and his whims. In their diversity lie both their aesthetic and documentary value and their occasional weaknesses. In an attempt to reach a wider public, Vollard was obliged to cater to those collectors whose taste still was influenced by the Academy, as well as to the more imaginative few. Despite this realistic approach, his editions met with little approval. Twenty years after their first appearance, the supply was not exhausted. Nevertheless, his well-known determination and his opinionated point of view were not to be set aside.

At Vollard's suggestion, Maurice Denis, one of the Symbolist painters, executed a series of twelve lithographs known as *Amour*. Their soft colors accentuate their mystic, other-worldly tone. Ker-Xavier Roussel began a series of soft landscapes with pale nymphs and diaphanously clad ladies. Bearing the influence of the Symbolist movement and its affinity to romantic music, the Denis and Roussel portfolios sustain an unvarying delicateness. But in this lies their charm, if not their strength. Vuillard, master of patterned interiors and subtle landscapes, in 1899 carried out an album of a dozen lithographs in color entitled *Paysages et intérieurs*. They capture the intimate atmosphere of the small streets, crowded cafés, rooms in attractive disarray—in short the varied countenance of Paris. They record the unhurried pleasures and comfortable ease of a period not yet submerged in the uncertainties of the twentieth century.

Although his portfolios of prints were materially unsuccessful, Vollard continued to indulge his extravagant, highly personal interests. He next published two portfolios by Odilon Redon. Past sixty when these lithographs were finished, Redon used blacks with superb power, to be equaled later only by the graphic work of Georges Rouault. Flaubert's *La Tentation de Saint-Antoine* held such sustained fascination for Redon that he produced three different series of illustrations, or "correspondances." A third series was ready for Vollard in 1896. This edition finally appeared under Vollard's imprint in 1938. Two years previous to its publication Vollard recalled:

> . . . I wanted to publish *La Tentation de Saint-Antoine* with illustrations by Redon. But the heiress of the great novelist, Mme de Commaville, had not forgotten that the devil, in order to seduce Anthony, caused naked women to appear before him. . . . In the contract I wrote at her dictation she stipulated that I was to submit the artist's compositions to her. Redon's illustrations comprise more than twenty original lithographs and about fifteen compositions designed as wood-engravings. I had mislaid the latter but to my great joy I have found them again and the book can at last be published.[11]

Another even more impressive series of nineteen large-scale drawings based on Redon's further interpretation of Flaubert's *La Tentation de Saint-Antoine* remained in Vollard's collection.[12] It is not known definitely whether they were destined for still another series of lithographs. For Redon, his drawings, with their infinite nuances and evocative subtleties, were complete in themselves without the embellishments of another medium. In 1899, the same year that Vollard issued Vuillard's *Paysages et intérieurs,* he also published another Redon series entitled *Apocalypse de Saint-Jean.* Preoccupied with the unknown and with his penetrating symbolism, Redon continued to create a broodingly somber world, one in which dreams are the ultimate reality. Two more widely diverse series of prints than those of Vuillard and Redon would be difficult to imagine.

It was Fantin-Latour who had taught Redon his skillful use of lithographic blacks. Fantin-Latour's *Suite de six planches,* issued by Vollard in 1898, reflects a lightness of technique and aloofness of manner bordering on the evanescent. Fantin-Latour frequently turned, and with exquisite results, to the method of the grainy transfer lithograph. Bathers, dancing figures, Siegfried and the Rhine Maidens, and other romantic subjects were themes that suited Fantin's style and that he portrayed with characteristic sureness. The portfolio

and the individual print *Portrait de Rossini,* also issued by Vollard, are typical examples of the artist's later work.

Renoir's *L'Album de douze lithographies* was completed in 1904, but Vollard did not issue it until fifteen years later, when he also published his biographical study, *La Vie et l'oeuvre de Pierre-Auguste Renoir.* The portfolio contains several excellent portraits, one of Vollard and others of Valtat and Claude Renoir. The remaining lithographs resemble wash drawings and slight sketches and owe their charm mainly to the skill of the master-printer Auguste Clot. Vollard spent much time at Clot's printing shop, overseeing his own projects and noting the elaborate printing processes being carried on in the shop. It was at this time that Clot, at Vollard's request, executed a lithograph in colors after Cézanne's painting *Le Dejeuner sur l'herbe,* which was then in Vollard's collection. A letter from Vollard to Clot confirms that this lithograph was planned and completed some six years after Cézanne's death in 1906.[13] Thus the artist had nothing to do with either the concept of this lithograph or its execution. The painting itself probably served as the maquette for the Clot reproduction. An undesignated number of impressions were printed on loose china paper and were only slightly smaller than the painting itself (34 x 39 cm.).

In 1913 Vollard purchased from Picasso a number of the artist's copper plates, drypoints, and etchings. At Vollard's bidding these were steel-faced by the printer Louis Fort. However, only fifteen pieces from the 1905–06 series of *Saltimbanques* were selected by Vollard for printing on Van Gelder paper in a rather large edition of 250 impressions. Unsigned and unnumbered, the edition varies greatly in printing. This is especially true of the well-known *Le Repas frugal.* Because of imperfect oxidation of the plate in the process of steel-facing, one subject had to be deleted from the series. There are those who insist that Vollard, having a strange and violent dislike of the subject, intentionally had one plate destroyed. If such is truly the case, it serves to emphasize Vollard's whims and occasionally ruthless prejudice. In the end, the *Saltimbanques* series, reduced to fourteen subjects, was issued without benefit of a cover and was sold to collectors as well as to other dealers.

Vollard had purchased from Pablo Picasso all the paintings of the Blue and Pink periods that remained in his studio, and had issued five of his small bronzes. However, he did not commission Picasso to produce any graphic work until sometime in 1925, when Picasso began work on Balzac's *Le Chef-d'oeuvre inconnu.* This was due more to Picasso's independence than to Vollard's hesitation.

Books

The eccentric, temperamental, and unpredictable Vollard was not content with his thriving picture business and his not-so-thriving publishing ventures. In his autobiography, *Recollections of a Picture Dealer,* he remarked, "Little by little the idea of becoming a publisher, a great publisher of books, took root in my mind." From 1900 until his death in 1939, he devoted his limitless enthusiasm to the production of fine, exquisitely illustrated books. How well he achieved his desire to become "a great publisher" may be witnessed in the twenty-odd volumes that bear his name.

But where to start was the question. He was not well versed in literature; his life had been far too active for much leisurely reading. Yet, as with his portfolios of prints, he had definite ideas about the publishing of illustrated books. His interest first and foremost was in the artist and his chosen images. The author's work was, to Vollard, always secondary, and it is significant that once the artist started work Vollard never interfered with his interpretation. It has been suggested that Vollard was content with any old text, but the fact is that he asked specific artists to illustrate works of their own choosing. He occasionally suggested an author but unfailingly went along with the artists' preferences.[14]

It was perhaps a caprice rather than critical judgment that led him to publish *Parallèlement* by Paul Verlaine. Riding along on a Paris omnibus,

Vollard overheard a conversation: "'There's Verlaine,' whispered one of the passengers to his companion as a small, poorly dressed man boarded the bus.

"'Who is Verlaine?' queried the companion.

"'A poet,' the other replied impatiently, 'Next to Stéphane Mallarmé, the greatest.'"[15]

Intrigued by these snatches of conversation, Vollard set out with characteristic determination to find the writings of Verlaine.

He decided to publish an edition of *Parallèlement,* written by Verlaine a decade before. Vollard asked Lucien Pissarro to illustrate it with woodcuts. However, Lucien's father, Camille Pissarro, who had come to disagree with Vollard, advised his son against this step, pointing out that Vollard was not only too demanding but also offered the artist too little in return. This was perhaps fortunate, for in the end Vollard commissioned Bonnard to carry out the illustrations in lithography. Since the publications of the Romantic era, notably the Delacroix illustrations for Goethe's *Faust,* lithography had only rarely been associated with the printed page. Firmly believing in Bonnard's ability and innate taste, Vollard gave the artist free rein. The freedom with which arabesques were scattered over the margins and in every available space seemed at the time as audacious as the text itself. The Bonnard sketches, in rose tones,[16] are delicate and free—a sensitive accompaniment to Verlaine's poems and reminiscent of the elegance of the earlier Japanese painter-poets. After L'Imprimerie Nationale had printed the edition of *Parallèlement* for Vollard, the director became concerned with what was termed the questionable contents of Verlaine's text, and demanded that the entire edition be returned. Vollard returned the books, save for a small number of copies that had already been distributed. The pages carrying the typographical mark and the imprint notation were removed from all these copies and another signature carrying a different typographical mark, half title, and title page was substituted in most of the copies. Of the Vollard *éditions de luxe* illustrated by Bonnard, *Parallèlement* is the first and one of the finest.

In 1902, Vollard published *Daphnis et Chloé* by Longus. He may have chosen this Greek romance of the third century because it approached so nearly the tone of the modern novel. Illustrated with lithographs by Bonnard, it has been described as one of the most beautiful books published since the eighteenth century. Carefully following the text, conjuring up woodlands, harbors, and pastoral figures, Bonnard's genius portrays with lavishness and antique grace the tranquil atmosphere of the Golden Age. The quality of the printing process, attained with such success in *Parallèlement,* lingers on in *Daphnis et Chloé,* giving it exceptional charm and nuance. The noticeable contrast between the boldness of the Grandjean type and the delicacy of the lithographic illustrations, and in some instances the crowding of type and illustration on a single page, are occasionally distracting. However, these minor points are manifestly outweighed by the excellence of the book as a whole.

In the year that the *Daphnis et Chloé* appeared, Vollard also issued Mirbeau's *Le Jardin des supplices* with illustrations by the sculptor Auguste Rodin. The twenty illustrations accompanying the text are refined line drawings executed in lithography by the master-printer Auguste Clot. Although Delteil[17] says that five of the illustrations were drawn directly on the stone by Rodin, it is known that the entire twenty, like the print in the second album, are lithographic facsimiles of known drawings by the artist, faithfully and carefully printed by Clot. After the consternation caused by the printing of Bonnard's *Parallèlement,* which the director of L'Imprimerie Nationale had belatedly decided was undignified and questionable as to subject matter, Vollard sought another printer for the Mirbeau work, assigning it to Philippe Renouard.

The foregoing editions were all illustrated with lithographs that collectors still disdained. In an attempt to interest the bibliophiles of the time, Vollard presently published three more books. The first was *L'Imitation de Jésus-Christ* by Thomas à Kempis, with wood-engravings by Maurice Denis in the form of large illustrations and with vignettes generously scattered throughout the book. This volume was more successful. The Denis illustrations have a gracefulness of design and maintain a subtle

harmony with the Thomas à Kempis text.

Gaspard de la nuit by Louis Bertrand was Vollard's next undertaking. Armand Séguin executed 230 wood-engravings for the book, with all the "finish" that the bibliophiles demanded. A bookseller offered it to Henri Béraldi, outstanding collector and

ARMAND SÉGUIN. *Gaspard de la nuit* by Louis Bertrand, page 87, 1904. Wood-engraving, 31 x 25 cm. (page). Spencer Collection, The New York Public Library, Astor, Lenox, and Tilden Foundations. (Cat. no. 205)

authority on art, who, until he learned the name of the publisher, praised it highly. When told it was Vollard, he threw up his hands exclaiming: "The man who published *Parallèlement* and *Daphnis et Chloé*? Ah no! That would be letting the devil into my library."[18] Vollard doubtless enjoyed the anecdote, while continuing to publish as he pleased.

In 1911 Vollard brought out a slightly different kind of book, *Lettres de Vincent van Gogh à Emile Bernard.* Forerunner of several editions of collected letters by van Gogh, it was issued in both a limited

and a popular edition. The 100 illustrations reproduced a number of the artist's paintings and an unusually fine selection of his drawings. In the same year he offered his edition of Paul Verlaine's *Sagesse* with illustrations in color by Maurice Denis.

Shortly after the publication of Bonnard's *Parallèlement,* Vollard had asked Emile Bernard to illustrate with woodcuts Baudelaire's *Les Fleurs du mal,* a work that had held much interest for artists since its first appearance. Five years later the Bernard woodcuts still remained incomplete, save for an early prospectus and a few partially finished "exhibition copies." This elaborately illustrated work, with 36 full-page woodcuts and some 300 within the text itself, was finally considered complete by the artist and Vollard published it in 1916. In spite of the long delays in the work for *Les Fleurs du mal,* Vollard requested Bernard to begin work on another volume, *Les Amours de Pierre de Ronsard.* Etchings as well as woodcuts were carried out in a somewhat eclectic manner, sparing neither time nor effort. Bernard not only designed and printed the illustrations, but provided the special type as well. This volume was issued by Vollard in 1915, one year prior to Bernard's *Les Fleurs du mal.*[19]

Although war closed the doors of the little gallery on the rue Laffitte, Vollard moved its contents into his lodgings on the rue de Gramont, where he continued intermittently to publish his books. In 1918, Vollard published *Les Oeuvres de maistre François Villon,* again illustrated by Bernard. The style of the woodcuts is rather heavy and black. Apparently Bernard's style strongly appealed to Vollard, for he issued two more books with his illustrations, *Les Petites Fleurs de Saint-François* and Homer's *L'Odyssée.* These do not, as a whole, have the freshness and originality of Bernard's previous undertakings.

It should not be forgotten that Vollard was preparing his own monographs on Cézanne and Renoir during the years of World War I. He was also preoccupied in a creative way with the fantastic affairs of Père Ubu. It is remarkable that Vollard had managed during such times to carry on his work.

Accomplishing the unexpected and stimulating interest by means of startling contrasts were Vol-

lard's particular forte. He applied this to publishing ventures as well as to his picture dealings. In the same year that *Les Petites Fleurs de Saint-François* appeared, Vollard also brought out *Fêtes galantes* by Paul Verlaine. *Fêtes galantes,* comprising a slight fifty pages of verse, proved problematical for illustration. Much depended on the pictures; however, establishing a lyric sympathy and formal balance between the text and the proposed color vignettes to head each page was essential. There were those who felt the material too sparse to justify so large a book. Pierre Laprade illustrated it with a piquancy and deft refinement reminiscent of Bonnard's early works for Vollard. Laprade's sixteen full-page etchings and gemlike vignettes not only captured and enhanced Verlaine's quintessent imagery, but also fulfilled Vollard's expectations.

Far more ambitious volumes were conceived by Vollard. One, *La Belle Enfant, ou L'Amour à quarante ans* by Eugène Montfort, was profusely illustrated by Raoul Dufy. Over 100 plates for chapter headings, full-page illustrations, vignettes, and elaborate tailpieces were completed by the artist. They were the result of several journeys to Marseilles, where Dufy made countless sketches of the docks, fisherfolk, and the boats from distant ports. Even Vollard marveled at Dufy's perseverance. The book merits a place of distinction among the Vollard publications.

Another volume followed soon after *La Belle Enfant.* This was *Le Chef-d'oeuvre inconnu* by Honoré de Balzac with illustrations by Pablo Picasso, issued in 1931. Vollard made a sterling, almost inspired choice in commissioning Picasso. Balzac's tale tells of an old painter who had worked ten years to create on canvas the epitome of feminine beauty—to have, in the end, nothing for his labors save a painting insignificant and meaningless to everyone except himself. The illustrations are wrought, for the most part, in a definitely representational manner. While Picasso limited himself to a representational style, his designs for the wood-engravings are reduced to completely abstract patterns of dots and lines. Some book designers and bibliophiles objected to Picasso's "disregard" for the actual text and preferred more exact illustra-

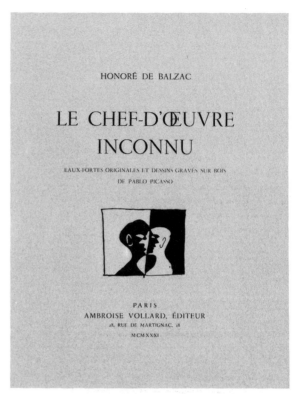

PABLO PICASSO. Title page for *Le Chef d'oeuvre inconnu* by Honoré de Balzac, 1931. Wood-engraving, 32.5 x 25.5 (page). The Museum of Modern Art, N.Y., Louis E. Stern Collection. (Cat. no. 191)

tions to an artist's free interpretation of the Balzac story. In presenting the genius of Picasso in all its remarkable diversity, Vollard realized the importance of meticulous planning as to the type, paper, and general format that would best complement the text and illustrations. How well he succeeded is demonstrated by the volume itself. It ranks as one of the most beautiful books of the twentieth century.

Vollard's next project was Octave Mirbeau's story of his dog, *Dingo,* illustrated with etchings by Pierre Bonnard. It marked a departure from Bonnard's usual lithographic work. The delightful ease, enjoyment of inconsequential pleasures, and affectionate understanding between dog and master are all sensitively realized in Bonnard's full-page etch-

ings and slight vignettes. They reveal combined artistry on the part of author, illustrator, and publisher.

From 1934 to 1936 Vollard issued three books, all with illustrations by Degas: Maupassant's *La Maison Tellier,* Pierre Louÿs's *Mimes des courtisanes de Lucien,* and *Degas/Danse/Dessin,* which included comment by Paul Valéry on the dance. The illustrations for these books came from a portfolio of Degas monotypes done in the late nineteenth century, which the artist had called *Scènes de maisons closes.* They had originally been designed and printed by Degas in regular printer's ink on a copper plate. The resulting monotype was often touched up with pastel by the artist. As a rule Degas worked on his little *plats du jour* in the evenings at Cadard's printing shop. Before his death he had completed several sizable portfolios of *Scènes,* one of which Vollard first saw in a private collection and which he induced the owner to let him publish. The problem was to make a plate faithful to the original monotype, one that could be printed in a regular edition and still retain the sensitiveness of Degas's drawing as well as his subtlety of tone. With the necessary skill and patience, engraver Maurice Potin set out to master this exacting task. Often he had to engrave as many as three different copper plates to capture the rich, feathery effects of Degas's monotypes. Six years were required for the successful reproduction of the portfolio. In his superbly engraved plates of aquatint-etching Potin has preserved the rich blacks and pastel colors of the originals. Thanks in part to his mastery, they now enliven the writings of Maupassant, Louÿs, and Valéry—writings for which Degas had certainly never planned them.

The last two publications issued in Vollard's lifetime carried the forceful visual dreams of Georges Rouault. *Cirque de l'étoile filante* was published in 1938 and *Passion* in 1939, shortly before Vollard's death. The former was entirely Rouault's creation, as the text was his own. His etchings in bright colors and wood-engravings after his drawings vividly portray clowns, kings, a tormented Christ, judges, and prostitutes—all tinged with the artist's sense of despair and suffering. As for the circus, to Rouault it was a complex, tragicomic symbol of human folly. Vollard's first plan had been to combine a text by Suarès entitled *Cirque* with illustrations by Rouault. After a number of detailed maquettes were nearly completed by the printer and approved by Rouault, Vollard finally got around to reading the text. He realized with some consternation that the Suarès text was not only too controversial but that its harsh attack on some United States political leaders would alienate many of his American collectors, and he belatedly withdrew the work from production. Thus Rouault, anxious to retrieve his own work and with his friend Suarès's permission, wrote his own text, calling it *Cirque de l'étoile filante.* Accompanying the text were seventeen new, full-page etchings in color and eighty-two wood-engravings by Georges Aubert after the artist's gouaches. These volumes, of lectern size, are spectacular *éditions de luxe.* Copiously illustrated and richly printed on heavy, hand-made Montval and on Arches paper, they are Vollard's last contribution to the publishing arts. As he slowly leafed through the Rouault illustrations for *Passion,* Vollard mused to André Suarès, "Books like these have never been done before and will never be done again."[20]

Paper, Presses, and Printers

Before discussing the works in which Vollard was not only publisher but author, it may be well to consider the physical problems, difficulties, and limitations involved in his fine editions. Also, it is important to take cognizance of the fact that the careful judgment and inventive genius of his artisans were always taken for granted.

As meticulous about paper, typography, margins, and illustrations as any confirmed bibliophile, Vollard spared neither time nor expense. For his earlier works he had special paper made that carried as a watermark the title of the book. Arches, Masure et Perrigot, Montval, Rives, japan Shidzuoka, Van Gelder, and Vidalon were the papers

used for his editions. For his admirably illustrated edition of Virgil, the sculptor Aristide Maillol some years earlier had resolved to make his own paper "of good solid sheets." From an old formula he produced the paper known as "Montval." With the aid of papermakers Canson et Montgolfier, Gaspard Maillol, the sculptor's nephew, later developed its manufacture. This paper was Vollard's final choice and gave him the most satisfaction. On this strong, heavy paper *Cirque de l'étoile filante* and *Passion* were printed. In order to obtain the exact kind of paper he wanted, Vollard went directly to the makers of handmade paper. Thus he was able to order paper that carried the watermark of a particular work or his own signature, "Ambroise Vollard." This elegant custom was applied to most of his publications. However, after the completion of the *Suite Vollard,* some reams of paper with the "Vollard" and "Picasso" watermark remained in the Lacourière printing shop. These papers were utilized later in the printing of approximately forty-nine plates by Picasso that are dated 1942. These prints, which are not signed or numbered, are annotated in the Bloch catalogue raisonné and were not Vollard projects. The Vollard archives at Winterthur contain a few reproductions of paintings that have the Vollard watermark, as do some of the Rouault prints made from canceled plates. These plates had been rejected by the artist and consequently no edition was issued.

As to the typography of his books, Vollard had very definite ideas. Impatient with the models of modern type, he felt that contemporary artisans were less creative in type design because of a dependence on "over-perfected instruments." No longer did they achieve the fruitful and imaginative results that gave such character to the works of the earlier, less well-equipped craftsmen.

For *Parallèlement,* his first experiment in book production, Vollard had used an old Garamond italic typeface that harmonized well with Bonnard's lithographs. Garamond typeface was happily combined with Degas's illustrations in *La Maison Tellier* and in *Mimes des courtisanes de Lucien.* It also matched the refinement of Laprade's vignettes for *Fêtes galantes.* Didot's type, so popular in France during the nineteenth century, Vollard found most suitable for Rodin's illustrations of Mirbeau's *Le Jardin des supplices.* Previous mention has been made of the type designed, cut, and printed by Emile Bernard. Vollard found the rugged Plantin type to be best suited for the books illustrated by Rouault, namely *Les Réincarnations du Père Ubu, Cirque de l'étoile filante,* and *Passion.*

To the care, perseverance, and disregard for time that Vollard brought to his bookmaking, two books illustrated by Marc Chagall are witness: Gogol's *Les Ames mortes* and La Fontaine's *Les Fables,* which had to be printed several times before the publisher approved them. On one occasion, he found better paper; on another, more suitable type. Because of some caprice of temperament or a lingering dissatisfaction with the final results, these books were withheld from the public after their completion.

Often Vollard found himself confronted with material difficulties. For example, after the Rouault drawings had been conscientiously engraved on wood by Georges Aubert, printer Aimé Jourde found that ordinary presses, with two men working them, produced only mediocre results. The prints came out pale and opaque. Aimé Jourde constructed for Vollard's purposes a press operated both by hand and electricity, the power of which permitted the application of a minimum of ink and a maximum of pressure. The sensitive and delicate mechanism of the specially constructed press enabled Jourde to print an extended scale of shading. Rarely have wood-engravings of more beautiful quality or texture been realized. Through the skill and xylographic talent of Georges Aubert and the master-printer Aimé Jourde, all the gradations of the artist's original drawings are preserved.

The printers who worked with the artists' plates—whether copper, lithographic stones, or wood blocks—deserve recognition. Vollard fully understood the important part they played in his projects. He was personally acquainted with the master-printers then at work in Paris, and he chose them with unerring judgment.

Auguste Clot, printer of Vollard's finest portfolios and books, was himself a genius at printing plates in color. Especially interested in lithography, he

achieved virtual wizardry in this medium. Bonnard, Toulouse-Lautrec, Vuillard, and many others came to his printing shop to experiment and to print their work under Clot's direction. The artists conceded more than once that Clot could accomplish more with a plate than they would have thought possible. Whether it was lithographs or woodcuts or delicate etchings, Auguste Clot did justice to his task.

It was the printer Blanchard who ably printed many of the Redon lithographs. Louis Fort will be remembered for his successful steel-facing and printing of Picasso's plates for *Saltimbanques* and the printing of the etchings for Balzac's *Le Chef-d'oeuvre inconnu.* It was Roger Lacourière, assisted by Jacques Frelaut, whose nearly magical skills accounted for the printing of Picasso's etchings for Buffon's *Histoire naturelle* and the *Suite Vollard,* as well as of Rouault's prints for *Cirque de l'étoile filante* and *Passion.* Again it was Lacourière who printed with special subtlety the Rouault illustrations for Vollard's incompleted *Cirque* by Suarès and *Les Fleurs du mal* by Charles Baudelaire. The house of Jacquemin accounted for the printing of Rouault's *Miserere* series and L'Imprimerie Nationale for the texts of a number of Vollard's editions. Not only did Vollard seek out those artists whose work he admired, but also he constantly searched for well-crafted handmade papers, special typefaces, and masterly printing skills. He once remarked with justifiable pride, "I am the architect of my books."

Vollard, Author

As Paris settled down to the disconsolate years of World War I, many of the younger artists were called to the front. The older ones, remembering the chaotic period following 1870, carried on from 1914 to 1918 as best they could. Wishing to keep the art interests of the public alive in neutral countries, the French Service of Information sent Ambroise Vollard first to Switzerland and later to Spain to lecture on Cézanne and Renoir. This suited Vollard, for he, too, wished to preserve these vital outside contacts.

Out of his amusing and informative discourses abroad arose a desire to record in print his vast store of information and anecdotes concerning the contemporary artists who were his friends. For the subject of his first monograph he chose Paul Cézanne, whom he had long known and whose work he had sponsored. In my book on Cézanne," Vollard explained, "I tried to write simply, colloquially, so to speak, eschewing the slightest hint of art criticism."[21] A most willing and diligent collector of anecdotes, Vollard by this method has afforded unusual insight into Cézanne's character. In reviewing Vollard's book, Roger Fry remarked:

> When the time comes for the complete appreciation of Cézanne, M. Vollard's book will be the most important document existing. . . . To say, as I would, that Vollard's book is a monument worthy of Cézanne himself is to give it the highest praise. M. Vollard has had the wit to write a book about Cézanne and not about his pictures. [He] has played Vasari to Cézanne and done so with the same directness and simplicity, the same narrative ease, the insatiable delight in the oddities and idiosyncrasies of his subject.[22]

Some have found in this biography too little Cézanne and too much Vollard. Still, it is well to remember that despite his strongly held attitude toward modern art, Vollard did not set himself up as the solemn and erudite critic. He did succeed through well-chosen anecdotes—often embellished—in capturing the essence of an artist's personality. Some ten years after Vollard first published his book on Cézanne, Paul Valéry observed in a letter to Vollard: *"Vous etes un fameux portraitiste. Le Cézanne en particulier, est delectable."*

In the years before World War I both Leo and Gertrude Stein often visited Vollard's gallery, where they bought a number of Cézanne's works. Vollard, who always made it his business to learn the financial status of his clients, commented that they were the only ones who bought pictures "not because they were rich, but despite the fact that they weren't." When Vollard's book on Cézanne was published in Paris in 1914 Gertrude Stein found it enjoyable reading. In a letter to her friend Henry McBride, who was then art critic for the New York *Sun,* she commented at some length:

> It's about Vollard. He has just finished a book about Cézanne and it's really extremely good. . . . He is delight-

ful he comes in in great haste in a cab, you remember how big he is, with original paintings and drawings and reproductions and a page of text and asks to be admired and you do and he says he esteems your advice and he litters the floor with papers and then cab and all goes off and he comes with a new supply. I have done a rather nice sketch of him.[23]

McBride later reviewed the Cézanne book and also had Gertrude Stein's portrait-poem "M. Vollard and Cézanne" printed in the *Sun*.[24]

Following the Cézanne study, Vollard wrote in much the same informal style about Renoir and Degas, although the latter book was not his own publication. His work on Renoir was ambitiously planned as a trilogy. The first volume, released in 1918, is entitled *Tableaux, pastels et dessins de Pierre-Auguste Renoir,* and includes a brief introduction, based on a conversation with Renoir, and 700 reproductions of the artist's work. Now rarely seen, this early volume offers many unusual and little-known pieces. The next year appeared the well-known and often-quoted second volume, *La Vie et l'oeuvre de Pierre-Auguste Renoir.* Vollard wrote of this: "In my book on Renoir I gave a great deal of space to painting, though merely, I must add, as a reporter of Renoir's sayings on the subject. But here also the person and life of the artist deserved the fullest treatment I could give them. His career had something of magic about it: a little decorator of plates rising to the incomparable brilliancy of the art of *La Loge, Le Moulin de la Galette, La Danseuse, Les Canotiers . . .*"[25] After reading Vollard's manuscript, Renoir remarked, "Fortunately, you haven't made me talk too much rubbish." The last volume of the Renoir trilogy was, as far as is known, never printed. It was to have had the same title as the first, and was to record in picture-book fashion the works that had not appeared in the two previous volumes.

Vollard's monograph on Degas followed the now-familiar anecdotal pattern. He attempted "to fix certain traits of the man's personality, a personality compounded of a seemingly cold cruelty and disciplined emotion." Another Degas picture book, although copyrighted by Vollard, was actually issued by Bernheim Jeune. In assembling material for his writings on Degas, Vollard had acquired approximately twenty of the artist's canceled etching plates, along with the plate for a Degas portrait by Desboutins. In his catalogue of 1917 Loÿs Delteil records that Vollard was about to publish a series of Degas prints. He also remarked that this information was received too late for definitive information in his own catalogue. Prints from these canceled plates appear in the Vollard archives that the Kunstmuseum in Winterthur acquired from Lucien Vollard, the brother of Ambroise Vollard. They are printed on japan paper of uniform size sheets, but unfortunately they are pale shadows of Degas's distinguished graphic work. Although Delteil mentions that an edition of 250 was printed, apparently Vollard released an undesignated edition without a cover or title page.

During World War I, when Vollard was working on his books of Cézanne, Renoir, and Degas, he was also collecting material for a similar opus on the paintings, pastels, and watercolors of Berthe Morisot. However, according to Georges Wildenstein, Vollard finally relinquished this project in early 1930. It was completed by Marie-Louise Bataille and published in 1961.[26] Berthe Morisot, at the urging of her friends Mary Cassatt and Mallarmé, had made a small group of drypoints between 1888 and 1890. The artist considered these merely preliminary sketches or notations for some of her major paintings, and only a few very rare proofs were pulled at the time. It has long been surmised that Morisot had made but eight drypoints. However, it seems more likely that she made at least a dozen plates. These were acquired by Vollard sometime between 1893 and 1900, either from the artist or from Edouard Manet's widow—from whom he had purchased a group of Manet's drawings. Because the images on four of these plates were merely very slight sketches, Vollard may have printed, in an undesignated edition, only eight of the plates. At any rate they apparently were released without a cover or any explanatory note.

At this time Vollard purchased a few pastels from Mary Cassatt and requested Auguste Clot to make counterproofs from them.[27] Curiously enough, there also appeared in Vollard's holdings a series of progressive states for Mary Cassatt's well-known

drypoints with aquatint in color that contains notes as to their printing. It is doubtful that Vollard had any definite plans concerning them. Sometime later this unique series was acquired by the collector Lessing J. Rosenwald.[28]

Because Vollard returned again and again to that sinister *farceur* of Alfred Jarry's creation, Père Ubu, and later carried his evil deeds to such disturbing lengths, Ubu's origin and development must not be ignored.[29] At the age of seventeen, Alfred Jarry, a precocious student in Rennes in Brittany, wrote a short but biting farce entitled *Ubu Roi*. It scathingly ridiculed one of his professors, and was first staged in 1888 by Les Marionettes du Théâtre des Phynances. Eight years later it was produced on the legitimate stage at the Théâtre de l'Oeuvre in Paris by Lugné-Poe, successful producer of Wilde's *Salomé* and Ibsen's *Peer Gynt*. R. H. Wilenski described it:

> Maurice Denis took part in the staging of the play but Jarry himself planned the sets, masks and costumes. The scenery was conventional; changes of scene were announced by cardboard notices. Ubu hung a cardboard horse's head about his neck to symbolize the mounting of his charger; a single soldier symbolized his army . . . Jarry had made drawings for Ubu which resembled the monstrous figure in the foreground of Ensor's painting *L'Entrée du Christ à Bruxelles*. The music was written by Claude Terrasse. Before the first performance, Jarry explained that the piece would be played by masked actors moving like marionettes. He reminded the audience that the scene was laid *"en Pologne, c'est-a-dire nulle part."* The play began with what we should today call Dada or neo-Surrealist shock tactics. The monster Ubu, symbol of all swollen-bellied, idiotic bullies and humbugs, bellowed belligerence in a voice of thunder. The boos, hisses and catcalls at this opening lasted, Mme Rachilde tells us, a quarter of an hour, but despite interruptions the farce played on. Next day the critics spoke of Ubu as a terrifying figure.[30]

A glowing tribute to the play ecstatically announced that Jarry employed the "satirical simplicity of Aristophanes, the good sense and truculence of Rabelais, and the lyrical fantasy of Shakespeare."[31] *Ubu Roi* had, at any rate, shocked and disturbed the theatre-goers of Paris, and his grotesque drolleries were not to be forgotten.

Vollard was delighted, almost entranced, with the inventive character, Père Ubu. Jarry was one of the artists who appeared at Vollard's celebrated suppers. Under the title *Le Petit Almanach du Père Ubu*—a small brochure that Vollard published in

1899 with a frontispiece by Bonnard—Jarry wrote still more of the reprobate's sayings. In 1900 and 1901 Jarry, aided by Fagus, Charles Terrasse, Vollard, and others, carried on the sayings of Ubu in the brochure *Le Grand Almanach du Père Ubu*. From 1916 onward, Vollard himself wrote and had printed a number of similar brochures on the affairs of the fictitious, conspiring reprobate. He spun out Ubu's fantastic experiences in a hospital, in aviation and war, and his ideas on colonial administration—the last a satire on venal French colonial practice, a subject on which Vollard was both disillusioned and embittered.

The contents of these small Ubu items formed the text of his first large Ubu publication, *Le Père Ubu à la guerre*, with illustrations by Jean Puy, issued in 1923. Speaking of his problems concerning Père Ubu, Vollard once said:

> I was obliged to publish two illustrated editions of *Père Ubu*. The first one was begun during hostilities. Confronted at that time by all the difficulties one must face with a so-called "de luxe" edition, I had to content myself with illustrations of a quality found, up to then, in cheaper editions: drawings reproduced by the photo-engraving process. The chief trouble with the latter was its lack of live, original feeling that hand-work affords. Nevertheless, I was convinced that one should be able to effect better results by mechanical means than had heretofore been attained. It was to the painter, Jean Puy, that I turned with my undertaking. He made a series of pencil drawings for *Ubu* which, reproduced on zinc plates, preserve that soft, somewhat heavy line one thinks of in connection with wood-cuts.
>
> All this transpiring in war time, it proved necessary to reckon with censorship, as much for the text as for the illustrations. Indeed, I was obliged to submit my illustrations for the approval of the military authorities. Permission to print them was granted on the condition that the General's nose, and that of Père Ubu, be shortened.
>
> "They are too long," the censor told me. "They are sure to convey some obscene innuendo!"
>
> "But they portray the enemy," I protested. "The action even takes place outside our frontiers!"
>
> "They're generals just the same. It's no trick for your illustrator to cut off their noses a little . . ."
>
> In the end I rejected those drawings where the nose proclaimed itself too loudly.[32]

Under Vollard's tutelage, old Ubu became a still more violent and sinister character whose nonsense reduced actual events to sheer absurdities. By means of ridicule and grotesque exaggeration, Vollard delighted in heaping upon him all the shortcomings of society, the corruption of its political

systems, and the stupidities of its officialdom. He armed Ubu with a savage vocabulary and showed him up as a scapegoat and villain. In Ubu he voiced his own skepticism of society, his own insecurity, his blustering and conniving, his clowning to make the public aware of his particular genius. By refusing on occasion to sell his paintings and books, he invited the public's curiosity, until it persistently sought whatever he would sell.

Small wonder, then, that Père Ubu emerged for Vollard as a kind of alter ego, one from which he never parted. In 1932 he brought forth a more massive and ambitious volume, *Les Réincarnations du Père Ubu,* with illustrations by Georges Rouault. The artist had completed the plates during 1916–28, but Vollard, as usual, did not publish the book until several years later. His own conception and Rouault's heroic-comic symbols have much in common. Yet Georges Rouault lifted the Vollard character, as it happened, to the plane of somber and disturbing drama. The hero wears a mask of cruelty and abjectness. Ubu, a victim of his own argumentativeness, tolerated no atmosphere save that of his own choosing. The lesser, larvaelike characters of the story inhabit a dark, infernal landscape, an eerie region partaking ironically of the circus. Where Vollard had earlier permitted Ubu the extravagance of mimicry, Rouault let Ubu only reflect his own doubts. Rouault, with his customary historic fervor, gave to Ubu a new and ominous meaning. He made him the strange prophet of fanatical and ruthless ideologies.

It is a far cry from Ubu to the story of *La Vie de Sainte-Monique.* Undistinguished as the text may be, Vollard's *Sainte-Monique* is beautifully and lavishly illustrated by Pierre Bonnard with etchings, lithographs, and wood-engravings. With aptitude and ease Bonnard improvises on a slight but pleasant theme, one which brought to Vollard recollections of his own childhood spent on what he liked to call his "enchanted isle of La Réunion." The theme, a romantic one, suited Bonnard's talents much better than Vollard's.

Vollard's memoirs, *Souvenirs d'un marchand de tableaux,* are a simply and unpretentiously written testament of a singularly eventful life. This book was his answer to those associates who had urged him to write a candid personal history. Those who had hopes of the sensational were doomed to disappointment. Contrary to the usual order of events, it was first published in English in 1936 as *Recollections of a Picture Dealer.* The original French version, expanded by additional happenings, including Vollard's trip to United States, was published in 1937. A unique copy of the French edition, bound in red and brown Morocco leather, was a presentation copy from Vollard to his long-time chauffeur, Marcel Z. Meraud, with the special dedication: "For Marcel, who drives so well—and who is so cautious with *objects d'art.*"[33] Included in this volume were original drawings by Bernard, Chagall, Derain, Matisse, Picasso, Roussel, Segonzac, and Vlaminck. The Picasso drawing in pen and ink and colored crayons was a portrait of Vollard.

Unpublished Books and Albums

Twenty-five volumes were in preparation by Vollard at the time of his death in 1939. Some were printed and ready to be assembled; others were in various stages of completion. Prior to the fall of France, Lucien Vollard announced that he intended to issue a number of the works that remained in Vollard's shop. Only the Francis Thompson *Poèmes* with illustrations by Maurice Denis was published under the imprint of Lucien Vollard and Martin Fabiani in 1942. It is to be noted that a few earlier "exhibition copies" of this volume exist that carry the imprint "Ambroise Vollard, éditeur."

A strange twist of temperament, an inordinate desire for perfection, and a habit of procrastination may have made Vollard reluctant to finish or, in some instances, to release his most important projects. He thought nothing of holding in his shop plates that the artist had completed fifteen or twenty years earlier. Great patience, fatalism, and even self-abnegation were required of the artist who carried out this publisher's ambitious schemes.

Among those whose work remained unpublished were Marc Chagall and Georges Rouault, who

devoted years to Vollard's illustrated books and portfolios. Rouault had the satisfaction of seeing three of his works in print. But Chagall knew the disappointment of witnessing two of his projects— *Les Ames mortes* by Gogol and *Les Fables* by La Fontaine—printed and ready to be issued but for some reason left as stock not for sale in Vollard's shop. As for Chagall's style, he progressed from the lightly satirical manner of the illustrations for *Les Ames mortes,* and the childlike gaity and charm of *Les Fables,* to the brilliance of his etchings for the Old Testament.

Vollard received sharp criticism for his selection of a foreign-born artist to illustrate La Fontaine's treasured work. Counted among the masterpieces of French literature, it was celebrated for its admirable clarity, its lyrical idiom, and its revelation of the beauty of the French language. Critics protested that only a native French artist was capable of capturing the nuances of *Les Fables.* Vollard's defense was that La Fontaine did not invent the material of his Fables but instead recreated the stories of Aesop and those of the storytellers of Persia, Arabia, and the Far East in a style that pleased the taste of eighteenth-century France. Vollard's choice of Marc Chagall as the illustrator was an exceedingly fine one. Chagall understood this masterpiece well and brought to it the rich fantasies of his own Russian childhood. Today it remains one of Chagall's and Vollard's distinguished accomplishments.

Chagall's 100 gouaches for *Les Fables* were exhibited at the Galerie Bernheim-Jeune in Paris in April 1930. Vollard's brief preface to the catalogue was his answer to the critics. The gouaches themselves were later exhibited in Brussels, Berlin, and other continental cities.

Vollard had originally hoped to issue *Les Fables* with Chagall's etchings in color in a manner reminiscent of the eighteenth century. However the technical difficulties of transferring the color of the gouaches to a printing surface proved to be so involved that Chagall abandoned this idea and etched the 100 plates for *Les Fables* in black and white. They were printed by Maurice Potin in 1927–30. Numerous delays so typical of many Vollard projects extended the production over many years.

At the time that Chagall was working on his plates for *Les Fables* Vollard suggested that he consider illustrations for another work—that of *Cirque* by André Suarès. Chagall had completed nineteen gouaches for this project when a still more ambitious and enthralling idea captivated both artist and publisher. *Cirque* was set aside and Chagall began his illustrations for the Bible, initially called *Le Livre des prophètes.* In 1931 Chagall traveled to a number of countries in the Near East, where he experienced an entirely different vision of light intensified by the rapidly changing patterns of deep-toned shadows. From his early background of Hebraic history and ritual Chagall brought to his Old Testament series a profound, almost medieval fervor. The devout yet afflicted world of the Mosaic Law and the Prophets is projected into a vision of a fluid chaos, deeply poetic and religious. Where Rouault's world is intensely dramatic in its contrasts, Chagall's is more tempered by a wistfulness and simplicity of vision.

The Bible illustrations are in scope almost a life's work. To them Chagall unstintingly accorded his rich, creative energy and his reverence for biblical idiom. Among them are depicted the Creation of Man, the Meeting of Rachel and Jacob, Crossing the Red Sea, David and Goliath, and Moses Breaking the Tablets. Because, as he said, he dared not break the sacred Tablets, even pictorially, Chagall carefully and beautifully etched them with only the merest edge broken away. The 105 illustrations the work comprises were planned for a book the size of the Rouault *Père Ubu.*

Chagall, like Rouault, disregarded the conventional method of making an etching. He employed anything capable of scratching or cutting the copper surface, from the graver to various needles and pens. He achieved his dark areas by carefully bitten lines, delicate cross-hatching, and a feathery shading in drypoint. Chagall achieved intensified patches of light within the already darkened areas of the plate by covering a previously etched section with a porous lacquer. These sections were then reworked with a burin to produce the desired tones

and textures of translucent light. Trial proofs for the Bible series of 105 compositions exist in no less than four and sometimes as many as fourteen states. During the time that Chagall was working on the copper plates, Vollard spent much time at his studio. Enthusiastic with the results, the publisher remarked that the illustrated Bible would be Chagall's and *his* monumental work. Haunted by the desire for immortality, Vollard wished to be remembered as the publisher of a Bible with modern illustrations.

While Chagall was still at work on the plates for the Bible, Vollard was already entertaining other elaborate ideas. This time Chagall was to handle a pagan theme, *The Arabian Nights.* The medium was to be lithography. Vollard thought little of monopolizing the whole creative existence of an artist for an indefinite number of years. He himself had all the time in the world. Nothing but his own dreams seemed to concern him. Chagall never undertook this latest Vollard scheme. However, he later designed twelve lithographs in color for *Four Tales from the Arabian Nights,* published in New York in 1951.[34] Chagall had devoted many years to his great visual interpretations of the biblical themes. When Vollard died the artist had completed to his own satisfaction sixty-six of the plates. The work on the thirty-nine remaining images, begun in 1939 but not resumed until 1952, was finished in 1956. Finally, after some thirty years, Chagall had the belated pleasure of seeing his three books for Vollard—*Les Ames mortes, Les Fables,* and the *La Bible*—published by Tériade in Paris.

The case of Rouault differs considerably from that of the other artists whose works for Vollard remained unpublished during his lifetime. Although Rouault gave Vollard over thirty-three years of his creative genius, he at least had the satisfaction of seeing three of his large projects published. These were *Les Réincarnations du Père Ubu* in 1932, *Cirque de l'étoile filante* in 1938, and lastly, *Passion* in 1939. In spite of discouragements and bitter quarrels, Rouault continued to fulfill his somewhat vague contracts with Vollard. In 1933 he completed and Vollard issued four lithographs, including the *Portrait de Verlaine* and *Automne.* The

latter, a complicated and unusual composition, is Rouault's by no means insignificant contribution to the ever-recurring bathers theme. The posthumous *Portrait de Verlaine* was inspired by a death mask of Verlaine. Rouault greatly admired its plastic qualities, its strongly modulated forehead, and its strangely preserved inner force. This cast remained in the artist's studio as a cherished work of art and may have inspired Rouault's lithograph *Saint Jean-Baptiste.* These large-scale lithographs in black and white were issued as separate titles in what for Vollard were small and sometimes undesignated editions. They also appear with varying annotations in Rouault's hand. In 1933 a less imposing lithograph, *Fleurs du mal,* appeared. It was based on the two nude figures in the center section of his *Automne* lithograph, which Rouault chose to define more clearly within a considerably simplified composition. Between 1936 and 1938 Rouault worked out to his satisfaction three large color prints in what had become a familiar method of aquatint and etching. Their size was comparable to the plates for the *Miserere* series. They were printed on Arches heavy wove paper at the Lacourière Atelier. One title, *Le Christ en croix,* is a variant of the black and white plate number thirteen of the *Miserere; La Baie des trépassés* had also originally been destined for the same series. In his second large *Automne* Rouault reinterpreted with subtle changes the bathers theme.

At the time Rouault began work on Vollard's *Père Ubu* opus he was formulating a vast work that would mirror his religious convictions and questionings—perhaps a medieval *danse macabre* set within the context of the twentieth century. This ambitious theme appealed to Vollard, and he agreed to carry it forward in return for Rouault's consent to illustrate the *Père Ubu* text. It was during World War I that Rouault embarked on the myriad gouaches, paintings, and finally on a growing number of large-scale photogravure plates. He worked on the plates during 1916–18 and 1920–27. Vollard's original plan was to have two large portfolios of fifty prints each: one to be titled *Miserere* and the other *Guerre.* Both were to be based on texts by André Suarès.[35] After Rouault had completed

nearly half of the plates and had printed a number of trial proofs Vollard, despite his flair for giant projects, realized that their size, combined with Rouault's dramatic black and white images, would make the two albums overpowering, unwieldly, and possibly unmarketable. His later plan was to issue the fifty-odd completed prints in a single album with the combined title of *Miserere et guerre.*

The innovative technical aspects of the prints for *Miserere* first appeared in his illustrations for Vollard's *Réincarnations du Père Ubu,* published in 1932. At first Rouault and Vollard were purposely vague about the techniques employed because of the mechanical methods that were involved. Rouault's rich blacks and powerful images captivated the print world and authorities began deducing the artist's methods. In the technical notes to Soby's book on Rouault, Rouault's methods are explained:

> Nothing could possibly be more baffling to the amateur of prints than to define the means by which . . . the *Miserere* series was executed. First, his preliminary drawing is reproduced on the copper plate by the photomechanical process of heliogravure. He then uses almost every instrument known to the engraver and every acid known to the etcher in order to render to his satisfaction the tones and values of his unique images. He engraves with a burin; he shades with a roulette, a rasp and often with emery paper. Sometimes he applies the acid directly to the copper with the aid of a brush, without any covering of wax, to produce those famous blacks of varying intensity, or to get the smooth or granular surfaces which please him.[36]

The sheets themselves, of Arches heavy laid paper, measure approximately sixty-five by fifty centimeters, a size permitting only small margins. The album was to be issued in five sections, but again Vollard did not carry out his intentions. There are several possible explanations for his hesitation. The question of its large scale may have been one reason.

The unusually large scale of many of Vollard's publications had led to some debate as to how large an original print might be and still not assume a posterlike quality. The *"estampe murale"*[37] was by no means universally accepted by the print connoisseurs of the period. Furthermore, they questioned the extensive use of the photomechanical means employed to set Rouault's basic image on the plate.

In reality they were as yet unable to accept Rouault's dramatic themes or his methods. It was ironic and even frustrating to Rouault that only a few decades later the realm of the modern print had changed so much that artists were adapting many commercial printing methods.

Still another problem arose in the use of the Suarès texts. Although they had supplied the inspiration for the illustrations, or "illuminations," the artist eventually made the theme so much his own that he wished to write his own captions. Regarding the titles, Rouault remarked that they were composed spontaneously and without regard for those he called *"les grammairiens pères."* Vollard also sympathized with Rouault. Nonetheless, during Vollard's lifetime the work remained hidden away in his crowded cellars. At one point, Ambroise Vollard showed his set of prints for this ambitious series to the noted art historian Lionello Venturi and remarked, "Here is a work that will never be published." It is well to remember that at the time that Vollard was issuing his *éditions de luxe,* individual copies were being offered for sale at less than $200 apiece. When Vollard issued Rouault's *Cirque de l'étoile filante* and *Passion* in the late 1930s the price was $150.

The complicated and frustrating saga of the *Miserere* album was to continue for another decade. The sudden death of Vollard, World War II and the occupation of Paris, followed by Rouault's lawsuit against the Vollard heirs for the return of his paintings formerly in Vollard's possession, caused long and discouraging delays. The legal proceedings against the Vollard heirs were in the French courts in 1946. The basic premise of the case was that only the artist retained the rights to his unfinished works and that only the artist himself was able to judge when a work of art was his final statement. Furthermore, the works themselves, done many years previously and in a style in which the artist no longer was working, could not be finished and therefore should be destroyed. After long litigation a precedent-making decision was made in the artist's favor.[38] On recovering his work, Rouault then destroyed many of the paintings and gouaches that he deemed either unfinished or badly damaged.

The work in his own quarters, which had been occupied and ransacked by Nazi officials, fared no better. Finally, for the *Miserere* series Rouault chose fifty-eight prints for a large album to be issued under the single title of *Miserere*. They were formally published by L'Etoile Filante in Paris in 1948. There has been some concern voiced over the size of the edition itself. It was Rouault's recollection that Vollard originally had hoped to issue an edition of 500 copies, but during the ensuing years he had sold or given away to special clients and friends a number of the titles, while others had been badly damaged during the war. When Rouault finally recovered his prints, the edition was established at 450 albums. In the justification of the edition it is noted that the work was "printed by Jacquemin, master-printer in Paris, from 1922 to 1927 under the initiative of Ambroise Vollard and conserved by him until his death." In the artist's preface Rouault also adds: "If injustice has been shown toward Ambroise Vollard, let us remember that he had taste and a passion for making beautiful books, regardless of time: but it would have taken three centuries to have completed the works which he wanted . . ." Each print in this long-awaited portfolio is enclosed in a large folded sheet of heavy Arches paper on which is printed the individual title. Accompanied by a title page, artist's preface, and the justification of the edition, the fifty-eight plates are sequestered within a weighty slipcase. Today, in spite of its large edition, a complete album of *Miserere* rarely appears on the market.

The extensive correspondence between Rouault and Suarès is often concerned with the publishing ventures and vague promises of Ambroise Vollard.[39] Initially the Suarès texts had been the inspiration for Rouault's illustration for *Miserere, Cirque de l'étoile filante, Passion,* and the abandoned *Cirque*. Eventually, the Suarès text for *Passion* with illustrations by Rouault, published by Vollard in 1939, was the first tangible result of their joint efforts. Rouault's letters show a mounting bitterness and not a little despair at the endless delays—Vollard's indecision, the time-consuming execution of the wood-engravings, and the unpredictable delivery of printers' proofs. Vague contracts or merely verbal agreements between artist and publisher and author and publisher led to little or no financial remuneration. For many years Rouault had his studio on the third floor of Vollard's large quarters on the rue de Martignac but, as the artist painfully observed, this did not support him or his family. However, Rouault's impecunious situation did not concern Vollard, who continued to demand more work from him. Perhaps Rouault was caught within the magic of his own burgeoning creative ideas and visions as well as by Vollard's innumerable plans for the publishing of magnificently illustrated books. At any rate, the artist did not move from his studio in Vollard's quarters—nor did he remove his work, which he occasionally warned Suarès was a final necessary step.

Rouault's illustrations for two other books remained unpublished during Vollard's lifetime: the ill-fated *Cirque* by André Suarès and *Les Fleurs du mal* by Baudelaire. The illustrations for *Cirque*, eight in number, had been completed by Rouault sometime before the issuance of his *Cirque de l'étoile filante*. The etchings are unusual in the softness of their colors. A green-clad figure, dancers, clowns, and a red-coated rider all are familiar subjects, yet their mood is less somber and less obviously dramatic. His stained-glass heritage seems remote and his figures, no longer bursting from the pages, become part of a larger vision. There exist maquettes and incomplete copies with varying title pages of the earlier abandoned edition. Seven of the etchings were issued in a wrapper with a title page carrying Vollard's imprint. They were for a prospectus and probably were completed at Potin's atelier in 1930 (cat. no. 202).

Both artist and author were most anxious that *Cirque* should again become an active project. In the previous effort Rouault had completed eight full-page etchings, and he wished to add wood-engravings after other drawings. Vollard, too, was encouraged to resume the project with a slightly modified text. His active interest is revealed in the extensive maquettes for the work, which contain several varying title pages dating from 1931, 1933, and finally 1939. These are accompanied by layouts and typography with added corrections. The pagi-

nation in the different maquettes varies from 70 to 240 pages, the latter containing as many as seventeen reproductions of full-page wood-engravings and numerous small vignettes. In a letter to Suarès at the end of May 1945, Rouault recalls that Vollard, dissatisfied with the Potin printing of the eight plates, had withdrawn the plates and Potin's completed suites and turned them over to Lacourière to finish the printing. He wrote: "There were only a few completed etchings for this work, at Potin's, and besides Vollard wasn't much satisfied with them; he later broke off and then continued the project with Lacourière. . . ."[40] In 1939 the illustrations were printed in color on Montval and Rives papers by Lacourière. Isabelle Rouault states that there are 500 suites in the edition.

Other complications beset the Vollard edition of *Les Fleurs du mal.* Rouault, in a 1918 letter to Vollard, had proposed an illustrated edition of the Baudelaire text with approximately twelve etchings in the general style of the *Miserere* prints, on which he was then working. It will be remembered that Vollard had issued in 1916 a two-volume edition of *Les Fleurs du mal* with elaborate woodcuts by Emile Bernard. A new edition with illustrations by Rouault was indicated by Vollard. The Rouault plates, comprising fourteen individual subjects executed in etching, were completed some ten years later, in 1926–27. They were printed in black and white at the Jacquemin press in an edition of 500 on Arches paper, as requested by Vollard in 1927. Vollard's original plan was to publish thirty of the Baudelaire poems with fourteen etchings and an undesignated number of wood-engravings. This plan, along with the one for *Cirque,* was terminated by Vollard's sudden death at the opening of World War II. There exist several important maquettes for this project (cat. no. 203).

Although Vollard had printed the Rouault etching plates in a large black-and-white edition, he entertained Rouault's idea of issuing a suite of new illustrations in color. Twelve aquatints in color were apparently first printed by Potin. However, not satisfied with this printing, Vollard later gave it to Lacourière, who in 1938–39 printed it in an edition of 250 suites on Montval paper with a watermark "V" or "M" or the symbol of a seated nude within a circle. At the present writing the major part of the suites remains in private hands.

Rouault mentioned in a number of letters to Suarès and in one in the collection of Louis E. Stern[41] his *"petits"* or *"miniscules livres."* He hoped that Vollard would issue small versions of his larger illustrations for *Les Réincarnations du Père Ubu, Les Fleurs du mal,* and other titles. To this end he composed many complete gouaches and drawings. Although Vollard did not refuse to consider Rouault's idea, he never got around to publishing the small versions. Perhaps Vollard's overriding vision was the giant, lectern-size book rather than the *"miniscule livre"* that so enchanted Rouault. A small version of *Les Réincarnations du Père Ubu* (27 x 20 cm.) was published much later (in 1955) by the Société Normande des Amis du Livre. Only a part of the Vollard text from his original edition was reprinted. The twenty-three illustrations, with one of the titles in two different states, were reproduced in photogravure touched with aquatint. The title page bears the somewhat misleading notation *"Executée à la demande d'Ambroise Vollard."*

It must be remembered that Rouault was nearing seventy years of age at the time of Vollard's death. The disruptions of World War II, the occupation and ransacking of Rouault's house at La Sarthe, near Paris,[42] and finally the lawsuit to retrieve his work from Vollard's heirs left him little time or energy for further creative work. Nevertheless, his paintings, gouaches, and prints span the first fifty years of twentieth-century art. His lithographs for Frapier, for the Editions Porteret, for the Editions des Quatre Chemins, and for Vollard, combined with his intaglio illuminations that grace Vollard's superb *éditions de luxe,* are a stupendous achievement.

Vollard asked both Dunoyer de Segonzac and Georges Braque to illustrate texts of their own choosing. Segonzac suggested that he illustrate *Les Géorgiques* of Virgil, as he believed the region of Provence where he lived had many of the antique qualities that had prevailed in the Italy of Virgil's time. Vollard agreed to this suggestion. Segonzac had discovered the charm and special ambience of

Provence when he first visited Saint-Tropez in 1908. Since then, he had spent much of his time in the South, where he maintained a small house and studio. He soon learned that Colette too spent her summers in a small villa not far from his own studio. They became lifelong friends. Both writer and artist enjoyed and were keenly observant of the changing seasons, small fields, the ancient trees, and the tangle of vines and flowers that grew undisturbed along the stone walls and fences. Segonzac had already begun a series of plates illustrating Colette's *La Treille muscate* when he embarked on his illustrations for the Virgil text. His illustrations for *Les Géorgiques* were divided into four sections following the text: Cultivation of the crops, Wine, Cattle, and Bees. These delightful visual essays were composed over a span of fifteen years during the artist's sojourns in Provence and the Ile de France.

Vollard's initial plan was to issue four volumes, one for each of the four sections of the work. However, this proved to be cumbersome, and he decided on two volumes of two sections each with a total of 119 original etchings. Segonzac had hoped in the final printing to avoid all plate marks, thus allowing the image itself to float freely on the page. Consequently he used copper plates that were larger than the designated size of the page itself. However, this caused many printing problems and he abandoned the idea. Many of the plates had to be trimmed or reduced in size. Segonzac always worked directly from nature. The plates were etched in a single biting of the acid with additional accents in drypoint. Evenly inked and cleanly wiped for clarity of impression, they are not only an eloquent tribute to Virgil's poetic text and the special ambience of Provence, but also reveal the sensitivity and skill of Segonzac's draftsmanship. Segonzac completed most of the plates by 1926, and they were printed in the Lacourière Atelier in 1937, 1939, and 1940. Segonzac had not signed a formal contract with Vollard; thus by the payment of an agreed-upon sum he was able to retrieve his work from the Vollard estate. The two-volume *édition de luxe* finally was published by Segonzac himself in 1944 and released by him in 1947. At the end of the second volume appears the notation "We wish to pay tribute here to the memory of Ambroise Vollard, who contributed to the choice of typeface and the first typographic tryouts for this volume."

Early in the 1930s Braque accepted a commission from Vollard to carry out a series of sixteen etchings for an edition of Hesiod's *La Théogonie*. Reporting from Paris, Janet Flanner described Braque's etchings: "He pictured the gods in a sensuously thin-lined neo-archaic style, adapted from the antiquities he had loved in the Louvre when young—those kirtled, fragmentary Greek figures, those strained equine heads, those nude Olympian scenes etched on Etruscan mirrors."[43] More philosophically, Werner Hofmann summed up the work: "Braque based his version of Hesiod's catalogue of the gods on a single symbolic idea—the genesis of linear form which emerges from chaos."[44] Braque was not concerned with archeological details but with the endless fluidity of lines out of which he created metamorphic figures of a pulsating vitality. He utilized the Greek alphabet not only to record the names of the gods but also as a foil for his own intricately interwoven lines. Braque completed the sixteen etchings for *La Théogonie* in 1932. Trial proofs were widely exhibited and received much favorable critical comment. The cover, frontispiece, and two ornamental plates were added later and eventually published by Maeght in Paris in 1955, nearly twenty-five years after Vollard's original commission.

In 1906–07 Vollard had provided André Derain with "ten thousand gold francs" in return for all the paintings resulting from two months of work in London. Vollard hoped to receive a series of views of London, something of a sequel to Monet's earlier Thames River views. Some years later Derain completed for Vollard a number of faiences, including a tea service. In the early 1930s Vollard asked Derain to illustrate several *éditions de luxe*. Consequently the artist finished sixty-seven lithographs that were to accompany an edition of La Fontaine's *Les Contes et nouvelles*. In 1934 Derain turned over to Vollard thirty-three line engravings augmented by forty-three ornamental woodcuts. These were illustrations for *Le Satyricon* of Petronius. The two works were never published by Vollard. Finally in 1950

and 1951 they were issued under the imprint Aux Dépens d'un Amateur in Paris (Colonel Daniel Sickles).

One of Picasso's most handsome and delightful series of etchings and aquatints carried out at the request of Vollard was issued by Martin Fabiani in 1942, several years after Vollard's death. Buffon's *Histoire naturelle* had been planned by Vollard and Picasso many years earlier. However, it did not get under way until 1936 when Picasso, in a flurry of work, completed the thirty-one etchings that compose this unusual modern bestiary. Vollard, again, had given Picasso a free hand in the work. Although Picasso did not adapt his illustrations to the Buffon text, he nonetheless composed a magnificent series of animals, birds, and insects. It was the printer who took over the task of later extracting passages from the text that described or treated the subjects that Picasso had chosen to depict. Thus in some instances a single illustration would be given eight pages of text while others received but a page or two. Whether this was due to Vollard's impatience or flagging interest or to production problems is not known.[45] It has been noted that rather than an illustrated book it is instead a wholly engaging suite of etchings coupled with excerpts from a classic French text. This is not an unknown procedure, as it was utilized centuries earlier by Dürer and Holbein and in the twentieth century by Redon and Rouault.

When Vollard was past seventy, further plans were under way. Picasso's suggestion that he sketch Vollard's portrait each time he paid him a visit, until enough for a suite should be finished, flattered Vollard hugely. But his death cut this project short and only three portraits were completed.[46] Meanwhile, Vollard had obtained ninety-seven etched copper plates from the artist in exchange for several important paintings that Picasso wanted for his own private collection. This group of plates, selected by Picasso from his large graphic oeuvre, had been completed in the six-year period from September 1930 through June 1936. The above-mentioned three portraits of Vollard were added to the group in 1937 to round out the *Suite de cent eaux-fortes originales,* better known as the *Suite Vollard.*

This title led to the erroneous assumption that the entire suite was actually commissioned by Vollard, as had been the procedure in most of his publications. Picasso himself perhaps added to the confusion when he is quoted by Françoise Gilot in a remembered conversation: "'This is a series of etchings, a hundred of them, that I did for Vollard in the 1930s.' On top of the pile were three etched heads, two of them with aquatint, of the picture dealer Ambroise Vollard."[47] The classifications of the prints in this large series seems somewhat arbitrary, as the various themes are often interwoven. However the prints making up the groups entitled *The Sculptor's Studio* and *The Minotaur,* combined with the later aquatint and etching *Satyr and Sleeping Woman* dated June 12, 1936 (pl. 27), give the entire series coherence and a dazzling brilliance. Vollard assigned the plates to the Lacourière Atelier, where they were printed in an edition of 303 copies. Along with Vollard's numerous unissued publications, the *Suite Vollard* remained in untidy stockpiles in Vollard's cellars.

After Vollard's death and during World War II, the well-known Paris print dealer Henri Petiet acquired the major portion of the *Suite* from the Vollard estate. These did not include the three portraits that completed the series of 100 prints. Petiet released his copies to the market around 1946–48. The portraits of Vollard were held and sold separately by the Paris dealer Marcelle Lecomte. These had been signed by Picasso in red or blue crayon.

One other work with illustrations by Picasso was planned by Vollard. The text *Hélène chez Archimède* by André Suarès was to have one original etching and also twenty-one of Picasso's drawings engraved on wood by Georges Aubert. Vollard's plan was to utilize some of the line drawings from a Picasso sketchbook of 1926 as an introduction. It is not known how he intended to incorporate the three ornamental sketches that later were developed as full-page illustrations in the 1955 edition published by the Nouveau Cercle Parisien du Livre. This edition was altered considerably from the Vollard plan. The single original etching was eliminated, along with one of the twenty-one wood-engravings.

It is doubtful that the extra suites of illustrations printed on blue- and on yellow-toned papers that appear in the 1955 edition were part of Vollard's initial project.

For some time Vollard had been collecting a group of nude studies that were to be issued as an *Album de nus.* To be included were prints by Bonnard, Dufy, Forain, Maillol, Matisse, Picasso, Rouault, and other artists not designated. The proposed edition of 250 remained incomplete.

Vollard had seen and admired the prints of Stanley William Hayter, at whose Paris studio Picasso, Braque, Segonzac, and many others gathered to learn the old technique of copper engraving. In 1937 Hayter had been invited by the Republican government of Spain to visit its war-torn country. During his brief sojourn there he learned of the Cervantes play *Numancia,* a vivid portrayal of the heroic defense of a Spanish town against the Romans in 133 B.C. It bore a striking and appalling resemblance to the latest, tragic Spanish struggle. On his return to Paris Hayter brought Vollard several of his new engravings based on the Cervantes text and his own recent experiences. Vollard was pleased with the clear-cut but disturbing images, questioning only the proposed format. A tentative plan called for a two-column printed page, one carrying the original Spanish text, the other the French translation. This book, perhaps one of Vollard's last interests, never materialized; but even in its somewhat nebulous form it reflects Vollard's tireless quest for new artists and ideas.

Too many schemes and plans, possible perfectionism, and frequently plain procrastination hampered this ambitious impresario of the arts. He left unissued or unfinished more portfolios and books than he had published.

Bronzes

Early in his career, Vollard became interested in issuing editions of bronzes. About 1899 Aristide Maillol, poor and unknown, came to Paris from Banyuls, bringing with him a load of small terracotta statuettes. Edouard Vuillard saw them and excitedly brought Vollard to Maillol's quarters at Villeneuve-Saint-Georges. Ever on the watch for new or unknown artists whose work in his own judgment or in the judgment of his artist-friends seemed a profitable investment, Vollard saw possibilities in issuing bronze editions of the Maillol terra-cottas. He purchased a few pieces and had them cast in bronze.

The sale of these small figures provided Maillol with a modest living. But he still was unable to build a kiln necessary for the firing of his terracottas. Upon hearing of this, Vollard had one built for the sculptor at Villeneuve. With almost pathetic relief, Maillol remarked, "It is thanks to Vollard that I am able to live." In 1902 Vollard held an exhibition of Maillol's work, consisting of thirty pieces of sculpture and three of his earlier tapestries. The integrity of his work—whether in terra-cotta, plaster, bronze, or marble—and his devotion to a classical interpretation of the human figure are always evident. Critics and public alike welcomed the serenity and warmth of his sculpture. Maillol made a number of models for Vollard, always specifying that any bronze editions be limited to no more than ten casts. Often this stipulation by the artist was ignored, as Maillol observed with exasperation and finally with resignation: "Well, he made ten casts, all right, except that they turned out to be ten thousand!" There are occasionally slight irregularities and small changes in certain of the casts in which the sculptor perhaps had little or no part. Needless to say, this was the exception rather than the rule, and in the nine known Maillol bronzes issued by Vollard, the majority are well executed.

Vollard had attempted to interest Degas in his bronze editions, but the artist insisted that he was a painter and that his models were made only to facilitate his painting and for his own pleasure. In his book on Degas, Vollard remarks with some regret:

> Degas made a great number of statuettes, but hardly more than one or two were cast during his lifetime. One day he showed me a little dancer that he had done over the twentieth time . . . The next day, however, all that remained of the little dancing girl was the original lump of wax from which she had sprung. Seeing my disappoint-

ment, Degas said, "All you think of, Vollard, is what it was worth. But I wouldn't take a bucket of gold for the pleasure I had in destroying it and beginning over again."[48]

Auguste Renoir was first inspired to work in sculpture when he posed for Maillol in 1907. It was after nearly a lifetime of painting that he was persuaded by Ambroise Vollard to consider working in sculpture. However, at the age of seventy-three he was in precarious health and gravely incapacitated by arthritis. It was Vollard who, on a visit to Cagnes, urged Renoir to work with a young assistant. Renoir was to supply the drawings and to supervise the work in plaster. First amused by such an idea, Renoir was soon involved in the plan. Vollard, amiable, witty, and nonchalant when artists were concerned, was adept at making his way into the most carefully guarded studios and persuading painters and sculptors to undertake his special projects. He also offered to bring them the necessary materials. With some dispatch, he brought the young sculptor Richard Guino to Renoir's studio. Guino had worked with Maillol and was unusually skilled in the various techniques of sculpture. He was also able and amenable to carrying out a style that was not necessarily his own. In the end Vollard's idea prevailed, with Vollard electing to pay Guino's expenses. This unusual arrangement proved to be uniquely successful, and the working relationship between Renoir and Guino was a happy and productive one. In fact, Guino's interpretations of Renoir's drawing, instructions, and wishes were so deft and expert that Renoir's bronzes and terra-cottas have always been accepted as originals. Perhaps Renoir's best-known sculptures are the modestly poised *La Laveuse,* or *Washerwoman,* and the stately *La Vénus triomphante.* Their method of working was carefully developed. Renoir would choose a figure from his paintings or drawings that he believed would lend itself to sculpture, then make a working sketch. Some of these sketches have been preserved. Guino in turn built up a small trial model in plaster. Occasionally he worked from a model who had formerly posed for Renoir. Vollard, a man of special taste and ingenuity, was always the astute businessman as well. Thus he managed to gain exclusive rights as agent for the Renoir sculptures. He obtained Renoir's permission to make bronze casts of some fourteen individual pieces. A letter from Renoir to Vollard, written at Cagnes, April 19, 1914 specifically states: "I authorize Monsieur Ambroise Vollard, picture-dealer, owner of my three sculpture models: small statue with base *Jugement de Pâris,* large statue with base *Jugement de Pâris* and the clock *Triomphe de l'amour,* to reproduce them in any material."[49] The latter model, *Triomphe de l'amour,* was never cast in bronze for Vollard. It was cast for the first time in 1955-56 in an edition of eight by Alfred Daber of Paris. In several instances Vollard retained in his gallery the first casts of the larger bronzes by Renoir and Maillol with their bronze pegs and guides intact. Alfred H. Barr notes this procedure in The Museum of Modern Art's casts of Renoir's large *La Laveuse,* or *Washerwoman.*[50]

From 1905 to 1909 Picasso modeled for Vollard four heads and a small statuette entitled *Femme se coiffant.* Picasso's famous Cubist head, *Tête de femme,* although distinct from his other sculpture, is closely allied to his painting of the same period. It was executed in the studio of Julio Gonzalez, and in the work Picasso hoped to revolutionize the perception of an object in a three-dimensional technique. In the end the head retained its basic solidity and form, but the surfaces were broken up into many facets, which in turn were related to the geometric planes that appeared in his Cubist paintings of the period. *Arlequin (Head of a Jester),* completed in 1905, is more representational. Its melancholy mood is similar to that expressed throughout the artist's series of *Saltimbanques.*

Vollard briefly mentions the bronze *Surtout de table* by Pierre Bonnard.[51] It is an oval ring composed of numerous small nude figures. Cast in bronze, it also has traces of hand-tooling by Bonnard. It is rarely seen and seldom mentioned in the various writings on Bonnard. Bonnard issued a few other small bronzes, but it has not been established that they were cast for Vollard.

In the twenty-odd bronzes that compose the Vollard editions only a few have cast numbers. It is doubtful that Vollard himself knew the total issue

of each. His practice was to keep in his shop an example of each of the bronzes. When a collector or dealer wished to obtain one, Vollard would order a cast made. Being a good businessman, he never had more on hand than he could sell. The Maillol figures were probably the most popular and, accordingly, Vollard issued more bronzes by Maillol than by any other artist. Vollard's active interest in his bronze editions began early in the twentieth century and ended in 1917 with the series of six medallions by Renoir.

Not long after his first bronzes were cast Vollard attempted to issue works in faience. He had seen and admired some of Rouault's pieces at André Mettey's studio at Asnières and had persuaded this master ceramist to turn out some plates, vases, and plaques to be decorated by various artists of his choosing. Among the artists who initiated this Vollard project were Bonnard, Denis, Derain, Laprade, Maillol, Puy, Rouault, Roussel, Valtat, and Vlaminck. Derain is known to have designed a tea service of 100 pieces and several vases. Vlaminck completed some vases, as did Maillol. Rouault decorated plates and vases and also several porcelain panels and a ceramic nude figure. In 1915 the American collector John Quinn purchased from Vollard paintings and ceramics by Rouault; in 1918–19 he acquired eleven more Rouault ceramics from Vollard. Quinn mentions, with some irritation, that he had trouble persuading U.S. customs officials that the Rouault ceramics should be exempt from any import duty.[52] At the Palais des Beaux-Arts in Brussels a group of the Vollard faiences were exhibited in conjunction with a survey of his *éditions de luxe*.[53] Nevertheless, Vollard found few collectors interested in faiences by artists whose work they either did not know or perhaps even disliked. After several years he discontinued the entire project. The various faiences are often difficult to ascertain as Vollard issues, because they carry no recognizable mark or symbol.

Whether by design or circumstance, nothing in the life of Ambroise Vollard was simple. Extremely secretive concerning his own affairs, he did not hesitate to question others. Gertrude Stein said of him, "Vollard never had any idle curiosity, he always wanted to know what everybody thought of everything because, in that way, he found out what he himself thought."[54] Vollard prefaced his many questions to artists, to the public, to special guests, to anyone with whom he spoke, *"Dites moi, dites moi*—tell me, tell me."

Except in a few known instances, Vollard's letters are somewhat unrewarding. At best they reveal the vague and secretive manner in which he conducted his business affairs. This perhaps served a definite purpose—that of confusing issues that might be of some concern to the government's financial officials. His early knowledge of French law and his long disillusionment with the French colonial system merely served to reinforce his secretiveness. At present there are known a small group of letters written by Vollard to his printer Auguste Clot, now at the Bibliothèque Nationale in Paris, the published letters of Gauguin to Vollard, and some scattered letters to Rouault and other artists. Early in Vollard's career the Paris critic Edmond Jaloux refers to Vollard's "starvation wages to his artists," to his high margin of profit, and to his "intelligence" and "generosity." Although Vollard brushed aside much of the criticism concerning his activities, the innuendos in the Jaloux article were such that he felt compelled to reply. In his carefully worded letter he remarked:

> Naturally I was very flattered to find you using the word "intelligence" in reference to me. However, I am bothered by the certificate of "generosity" which you award me at the same time. To speak of generosity in the relations of a dealer with an artist is, it seems to me, a little like saying that in buying land in which he hopes to find gold, the purchaser shows generosity toward the seller . . . Accustomed, as is any writer of your authority, to analyze personal feelings, you will understand the scruple which prompted me to write this letter.[55]

Perhaps the more revealing references are the letters and statements of those artists who knew Vollard and who, over some years, had direct dealings with him. Vollard's own recollections chart his enthusiasm for many artists and their work, his lifelong pursuit of the revealing anecdote, and his delight in the daily ironies that caught his attention. At the time of his death in 1939, the result of an automobile accident,[56] Vollard had published

more than two dozen superbly illustrated and crafted *éditions de luxe* and many albums of prints. He left more than two dozen others unissued or incomplete. For the next several decades his unpublished works continued to set an impressive mark in twentieth-century graphic art as they appeared under the imprint of other publishers in Paris.

Much has been said of his taste, his judgment, and his tactics as an art dealer. There can be little doubt that in his accord with the "new" artists and in his faith in their beliefs lay his genius. Because of his own desire that his name endure through his books, he often inspired a similar feeling in his artists. As the art historian Julius Meier-Graefe expressed it, "Vollard is one of those remarkable dealers, only produced in Paris, who are sometimes better connoisseurs—or rather have surer artistic instincts—than the connoisseurs themselves."[57] With some resignation and not a little self-assurance Vollard once declared, "All the same, I shall have the last word."

It must be remembered that Vollard opened his eventful and productive career with the first one-man exhibition of Cézanne's work in 1895, of Picasso's in 1901, and of Maillol's in 1902. He closed his remarkable achievements with the publication in 1939 of the Suarès *Passion* and its revealing illuminations by Georges Rouault, and the completed but unissued *Suite Vollard* by Picasso. The illustrated books, the albums, individual prints, bronzes, and the many paintings by the masters of modern art he so assiduously promoted are the distinguished and unique legacy of Vollard.

—Una E. Johnson

43

NOTES

1. Jean Renoir, *Renoir, My Father,* pp. 398–399.
2. Françoise Gilot and Carlton Lake, *Life with Picasso,* p. 49.
3. Jack D. Flam, *Matisse on Art,* p. 147.
4. Ambroise Vollard, *Souvenirs d'un marchand de tableaux,* p. 305.
5. Donna Stein, *L'Estampe originale, A Catalogue Raisonné.*
6. Ambroise Vollard, *Recollections of a Picture Dealer,* p. 247.
7. André Mellerio, *La Lithographie originale en couleurs,* p. 22.
8. Camille Pissarro, *Letters to his son Lucien,* July 5, 1896, p. 292.
9. *Ibid.,* July 18, 1896, p. 292.
10. John Rewald, ed., *Paul Gauguin: Letters to Ambroise Vollard and André Fontainas,* pp. 30, 48–50.
11. Vollard, *Recollections,* p. 257.
12. Hugh Edwards, "Redon, Flaubert, Vollard," *Bulletin of the Art Institute of Chicago,* vol. 36, no. 1, pp. 4–6.
13. Letter from Vollard to the printer Auguste Clot dated "Paris 4 re 1912," from the Dr. Georges Collection on deposit at the Bibliothèque Nationale, Paris. Courtesy of M. Jean Adhémar, Cabinet des Estampes.
14. Marcel Zahar, "The Vollard Editions," *Forms,* vol. 2 (January 1921).
15. Vollard, *Recollections,* p. 252.
16. *Parallèlement* also printed in blue.
17. Loÿs Delteil, *Le Peintre-graveur illustré,* vol. 6, nos. 13–17.
18. Vollard, *Recollections,* p. 254.
19. Paul Jamot, "Emile Bernard, illustrateur," *Gazette Beaux-Arts,* 1917, pp. 108–120.
20. André Suarès, "Ambroise Vollard," *La Nouvelle Revue Française,* vol. 54, p. 193.
21. Vollard, *Recollections,* p. 264.
22. Roger Fry, "Paul Cézanne by Ambroise Vollard," *Burlington Magazine,* vol. 31, pp. 52–61.
23. From an unpublished letter from Gertrude Stein to Henry McBride, Yale Collection of American Literature. Quoted in James R. Mellow, *Charmed Circle—Gertrude Stein & Company,* p. 194.
24. October 10, 1915 issue of the New York *Sun.* Quoted in Mellow, *Charmed Circle,* p. 5.
25. Vollard, *Recollections,* p. 265.
26. M.-L. Bataille and Georges Wildenstein, *Berthe Morisot: catalogue des peintures, pastels, et aquarelles,* p. 5.
27. Adelyn Breeskin, *Mary Casatt: A Catalogue Raisonné of Oils, Pastels, Watercolors, and Drawings,* pp. 18–19.
28. Now in the Library of Congress collection, gift of Lessing J. Rosenwald.
29. Roger Shattuck, *The Banquet Years,* pp. 234–242 (see also Appendix IX).
30. R. H. Wilenski, *Modern French Painters,* pp. 154–155.
31. Alfred Jarry, *Ubu Roi,* Editions du Mercure de France, Paris, 1896, publisher's note.
32. Vollard, *Souvenirs,* pp. 339–340.
33. H. P. Kraus, *The Illustrated Book,* catalogue 108, no. 138.
34. Original color lithographs for *Four Tales from the Arabian Nights.* Twelve lithographs signed by Marc Chagall; edition of 111 copies; 90 regular issue without extra lithographs and suite of progressive proofs.
35. Roger-Marx, "L'Oeuvre gravé de Georges Rouault," *Byblis,* 1931, pp. 93–100.
36. James Thrall Soby, *Georges Rouault: Paintings and Prints,* technical notes by Carl O. Schniewind, pp. 20–32.
37. Raymond Bouyer, "L'Estampe murale," *Arts et Decoration,* vol. 4 (July–December, 1898), pp. 185–191.
38. "The Rouault Case," translation by Harry Lorin Benasse from the *Gazette du Palais,* September 11–12, 1946. Summarized by Rev. Richard J. Douaíre and published by *Liturgical Arts* (New York), May 1948.
39. *Correspondance: Georges Rouault-André Suarès.*
40. *Ibid.,* letter no. 257, pp. 331–334.
41. Rouault letter in the Louis E. Stern Collection. Courtesy The Museum of Modern Art, New York.
42. Rouault-Suarès, *Correspondence,* letter no. 257, f.n. 4, pp. 332–334.
43. Janet Flanner, *Men and Monuments,* pp. 167–168.
44. Werner Hofmann, *Georges Braque: His Graphic Work,* pp. xv–xviii.
45. Abraham Horodisch, *Picasso as a Book Artist,* pp. 54–56.
46. Georges Bloch, *Pablo Picasso: Catalogue de l'oeuvre gravé et lithographie,* nos. 231–233.
47. Gilot and Lake, *Life with Picasso,* p. 48.
48. Vollard, *Degas: An Intimate Portrait,* p. 89.
49. Courtesy of John Rewald.

50. Letter from Alfred Barr to a New York appraiser. Courtesy The Museum of Modern Art, New York.

51. Vollard, *Recollections,* pp. 249–250.

52. B. L. Reid, *The Man from New York: John Quinn and his Friends,* p. 208.

53. W. Wartmann, *Schenkung Lucien Vollard, Bücher von Ambroise Vollard, 1900–1939* (also lists bronzes).

54. Gertrude Stein, *Autobiography of Alice B. Toklas.* Harcourt Brace, and Co., p. 47; Vintage Books, p. 39.

55. Paul Haesaerts, *Renoir sculpteur,* p. 15 f.n. Vollard, *Souvenirs,* appendice 3, p. 252.

56. Rouault-Suarès, *Correspondance,* letter no. 252, Paris le 23/7/1939, Suarès to Rouault: "Vollard tué sur le route, en allant au Tremblay, mon cher Rouault. Il y est resté toute la nuit, sans aide ni secours. Il a beaucoup souffert, les vertèbres cervicales rompues. Tous les détails sont affreux. Je suis consterné."

57. Julius Meier-Graefe, *Modern Art,* vol. 1, p. 266.

CHRONOLOGY

1867 Born on the island of La Réunion

1890 Arrived at Montpellier, France. Proceeded to Paris to study law at l'Ecole de Droit. Lived in the Montmartre secton, rue des Apennins

ca. 1891 Began working for Alphonse Dumas at his gallery, L'Union Artistique, to learn 'the trade'

ca. 1893 Opened a small picture gallery at 39 rue Laffitte, which was soon expanded to 39-41 rue Laffitte

1895 [Dec.] Held first Cézanne exhibition. Moved his gallery to larger, more accessible quarters at 6 rue Laffitte. Published first portfolio of lithographs: *Quelques Aspects de la vie de Paris* by Bonnard

1896 Journeyed to Aix to see Cézanne to buy more of his pictures. Issued first *L'Album des peintres-graveurs* (22 prints). Issued poster for l'Exposition des Peintres-Graveurs (lithograph by Bonnard). Published second portfolio of lithographs: Flaubert's *Tentation de Saint-Antoine;* illustrations by Redon

1897 Published second and last *L'Album d'estampes originales de la Galeries Vollard* (32 prints). Single prints by Auriol: *Selim, enfant de Damas.* Renoir: *Le Chapeau épinglé* (first plate)

1898 Published two portfolios of lithographs: Denis: *Amour.* Fantin-Latour: *Suite de six planches.* Single lithograph by Renoir: *Le Chapeau épinglé* (second plate)

ca. 1898 Bronze by Maillol: *Baigneuse se coiffant*

1899 Asked Cézanne to paint his portrait. Published two portfolios of lithographs: Vuillard: *Paysages et intérieurs.* Redon: *Apocalypse de Saint-Jean.* Single lithograph by Renoir: *L'Enfant au biscuit.* Bronze by Maillol: *Les Deux Soeurs*

1900 Single lithographs by Renoir: *Enfants jouant à la balle* and *Richard Wagner.* [Sept. 29] Published first book: *Parallèlement* by Paul Verlaine; illustrations by Bonnard. Bronze by Maillol: *Les Deux Lutteuses*

ca. 1900 Bronzes by Maillol: *Baigneuse debout, Jeune Fille accroupie, Jeune Fille assise, tenant la jambe,* and *Leda*

1902 Bronze by: Maillol: *Jeune Fille agebouillée*

1902 [May 24] Published *Le Jardin des supplices* by Mirbeau; illustrations by Rodin. Single lithograph by Renoir: *Paul Cézanne.* [Oct. 31] Pub-lished *Daphnis et Chloé* by Longus; illustrations by Bonnard

ca. 1902 Bronze by Bonnard: *Surtout de table*

1903 [Jan. 6] Published *L'Imitation de Jésus-Christ* by Thomas à Kempis; illustratons by Denis. Single lithograph by Fantin-Latour: *A. Rossini.*

1904 Published *Gaspard de la nuit* by Louis Bertrand; illustrations by Séguin

1905 Bronze by Picasso: *Arlequin*

1905-06 Bronzes by Picasso: *Fernande* and *Femme se coiffant*

1907 Bronze by Maillol: *Buste d'Auguste Renoir*

1909 Bronze by Picasso: *Tête de femme (Cubist Head)*

ca. 1909 Bronze by Picasso: *Tête d'homme*

ca. 1910 Lithograph by Renoir: *Auguste Renoir*

1910 [Aug. 30] Published *Sagesse* by Paul Verlaine; illustrations by Denis

1911 Published *Lettres de Vincent Van Gogh à Emile Bernard;* reproductions of paintings and drawings by van Gogh

ca. 1912 Single lithograph by Renoir: *Maternité*

1913 Series of prints by Picasso: *Saltimbanques* (etchings and drypoints)

1914-1918 Closed his shop and gallery and moved their contents into his private quarters at 28 rue de Gramont. Lectured on Cézanne and Renoir in Spain and Switzerland under the auspices of French Service of Information

1914 Issued bronzes by Renoir: *Le Vénus triomphante* and *La Vénus triomphante* (small size). [Sept.] Published his own book, *Paul Cézanne*

1915 Published *Les Amours de Pierre de Ronsard;* illustrations by Bernard

1916 Published *Les Fleurs du mal* by Charles Baudelaire; illustrations by Bernard. Wrote first brochure on Ubu: *Le Père Ubu à l'hôpital.* Issued bronzes by Renoir: *La Laveuse, La Baigneuse* (small version), *Le Forgeron, La Baigneuse accroupie,* and *Pâris* (head)

1917 Issued six bronze medallions by Renoir: *Rodin, Ingres, Cézanne, Delacroix, Corot* and *Monet.* Wrote second brochure on Ubu: *Ubu à l'hôpital*

1918 Wrote third brochure on Ubu: *Le Père Ubu à l'aviation.* [Nov. 15] Published his first volume (700 reproductions) on Renoir: *Tableaux, pastels et dessins de Pierre-Auguste Renoir*

1919 Reopened his gallery at 6 rue Laffitte. Issued bronzes by Renoir: *Le Jugement de Pâris.* Published *Oeuvres de maistre François Villon;* illustrations by Bernard. Published portfolio of lithographs by Renoir: *Douze lithographies de Pierre-Auguste Renoir.* [Dec. 15] Published his second book on Renoir: *La Vie et l'oeuvre de Pierre-Auguste Renoir.* Wrote fourth brochure on Ubu: *La Politique coloniale du Père Ubu*

1920 Wrote *Le Père Ubu à la guerre;* illustrations by Jean Puy

1923 [Apr. 15] Published first large book on Ubu: *Le Père Ubu à la guerre;* illustrations by Puy. [Dec. 15] Published *Dingo* by Octave Mirbeau; illustrations by Bonnard (book not released until 1927)

1924 Moved to 28 rue de Martignac

ca. 1924 Brochure: *Le Père Ubu au pays des Soviets*

1925 Wrote *Les Réincarnations du Père Ubu;* with a portrait of the author by Georges Rouault. [May 21] Awarded La Legion d'honneur (*Les Lettres et Critique d'Art*)

1927 Single etchings by Picasso: *L'Atelier, Homme et femme,* and *Les Trois Amies*

1928 Published *Les Petites Fleurs de Saint-François;* illustrations by Bernard. [June 15] Published *Fêtes galantes* by Paul Verlaine; illustrations by Laprade

1930 [Nov. 15] Published *L'Odyssée d'Homère;* illustrations by Bernard. [Nov. 30] Published his own work: *La Vie de Sainte-Monique;* illustrations by Bonnard

1931 Published portfolio of prints by Picasso: *Eaux-fortes originales pour Le Chef-d'oeuvre inconnu d'Honoré de Balzac.* [Nov. 12] Published *Le Chef-d'oeuvre inconnu* by Balzac; illustrations by Picasso

1932 Published portfolio of prints by Rouault: *Eaux-fortes de Georges Rouault pour Les Réincarnation du Père Ubu d'Ambroise Vollard.* [Feb. 15] Published *Les Réincarnations du Père Ubu* by Vollard; illustrations by Rouault

1934 [Dec. 27] Published *La Maison Tellier* by Guy de Maupassant; illustrations by Degas

1935 [Apr. 30] Published *Mimes des courtisanes de Lucien;* illustrations by Degas

1936 [Feb. 24] Published *Degas/Danse/Dessins* by Paul Valéry; illustrations by Degas. [Apr.] Vollard's *Recollections of a Picture Dealer* published in English by Little, Brown and Company. [Nov.] Visited the United States

1937 First French edition of his autobiography: *Souvenirs d'un marchand de tableaux* (expanded); published by A. Michel, Paris

1938 [Mar. 5] Published *Cirque de l'étoile filante;* text and illustrations by Rouault

1939 [Feb. 19] Published *Passion* by André Suarès; illustrations by Rouault. [July 22] Auto accident resulted in Vollard's death a few days later. [July 28] Obsequies held in the church of Sainte-Clotilde, Paris

Ambroise Vollard's Addresses in Paris

Montmartre section, rue des Apennins	1890–1893
39–41 rue Laffitte	ca. 1893–1895
6 rue Laffitte	ca. 1895–1914
28 rue de Gramont	1914–1918
6 rue Laffitte	1919–1924
28 rue de Martignac	1924–1939

ILLUSTRATIONS

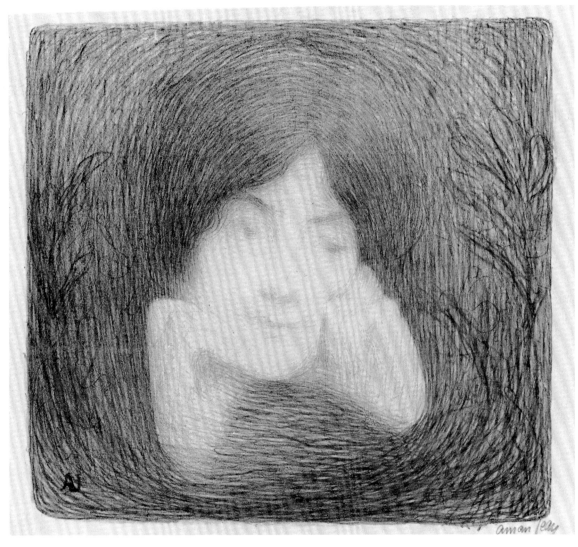

EDMOND-FRANÇOIS AMAN-JEAN. *Portrait de Mlle Moréno de la Comédie-Française*
from *L'Album d'estampes originales de la Galerie Vollard*, 1897. Lithograph, 34.6 x 37.7 cm.
The Museum of Modern Art, N.Y., Abby Aldrich Rockefeller Fund. (Cat. no. 1)

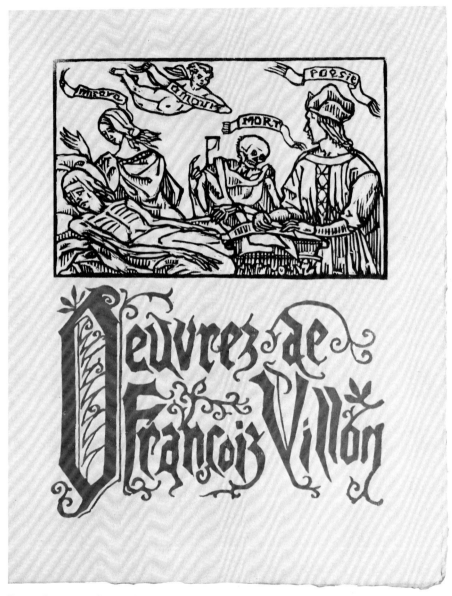

EMILE BERNARD. *Oeuvres de maistre François Villon*, title page, 1919 (1918).
Woodcut, 32.5 x 25 cm. (page). The Brooklyn Museum. (Cat. no. 163)

PIERRE BONNARD. *Maison dans la cour* from the album
Quelques Aspects de la vie de Paris, 1895. Lithograph, 34.5 x 25.6 cm.
The Museum of Modern Art, N.Y., Larry Aldrich Fund. (Cat. no. 10)

PIERRE BONNARD. *Parallèlement* by Paul Verlaine, pages 26–27, 1900.
Lithographs, 30 x 24 cm. (page). The Museum of Modern Art, N.Y.,
Louis E. Stern Collection. (Cat. no. 166)

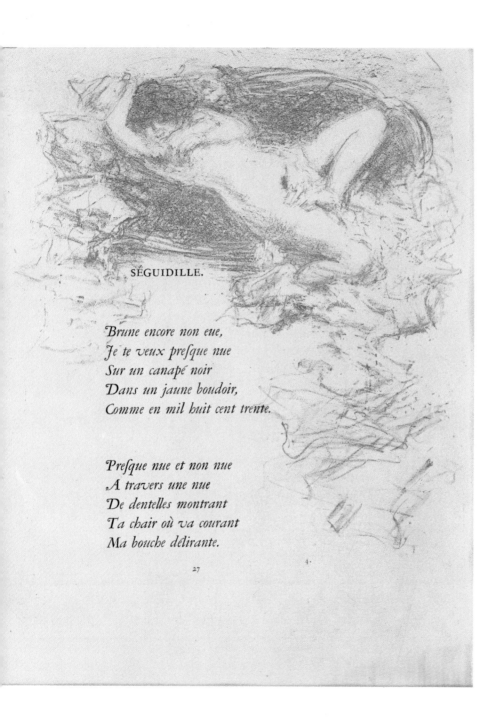

SÉGUIDILLE.

Brune encore non eue,
Je te veux presque nue
Sur un canapé noir
Dans un jaune boudoir,
Comme en mil huit cent trente.

Presque nue et non nue
A travers une nue
De dentelles montrant
Ta chair où va courant
Ma bouche délirante.

27

4·

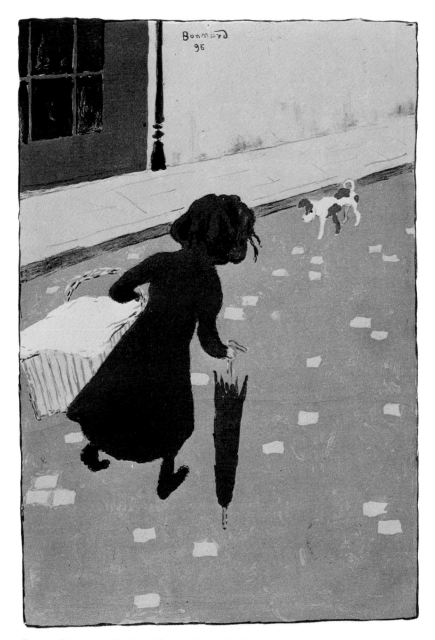

PIERRE BONNARD. *La Blanchisseuse* from *L'Album des peintres-graveurs*, 1896.
Lithograph, 29.5 x 20 cm. The Museum of Modern Art, N.Y.,
gift of Victor S. Riesenfeld. (Cat. no. 11)

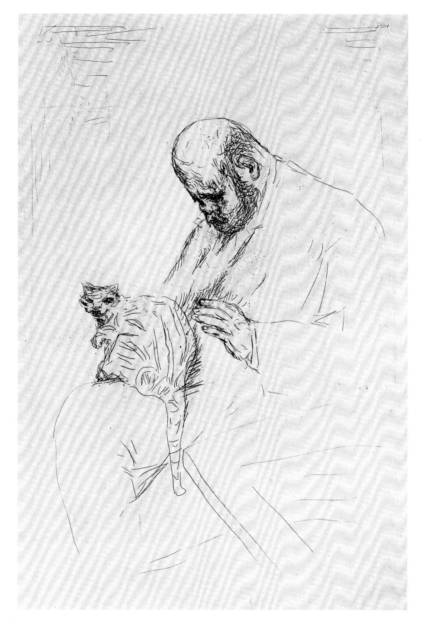

PIERRE BONNARD. *Portrait d'Ambroise Vollard*, ca. 1914.
Etching, 34.5 x 24 cm. The Museum of Modern Art, N.Y.,
purchase. (Cat. no. 16)

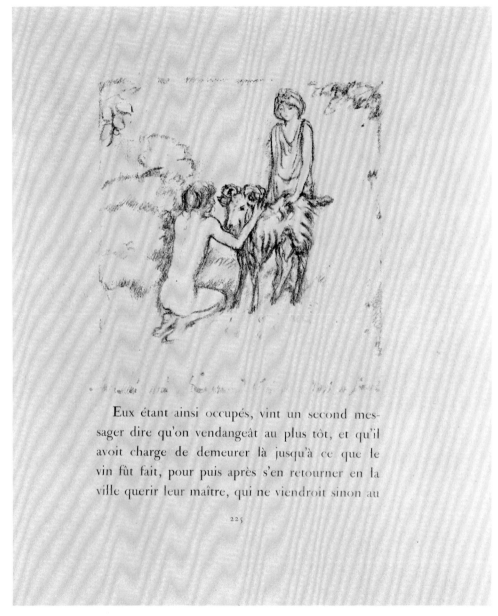

Eux étant ainsi occupés, vint un second mes-
sager dire qu'on vendangeât au plus tôt, et qu'il
avoit charge de demeurer là jusqu'à ce que le
vin fût fait, pour puis après s'en retourner en la
ville querir leur maître, qui ne viendroit sinon au

225

PIERRE BONNARD. *Les Pastorales de Longus ou Daphnis et Chloé,* page 225, 1902.
Lithograph, 30 x 24 cm. (page). The Museum of Modern Art, N.Y.,
Louis E. Stern Collection. (Cat. no. 168)

PIERRE BONNARD. *Almanach illustré du Père Ubu,* back cover, 1901.
Reproduced drawing, 29 x 21 cm. (page). The Museum of Modern Art, N.Y.,
Louis E. Stern Collection. (Cat. no. 167)

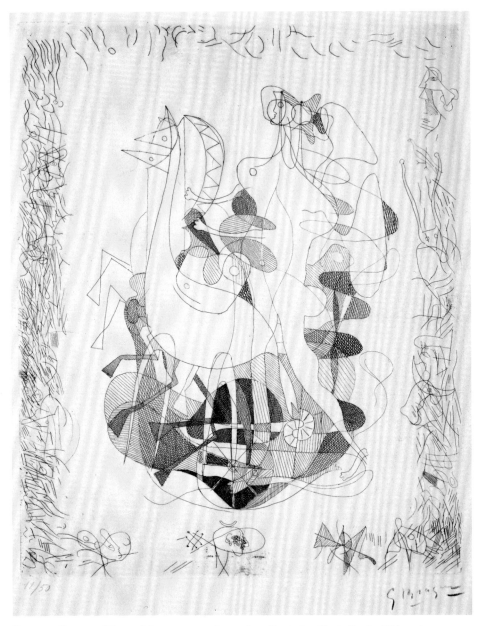

GEORGES BRAQUE. Plate with remarques from the album for Hesiod's *La Théogonie*, 1932.
Etching, 36.6 x 29.8 cm. The Museum of Modern Art, N.Y.,
Louis E. Stern Collection. (Cat. no. 171)

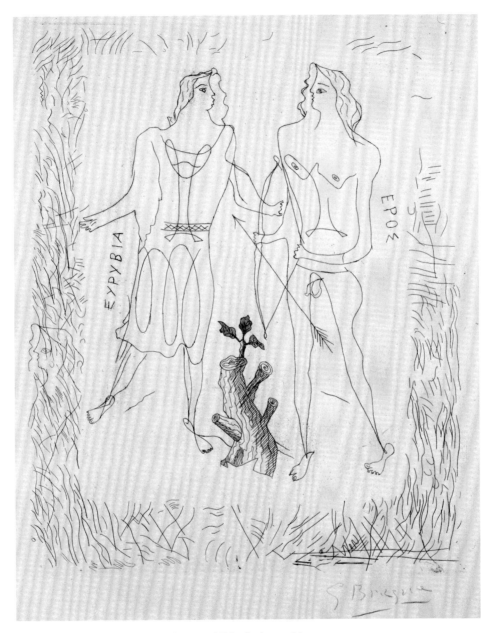

GEORGES BRAQUE. *Eros et Eurybia*, unpublished plate with remarques
for Hesiod's *La Théogonie*, 1932. Etching, 36.7 x 29.8 cm.
The Museum of Modern Art, N.Y., Louis E. Stern Collection. (Cat. no. 171)

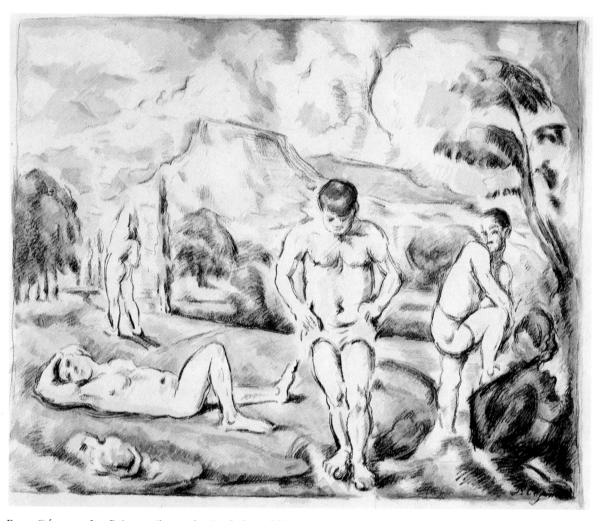

PAUL CÉZANNE. *Les Baigneurs* (large plate), 1896–97. Lithograph, 41 x 50.3 cm.
The Museum of Modern Art, N.Y., Lillie P. Bliss Collection. (Cat. no. 23)

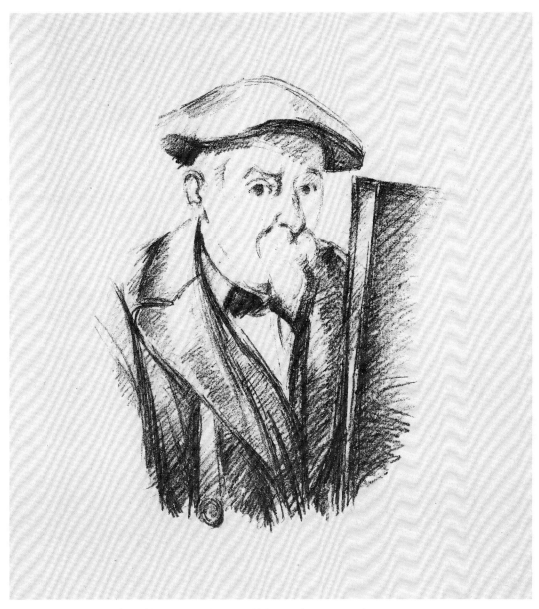

PAUL CÉZANNE. *Portrait de Cézanne,* ca. 1896–97. Lithograph, 32.3 x 27.8 cm.
The Museum of Modern Art, N.Y., gift of Abby Aldrich Rockefeller. (Cat. no. 24)

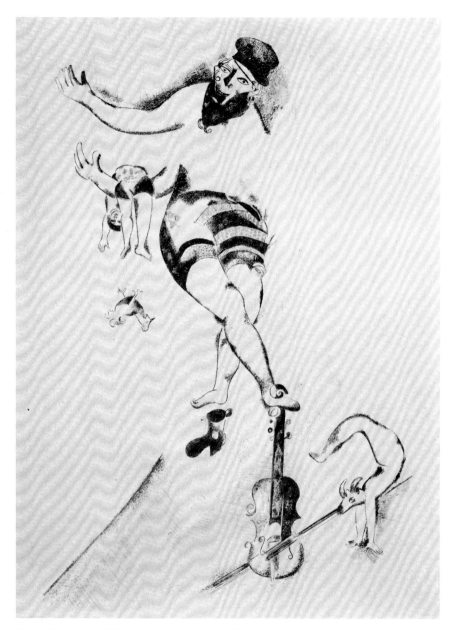

MARC CHAGALL. *L'Acrobate au violon,* 1924. Etching and drypoint, 41.8 x 31.8 cm. The Museum of Modern Art, N.Y., acquired through the Lillie P. Bliss Bequest. (Cat. no. 25)

MARC CHAGALL. *Les Ames mortes* by Nicolas Gogol, frontispiece, vol. II (1927), 1948.
Etching, 38 x 28 cm. (page). The Museum of Modern Art, N.Y.,
Louis E. Stern Collection. (Cat. no. 173)

MARC CHAGALL. *Le Coq et la perle* from *Les Fables* by La Fontaine (1927), 1952.
Etching, 39 x 30.5 cm. (page). The Museum of Modern Art, N.Y.,
Louis E. Stern Collection. (Cat. no. 174)

MARC CHAGALL. *La Vision d'Elie* from *La Bible, L'Ancien Testament*
(1931–39), 1956. Etching, 44 x 34 cm. (page). The Museum
of Modern Art, N.Y., Louis E. Stern Collection. (Cat. no. 175)

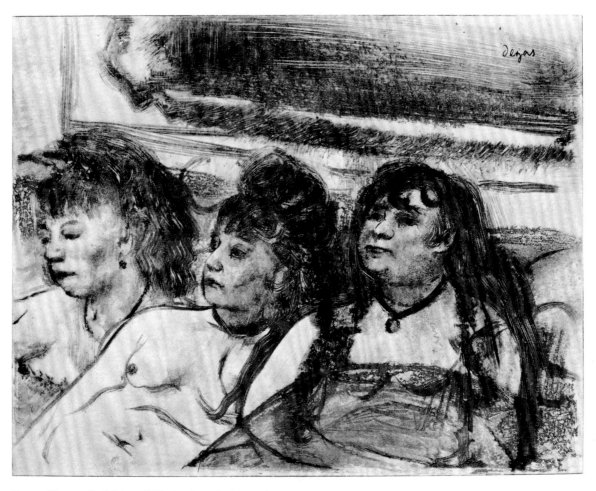

EDGAR DEGAS. *La Maison Tellier* by Guy de Maupassant, plate 6, 1934.
Aquatint-etching after monotype, 32.5 x 25.5 cm. (page). The Museum of Modern Art, N.Y.,
Louis E. Stern Collection. (Cat. no. 177)

ANDRÉ DERAIN. *Le Satyricon* by Petronius Arbitor, plate 4 (1934), 1951.
Engraving, 44.5 x 33.4 cm. (page). The Museum of Modern Art, N.Y.,
Louis E. Stern Collection. (Cat. no. 184)

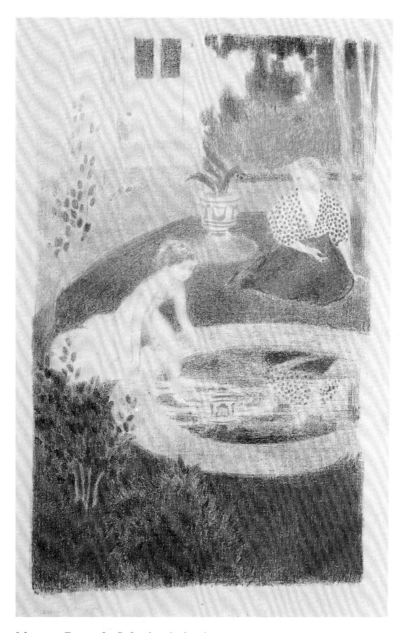

MAURICE DENIS. *Le Reflet dans la fontaine*
from *L'Album d'estampes originales de la Galerie Vollard*, 1897.
Lithograph, 40 x 24 cm. The Museum of Modern Art, N.Y.,
Purchase Fund. (Cat. no. 31)

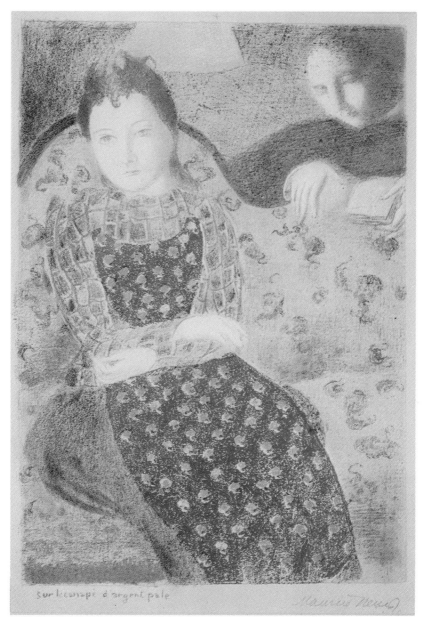

MAURICE DENIS. *Sur la canapé d'argent pale* from the album *Amour*, 1898.
Lithograph, 40.1 x 28.5 cm. The Brooklyn Museum. (Cat. no. 32)

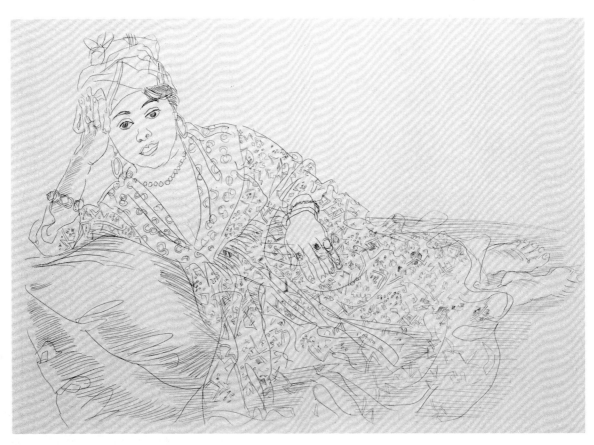

RAOUL DUFY. *La Havanaise,* ca. 1930. Etching, 34.9 x 51.3 cm.
The Museum of Modern Art, N.Y., Lent anonymously. (Cat. no. 36)

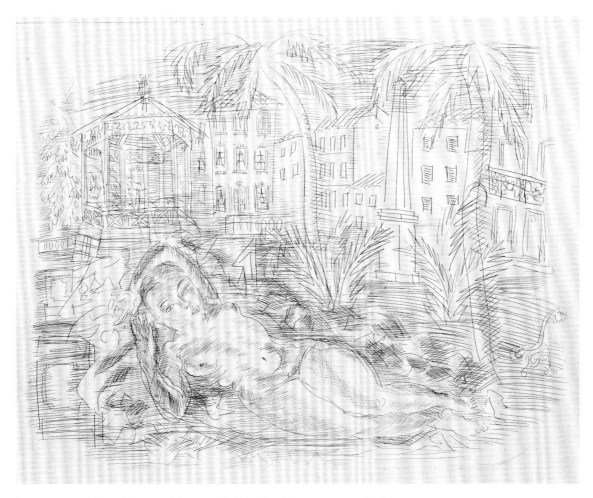

RAOUL DUFY. *Nu couché aux palmiers avec fond de Côte d'Azur,* ca. 1930. Etching, 34 x 49.3 cm.
The Museum of Modern Art, N.Y., Larry Aldrich Fund. (Cat. no. 37)

RAOUL DUFY. *La Belle Enfant, ou L'Amour à quarante ans* by Eugène Montfort, page 125, 1930.
Etching, 32.5 x 25 cm. (page). The Museum of Modern Art, N.Y.,
Louis E. Stern Collection. (Cat. no. 185)

TSUGOUHARU FOUJITA. *Auto-portrait*, 1923. Etching, 41.5 x 31.5 cm. The Museum of Modern Art, N.Y., gift of The Felix and Helen Juda Foundation. (Cat. no. 58)

MANDOLINE

Les donneurs de sérénades
Et les belles écouteuses
Échangent des propos fades
Sous les ramures chanteuses.

31

PIERRE LAPRADE. *Fêtes galantes* by Paul Verlaine, page 31, 1928.
Hand-colored etching, 32.5 x 25 cm. (page).(Cat. no. 188)

En cependant que la jeunesse
D'une tremoussante souplesse
Et de manimens fretillars
Agitoit les rougnons paillars
De Catin à gauche & à dextre,
Jamais ny à Clerc ny à Prestre,
Moine, Chanoine, ou Cordelier
N'a refusé son hatelier.

ARISTIDE MAILLOL. *Livret des folastries à Janot Parisien* by Pierre de Ronsard,
page 33, 1939. Etching, 24.2 x 18.4 cm. (page). The Museum of Modern Art, N.Y.,
Louis E. Stern Collection. (Cat. no. 190)

Alexandre Lunois. *Le Colin-Maillard,* n.d. Lithograph, 38 x 50.3 cm.
The Metropolitan Museum of Art, N.Y., The Elisha Whittelsey Fund, 1963. (Cat. no. 76)

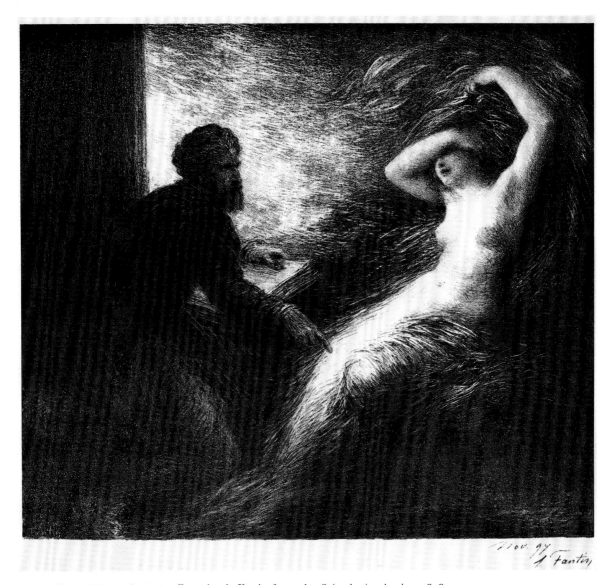

Ignace-Henri Fantin-Latour. *Evocation de Kundry* from the *Suite de six planches,* 1898.
Lithograph, 41.2 x 48.3 cm. Prints Division, The New York Public Library,
Astor, Lenox, and Tilden Foundations. (Cat. no. 41)

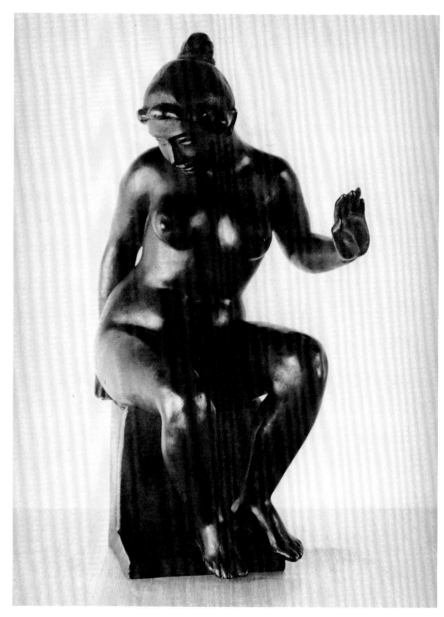

ARISTIDE MAILLOL. *Leda,* ca. 1900. Bronze, 29.2 x 13.5 x 13.5 cm.
Collection James Thrall Soby. (Cat. no. 224)

HENRI MATISSE. *Femme nue au collier,* 1926–29. Etching, 19.8 x 29.8 cm.
The Museum of Modern Art, N.Y., Purchase Fund. (Cat. no. 80)

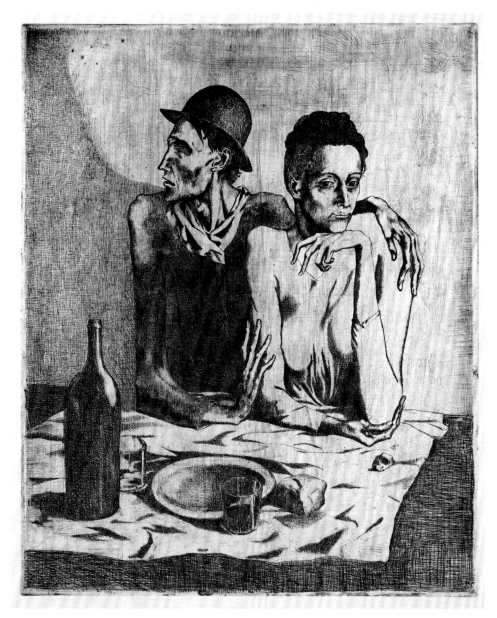

PABLO PICASSO. *Le Repas frugal* (1904) from the series *Saltimbanques*, 1913.
Etching, 46.3 x 37.7 cm. The Museum of Modern Art, N.Y.,
gift of Abby Aldrich Rockefeller. (Cat. no. 85)

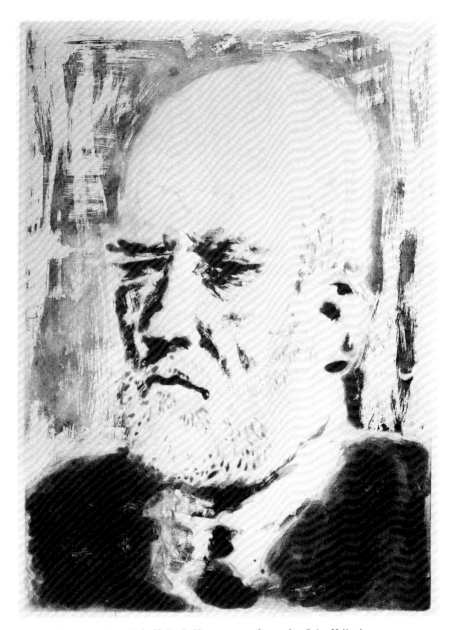

PABLO PICASSO. *Portrait de Vollard, II,* ca. 1937, from the *Suite Vollard.*
Aquatint, 34.8 x 24.7 cm. The Museum of Modern Art, N.Y.,
acquired through the Lillie P. Bliss Bequest. (Cat. no. 95)

PABLO PICASSO. *Le Chef d'oeuvre inconnu* by Honoré de Balzac, page P, 1931.
Wood-engraving, 32.5 x 25.5 cm. (page). The Museum of Modern Art, N.Y.,
Louis E. Stern Collection. (Cat. no. 191)

PABLO PICASSO. *Peintre et modèle tricotant* from *Le Chef d'oeuvre inconnu* by Honoré de Balzac, 1931.
Etching, 32.5 x 25.5 cm. (page). The Museum of Modern Art, N.Y.,
Louis E. Stern Collection. (Cat. no. 191)

PABLO PICASSO. *Faune dévoilant une femme,* 1936, from the *Suite Vollard.* Aquatint, 31.7 x 41.7 cm.
The Museum of Modern Art, N.Y., Purchase Fund. (Cat. no. 95)

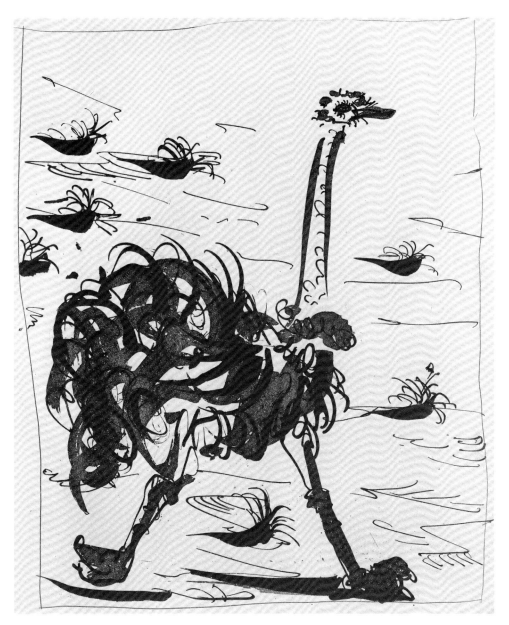

PABLO PICASSO. *L'Autruche* from *Histoire naturelle* by Comte de Buffon (1936), 1942.
Etching and aquatint, 37.5 x 28.5 cm. (page).
The Museum of Modern Art, N.Y., Louis E. Stern Collection. (Cat. no. 192)

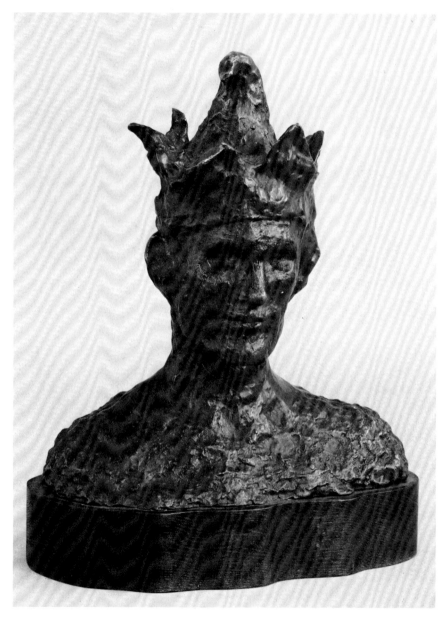

Pablo Picasso. *Arlequin*, 1905. Bronze, 38.2 x 36.5 x 21.6 cm.
Hirshhorn Museum and Sculpture Garden, Smithsonian Institution. (Cat. no. 227)

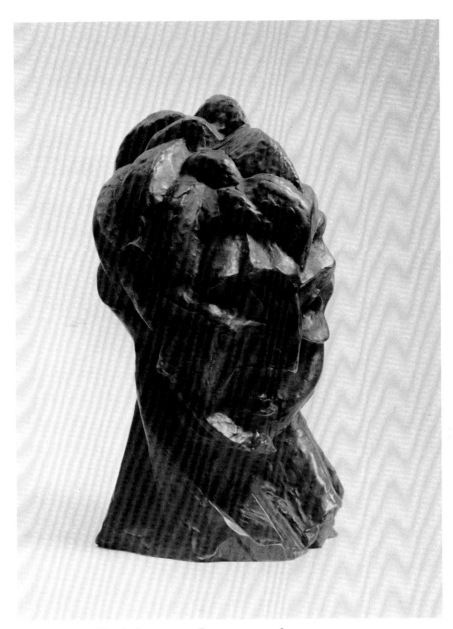

Pablo Picasso. *Tête de femme*, 1909. Bronze, 41.3 x 26.2 x 27.2 cm.
The Museum of Modern Art, N.Y., Purchase Fund. (Cat. no. 230)

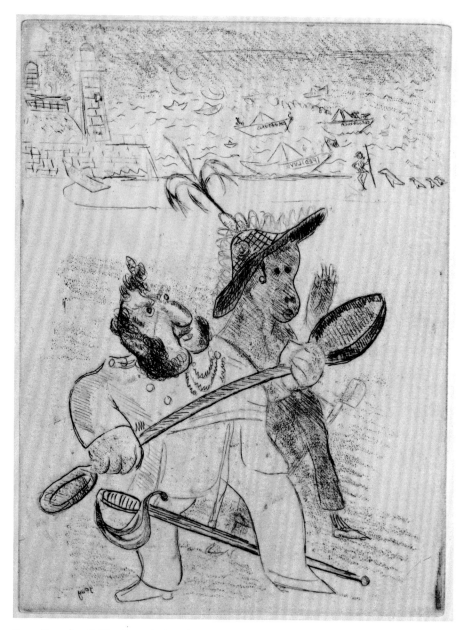

JEAN PUY. *La Cuillère à pot insigne du commandement*
from *Le Père Ubu à la guerre* by Ambroise Vollard, 1923. Etching, 38 x 28 cm. (page).
The Museum of Modern Art, N.Y., Louis E. Stern Collection. (Cat. no. 194)

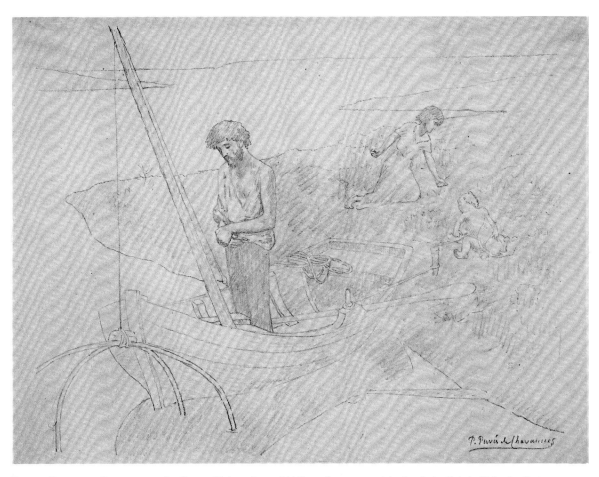

PIERRE PUVIS DE CHAVANNES. *Le Pauvre Pêcheur* from *L'Album d'estampes originales de la Galerie Vollard,* 1897. Lithograph, 41 x 52.5 cm. The Metropolitan Museum of Art, Harris Brisbane Dick Fund, 1932. (Cat. no. 98)

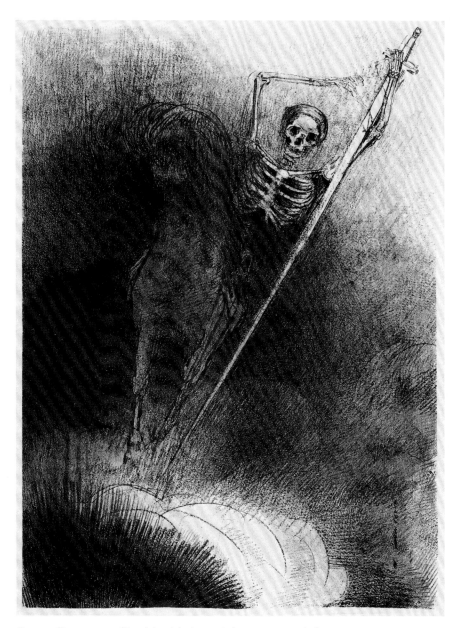

ODILON REDON. . . . *Et celui qui était monté dessus se nommait la mort*
from *Apocalypse de Saint-Jean,* 1899. Lithograph, 31 x 25.5 cm. The Museum
of Modern Art, N.Y., gift of Abby Aldrich Rockefeller. (Cat. no. 104)

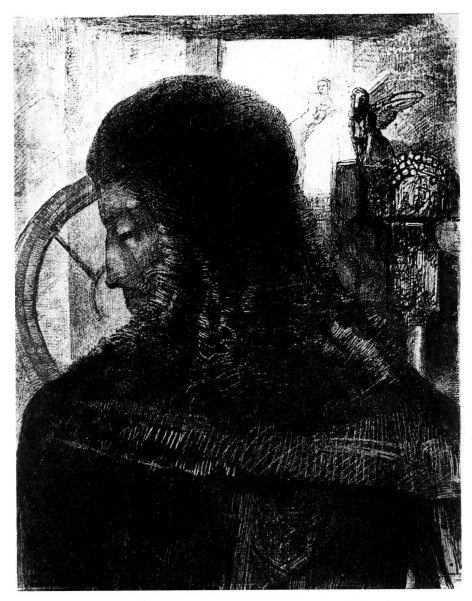

ODILON REDON. *Vieux Chevalier* from *L'Album des peintres-graveurs*, 1896.
Lithograph, 29.8 x 23.9 cm. The Museum of Modern Art, N.Y.,
gift of Abby Aldrich Rockefeller. (Cat. no. 101)

C'eſt dans la Thébaïde, au haut d'une montagne, ſur une plate-
forme arrondie en demi-lune, & qu'enferment de groſſes pierres.
　　La cabane de l'Ermite occupe le fond. Elle eſt faite de boue &
de roſeaux, à toit plat, ſans porte. On diſtingue dans l'intérieur une
cruche avec un pain noir; au milieu, ſur un ſtèle de bois, un gros
livre; par terre çà & là des filaments de ſparterie, deux ou trois
nattes, une corbeille, un couteau.

3

Odilon Redon. *La Tentation de Saint-Antoine* by Gustav Flaubert, page 3, 1938.
Wood-engraving by Aubert after Redon drawing, 45 x 33.5 cm. (page). The Museum
of Modern Art, N.Y., Louis E. Stern Collection. (Cat. no. 195)

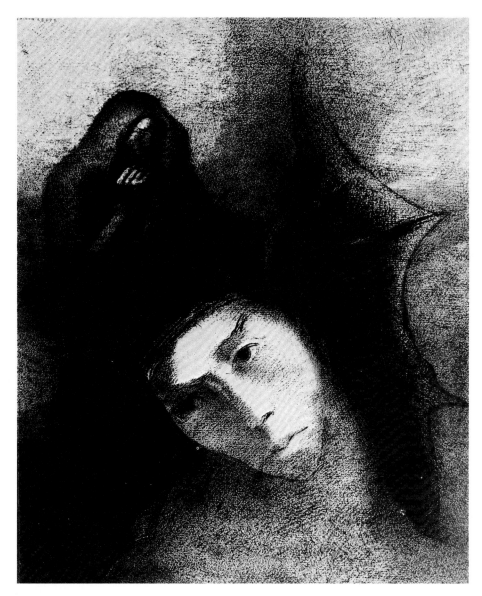

ODILON REDON. *Antoine: Quel est le but de tout cela? Le diable: Il n'y a pas de but!* from the Gustav Flaubert album, *Tentation de Saint-Antoine*, 1896. Lithograph, 31.1 x 25 cm. The Museum of Modern Art, N.Y., gift of Abby Aldrich Rockefeller. (Cat. no. 102)

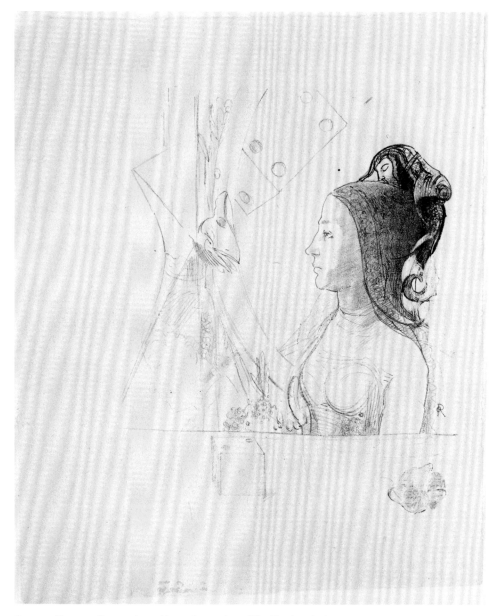

ODILON REDON. *Femme de profil vers la gauche coiffée d'un hennin* from
Un coup de dés jamais n'abolira le hazard by Stéphane Mallarmé, ca. 1898.
Lithograph, 30 x 24 cm. The Museum of Modern Art, N.Y.,
Larry Aldrich Fund. (Cat. no. 105)

ODILON REDON. *Béatrice* from *L'Album d'estampes originales de la Galerie Vollard,* 1897.
Lithograph, 30 x 29.5 cm. The Museum of Modern Art, N.Y.,
gift of Abby Aldrich Rockefeller. (Cat. no. 103)

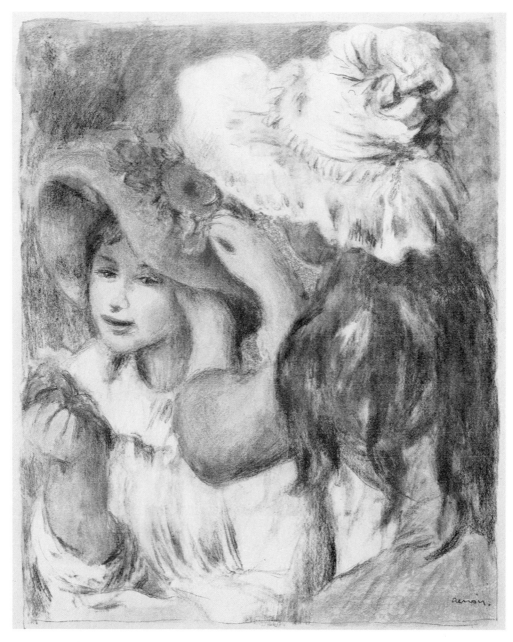

PIERRE-AUGUSTE RENOIR. *Le Chapeau épinglé*, 1898. Lithograph, 60 x 48.8 cm.
The Museum of Modern Art, N.Y., Lillie P. Bliss Collection. (Cat. no. 107)

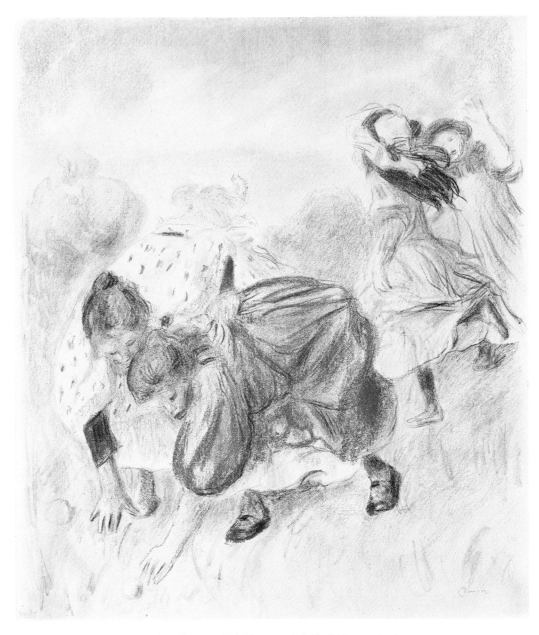

PIERRE-AUGUSTE RENOIR. *Enfants jouant à la balle,* 1900 (1898). Lithograph, 60 x 51 cm.
The Museum of Modern Art, N.Y., Lillie P. Bliss Collection. (Cat. no. 111)

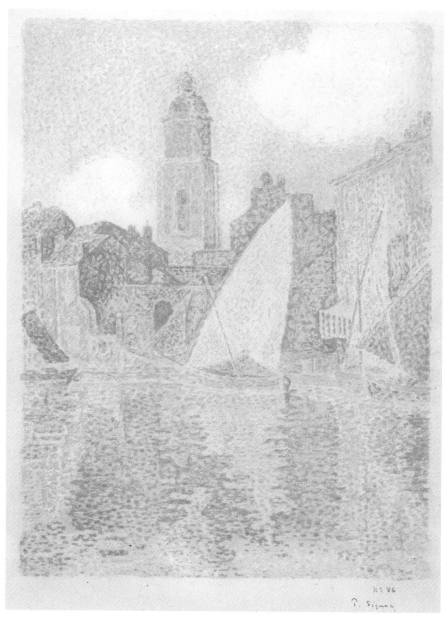

PAUL SIGNAC. *Port de Saint-Tropez,* 1897–98. Lithograph, 43.5 x 33 cm.
The Museum of Modern Art, N.Y., Abby Aldrich Rockefeller Fund. (Cat. no. 138)

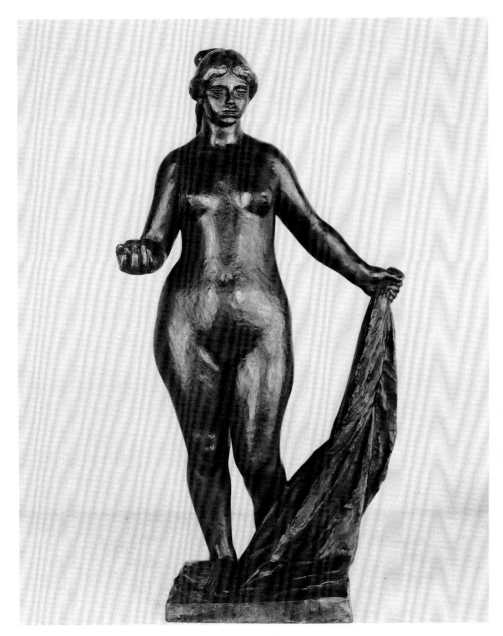

Pierre-Auguste Renoir, *La Vénus triomphante*, 1913. Bronze, 58.5 x 60 cm.
The Baltimore Museum, The Cone Collection. (Cat. no. 232)

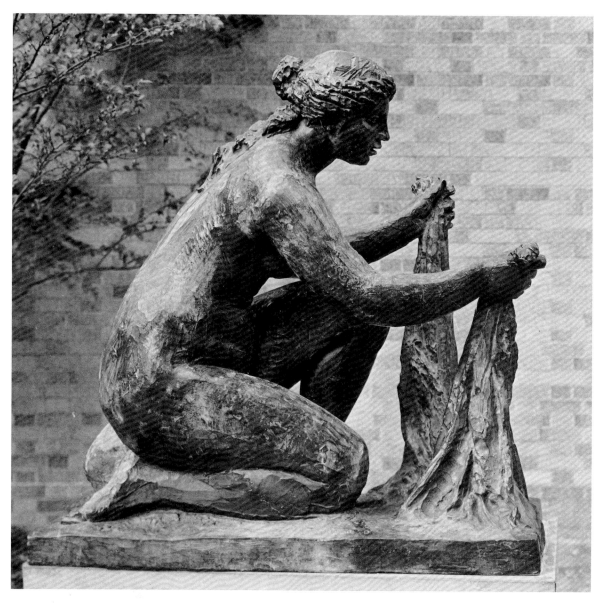

PIERRE-AUGUSTE RENOIR. *La Laveuse,* 1917. Bronze, 123 x 135 x 55 cm.
The Museum of Modern Art, N.Y., A. Conger Goodyear Fund. (Cat. no. 238)

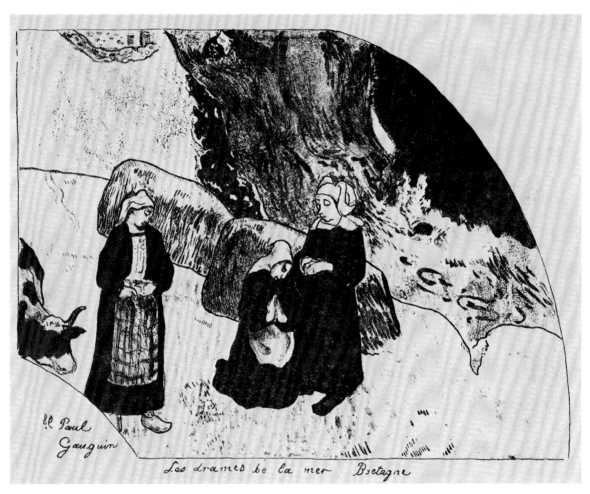

PAUL GAUGUIN. *Les Drames de la mer, Bretagne* from *Dix Zincographies,* 1889. Lithograph, 17.6 x 22.4 cm. The Museum of Modern Art, N.Y., given anonymously. (Cat. no. 59)

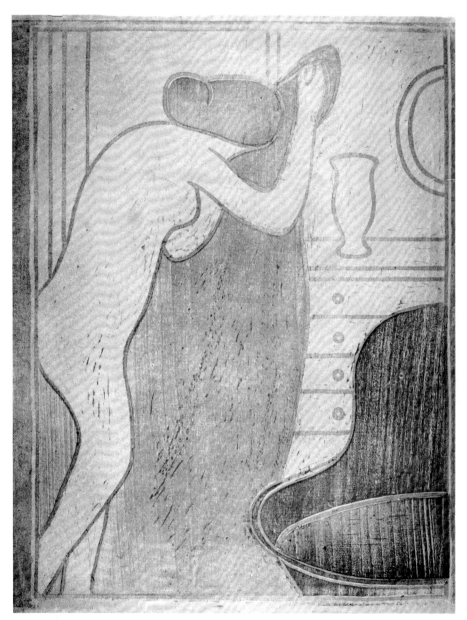

James Pitcairn-Knowles. *Le Bain* from *L'Album des peintres-graveurs*, 1896. Woodcut, 55.5 x 43 cm. Prints Division, The New York Public Library, Astor, Lenox, and Tilden Foundations. (Cat. no. 97)

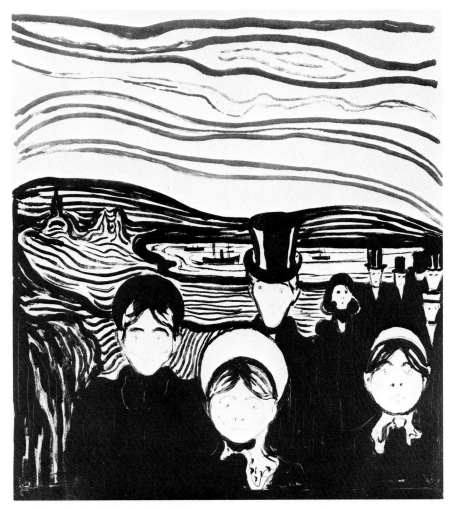

EDVARD MUNCH. *Le Soir* (Angstgefühl) from *L'Album des peintres-graveurs*, 1896. Lithograph, 41.3 x 38.7 cm. The Museum of Modern Art, N.Y., Abby Aldrich Rockefeller Fund. (Cat. no. 84)

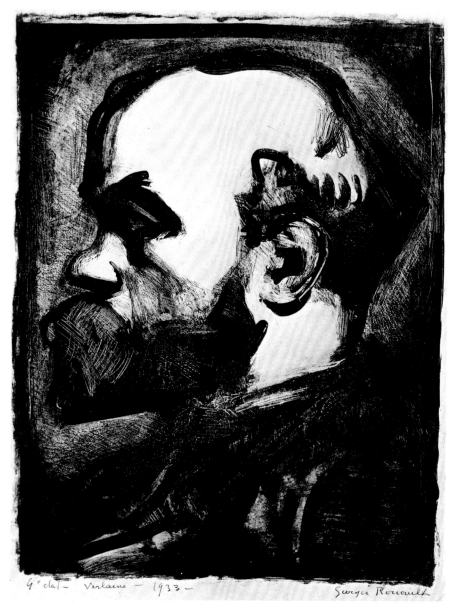

GEORGES ROUAULT. *Portrait de Verlaine,* 1926–33. Lithograph, 42.5 x 32.5 cm.
The Museum of Modern Art, N.Y., gift of the artist. (Cat. no. 122)

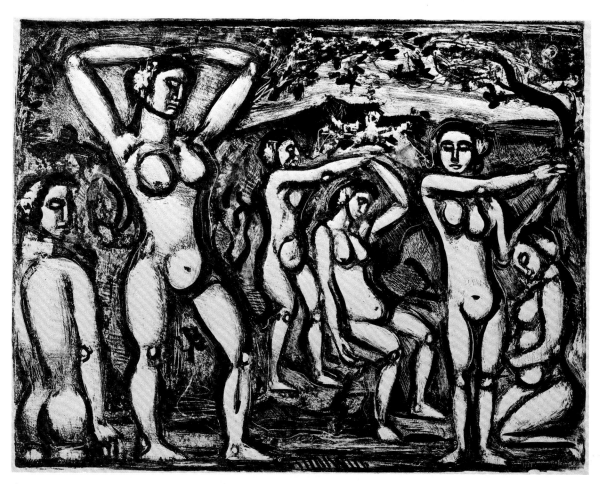

Georges Rouault. *Automne.* 1927–33. Lithograph, 43.5 x 57.4 cm.
The Museum of Modern Art, N.Y., gift of Norbert Schimmel. (Cat. no. 123)

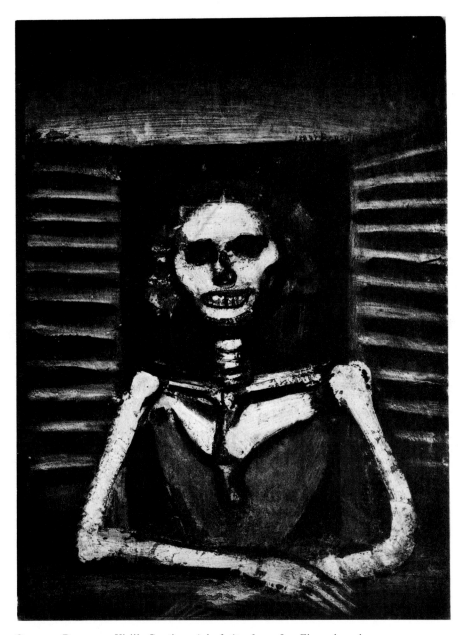

Georges Rouault. *Vieille Courtisane à la fenêtre* from *Les Fleurs du mal*
by Charles Baudelaire (1927), 1966. Etching, 45 x 34.5 cm. (page).
The Museum of Modern Art, N.Y., gift of Mlle Isabelle Rouault.
(Cat. no. 203)

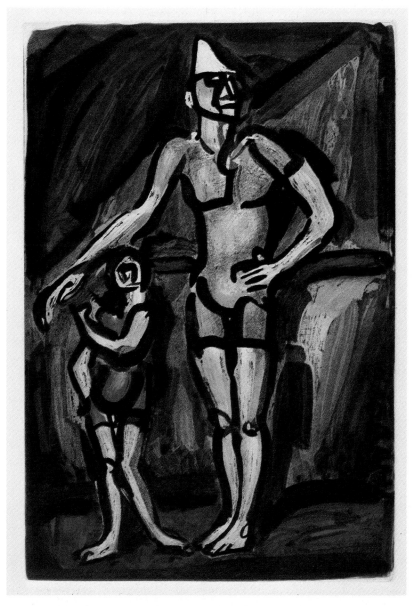

GEORGES ROUAULT. *Clown et enfant* from *Cirque* by André Suarès, 1930–39.
Aquatint, 31.2 x 21.2 cm. The Museum of Modern Art, N.Y., gift of the artist.
(Cat. no. 202)

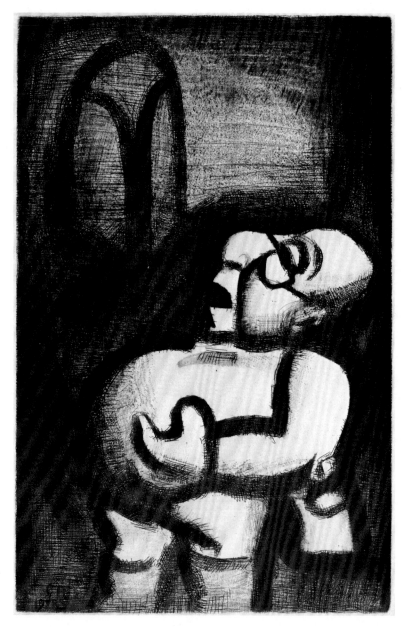

GEORGES ROUAULT. *Pédagogue* from *Les Réincarnations du Père Ubu*
by Ambroise Vollard, 1932. Etching, 44 x 33.7 cm. (page). The Museum
of Modern Art, N.Y., Louis E. Stern Collection. (Cat. no. 199)

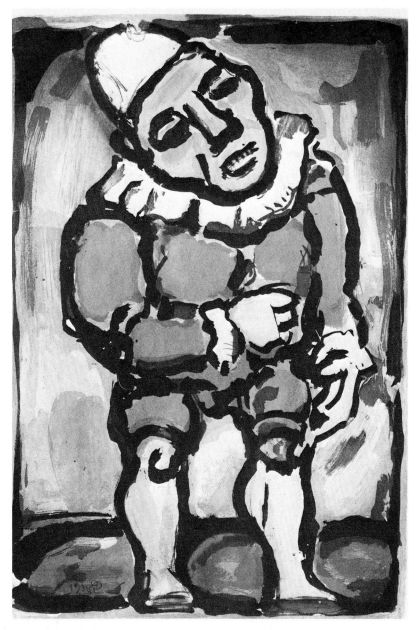

GEORGES ROUAULT. *Le Petit Nain* from *Cirque de l'étoile filante*, 1938.
Etching and aquatint, 44 x 34 cm. (page). The Museum of Modern Art, N.Y.,
Louis E. Stern Collection. (Cat. no. 200)

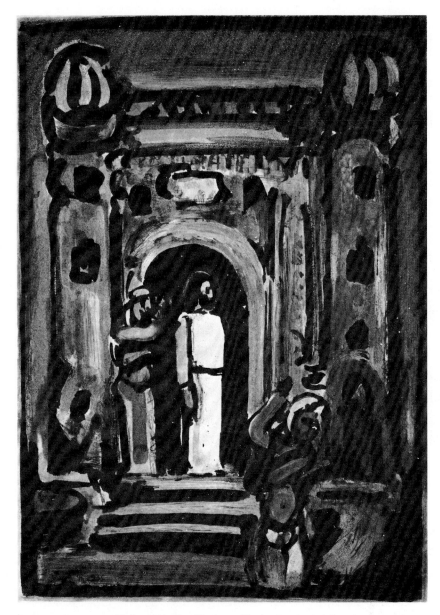

GEORGES ROUAULT. *Christ devant la ville* from *Passion* by André Suarès, 1939.
Aquatint, 44 x 34 cm. (page). The Museum of Modern Art, N.Y.,
Louis E. Stern Collection. (Cat. no. 201)

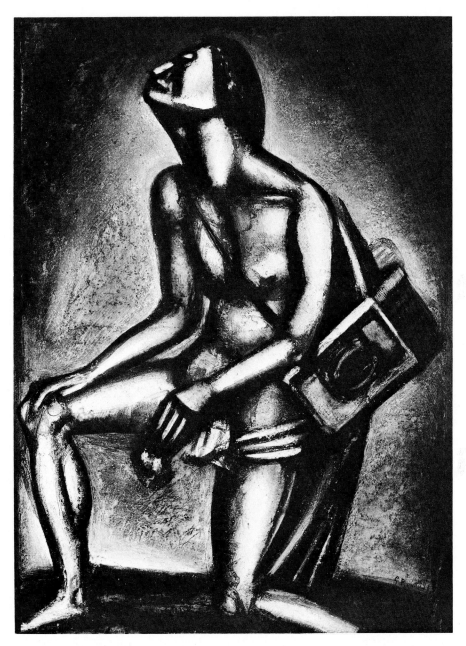

GEORGES ROUAULT. *Sunt lacrimae rerum* . . . from the album *Miserere* (1926), 1948.
Etching and aquatint over photogravure, 58.1 x 41.6 cm.
The Museum of Modern Art, N.Y., Louis E. Stern Collection. (Cat. no. 121)

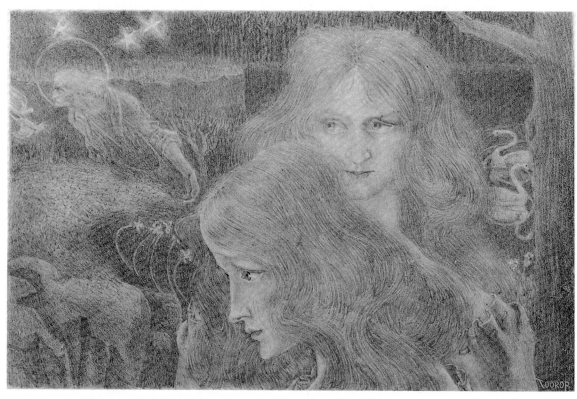

JAN THEODOOR TOOROP. *La Dame aux cygnes* from *L'Album des peintres-graveurs,*
1896. Lithograph, 22 x 33.4 cm. The Museum of Modern Art, N.Y., given anonymously. (Cat. no. 142)

KER-XAVIER ROUSSEL. *Femme en robe à rayures* from *L'Album de paysage,* ca. 1900. Lithograph, 21.4 x 32.5 cm. The Museum of Modern Art, N.Y., Abby Aldrich Rockefeller Fund. (Cat. no. 134)

EDOUARD VUILLARD. *Le Jardin des Tuileries* from *L'Album des peintres-graveurs,* 1896.
Lithograph, 28 x 43 cm. The Metropolitan Museum of Art,
Harris Brisbane Dick Fund, 1936. (Cat. no. 153)

EDOUARD VUILLARD. *Jeux d'enfants* from *L'Album d'estampes originales de la Galerie Vollard*, 1897. Lithograph, 26 x 44.7 cm. The Museum of Modern Art, N.Y., Purchase Fund. (Cat. no. 154)

EDOUARD VUILLARD. *Intérieur aux tentures rose, II* from the album *Paysages et intérieurs*, 1899. Lithograph, 36 x 27.2 cm. The Museum of Modern Art, N.Y., gift of Abby Aldrich Rockefeller. (Cat. no. 155)

ANDRÉ DUNOYER DE SEGONZAC. *Le Champ de seigle* from *Georgica* (*Les Géorgiques*) by Virgil
(1927), 1947. Etching, 46 x 34.4 cm. (page). The Museum of Modern Art, N.Y.,
Louis E. Stern Collection. (Cat. no. 204)

ANDRÉ DUNOYER DE SEGONZAC. *Vendages à Saint-Tropez sur la colline Sainte-Anne*
from *Georgica* (*Les Géorgiques*) by Virgil (1927), 1947. Etching, 46 x 34.4 cm.
The Museum of Modern Art, N.Y., Louis E. Stern Collection. (Cat. no. 204)

Maurice de Vlaminck. *La Plaine de Boissy-les-Perches*, 1923–25. Etching, engraving, and drypoint, 30 x 40 cm. The Museum of Modern Art, N.Y., purchase. (Cat. no. 150)

EUGÈNE GRASSET. *Morphinomane,* from *L'Album d'estampes originales de la Galerie Vollard,* 1897. Lithograph, 47 x 35.5 cm. Musée National de Cracovie, Cracow, Poland. (Cat. no. 60)

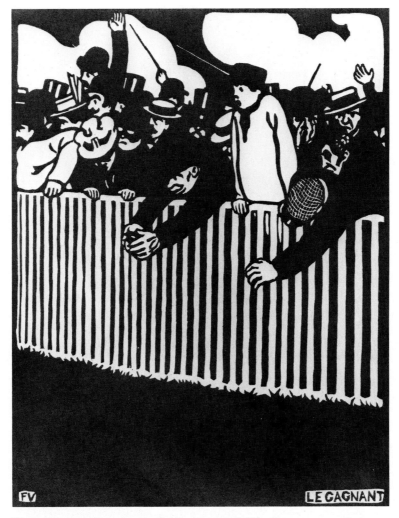

Félix-Edouard Vallotton. *Le Gagnant*, 1898. Woodcut, 22.4 x 17.8 cm.
National Gallery of Art, Washington, D.C., Rosenwald Collection.
(Cat. no. 146)

HENRI DE TOULOUSE-LAUTREC. *Partie de campagne* from *L'Album d'estampes originales de la Galerie Vollard,* 1897. Lithograph, 37 x 48.4 cm. Collection of Nelson A. Rockefeller. (Cat. no. 143)

CATALOGUE RAISONNE

Abbreviations of Collections

Achenbach	Achenbach Foundation for Graphic Arts, Palace of the Legion of Honor, San Francisco, California
AIC	Art Institute of Chicago, Chicago, Illinois
Austin	Humanities Research Center, University of Texas, Austin, Texas
Baltimore	Baltimore Museum of Art, Baltimore, Maryland
Barnes	Barnes Foundation, Merion, Pennsylvania
Berne	Kunstmuseum, Berne, Switzerland
Bibliothèque de l'Université	Bibliothèque de l'Université, Paris
Bibliothèque Nationale	Bibliothèque Nationale, Paris
BPL	Boston Public Library, Boston, Massachusetts
Brooklyn	Brooklyn Museum, Brooklyn, New York
Cincinnati	Cincinnati Art Museum, Cincinnati, Ohio
Clark	Sterling and Francine Clark Institute, Williamstown, Massachusetts
Cleveland	Cleveland Museum of Art, Cleveland, Ohio
CPLH	California Palace of the Legion of Honor, San Francisco, California
Cracow	Musée National de Cracovie, Cracow, Poland
Dartmouth	Dartmouth College Museum, Hanover, New Hampshire
Detroit	Detroit Institute of Art, Detroit, Michigan
Fogg	Fogg Art Museum, Harvard University, Cambridge, Massachusetts
GFK	Gottfried Keller Foundation, Switzerland
Grunwald	Grunwald Center for the Graphic Arts, University of California, Los Angeles, California
Guggenheim	Solomon R. Guggenheim Museum, New York
HCL	Harvard College Library, Cambridge, Massachusetts
Hirshhorn	Joseph J. Hirschhorn Museum, Smithsonian Institution, Washington, D.C.
LC	Library of Congress, Lessing J. Rosenwald Collection, Washington, D.C.
MMA	Metropolitan Museum of Art, New York
Minneapolis	The Minneapolis Institute of Arts, Minneapolis, Minnesota
Musée National d'Art Moderne	Centre Georges Pompidou, Musée National d'Art Moderne, Paris
MFA	Museum of Fine Arts, Boston, Massachusetts
MoMA	The Museum of Modern Art, New York
NGA	National Gallery of Art, Lessing J. Rosenwald Collection, Washington, D.C.
NYPL	New York Public Library, New York
Oberlin	Allen Memorial Art Museum, Oberlin College, Oberlin, Ohio
Ottawa	National Gallery of Canada, Ottawa, Canada
Phillips	Phillips Memorial Gallery, Washington, D.C.
PMA	Philadelphia Museum of Art, Philadelphia, Pennsylvania
Portland	Portland Art Museum, Portland, Oregon
San Francisco	San Francisco Museum of Art, San Francisco, California
Santa Barbara	Santa Barbara Museum, Santa Barbara, California
U of K	Art Museum, University of Kansas, Lawrence, Kansas
Williams	Lawrence Art Museum, Williams College, Williamstown, Massachusetts
Winterthur	Kunstmuseum, Winterthur, Switzerland
Yale	Yale University Art Gallery, New Haven, Connecticut

The catalogue is arranged within four major divisions: (A) Albums and single prints, (B) Editions de luxe published by Vollard or by later publishers, (C) Editions de luxe uncompleted, and, (D) Bronzes. Under these categories the artists' names are listed alphabetically and their works arranged chronologically. The undated items follow at the end of each artist's work. Major collections of museums and libraries in the United States are cited because of their richness in French graphic art of the late 19th century and the earlier decades of the 20th century. Where United States sources were unavailable a number of European national collections have been noted. Measurements are given in centimeters with height preceding width. An asterisk following a title indicates a plate will be found in the Illustration section.

Albums and Single Prints

AMAN-JEAN, Edmond-François
French, 1860–1936
1. Portrait de Mlle Moréno de la Comédie-Française*
From *L'Album d'estampes originales de la Galerie Vollard,* 1897

Lithograph in yellow, red, blue, and brown. 34.6 x 37.7 cm. (image), 43.1 x 57 cm. (sheet)

100 numbered impressions; 25 on antique japan paper; 75 on china paper; stones effaced after printing. Signed "Aman-Jean" lower right margin in pencil. Printed by August Clot

Ref.: *L'Estampe et l'affiche,* 1897, vol. 1, p. 24; *L'Estampe et l'affiche,* 1898, vol. 2, p. 19; Gheerbrant, 1897

Coll.: Clark, MoMA

2. Tête de femme (left, profile). ca. 1897
Lithograph in yellow, red, brown, and gray-black. 47 x 38 cm. (image), 64.5 x 52 cm. (sheet)

Edition not noted; impressions on japan paper. Signed "Aman-Jean" lower right margin. Printed by Auguste Clot

Ref.: Keller, no. 1

Coll.: Winterthur

AURIOL-HUYOT, Georges French, 1863–1938
3. Jeune Femme assise
From *L'Album des peintres-graveurs,* 1896

Lithograph in gray, green, brown, and beige. 46 x 25 cm. (image), 57 x 42.5 cm. (sheet)

100 numbered impressions on wove paper. Signed "Georges Auriol" lower margin in crayon. Printed by Auguste Clot

Ref.: *L'Estampe et l'affiche,* 1898, vol. 2, p. 19; Blum, no. 4; Gheerbrant, 1896

Coll.: Cracow

4. Selim, enfant de Damas. 1897
Lithograph in 10 colors. 57 x 42.4 cm. (sheet)

65 numbered impressions; two trial proofs printed from each of the stones; stones effaced after printing. Printed by Auguste Clot

Ref.: *L'Estampe et l'affiche,* 1897, vol. 1, p. 24

5. Tête d'enfant
From *L'Album d'estampes originales de la Galerie Vollard,* 1897

Lithograph in yellow, red, blue, brown, green, and gray on wove paper. 47 x 26 cm. (image), 57 x 42.4 cm. (sheet)

100 numbered impressions; stones effaced after printing. Signed "Georges Auriol" lower margin in crayon. Printed by Auguste Clot

Ref.: *L'Estampe et l'affiche,* 1898, vol. 2, p. 19; Gheerbrant, 1897; Blum, no. 3

Coll.: Cracow

BERNARD, Emile French, 1868–1941
6. Paysanne Bretonne (Woman Carrying a Water Jug). 1889
Lithograph. 30 x 22.4 cm. (image), 32.7 x 25 cm. (sheet)

Edition not noted; a small number of impressions. Signed "Bernard '89" lower right margin; some proofs signed in plate only. Printed by the artist

Ref.: Keller, no. 7

Coll.: Winterthur

Note: Because of the early date and the fact that Bernard usually printed his own work it is probable that Vollard acquired a small series of unnumbered impressions directly from the artist.

BESNARD, Albert French, 1849–1934
7. La Robe de soie
From *L'Album des peintres-graveurs,* 1896

Etching, drypoint, aquatint, and roulette in brown ink. 37 x 23.6 cm. (plate), 44 x 30.5 cm. (sheet)

100 numbered impressions on laid paper; several trial proofs. Not signed. Printed by Auguste Clot

Ref.: Delteil, vol. 30, no. 66, third state; Roger-Marx, *French Original Engravings*, pl. 49; Blum, no. 12; Klover, no. 72; Gheerbrant, 1896

Colls.: AIC (trial proof), NGA (first state)

Note: Delteil dates this print 1887. It was issued in the third state by Vollard in 1896.

BLANCHE, Jacques-Emile French, 1861–1942

8. Jeunes Filles lisant. 1895

From *L'Album des peintres-graveurs,* 1896

Lithograph in blue, yellow, and gray. 23.5 x 33.5 cm. (image), 42.3 x 56.4 cm. (sheet)

100 numbered impressions on wove paper; several trial proofs. Signed "J. E. Blanche 95" lower margin in pencil. Printed by Auguste Clot

Ref.: *L'Estampe et l'affiche,* 1898, vol. 2, p. 19; Blum, no. 15; Gheerbrant, 1896

Coll.: Cracow

9. Jeunes Filles dans un jardin. 1897

Lithograph in red, bister, and rose. 45 x 60 cm. (image)

50 impressions: 25 on japan paper; 25 on wove paper; several trial proofs; stones effaced after printing. Signed "J. E. Blanche" lower margin. Printed by Auguste Clot

Ref.: *L'Estampe et l'affiche,* 1897, vol. 1, p. 24

Coll.: Bibliothèque Nationale

Note: A letter from Vollard to Clot states that this print was originally planned for Vollard's projected third album of prints.

BONNARD, Pierre French, 1867–1947

10. Quelques Aspects de la vie de Paris*

12 lithographies en couleurs par Bonnard. Ambroise Vollard, éditeur, 6 rue Laffitte, Paris, 1895

Album of 12 lithographs and a cover in colors. 53 x 40.3 cm. (sheet)

100 albums on fine wove paper with cover printed on loose china paper; some trial proofs in black printed on paper with large margins. Each album signed "P. Bonnard" in pencil and numbered. A small number of albums were returned to the artist some years after publication and his signature was placed on each print. A few impressions have special dedications. Printed by Bonnard at Auguste Clot's shop

Ref.: Terrasse, no. 16; Roger-Marx, nos. 56–68; Rewald, *Pierre Bonnard,* p. 26; Gheerbrant, 1895

Colls.: AIC, BPL, Brooklyn, MMA, MoMA (2 titles), NYPL, Clark, NGA, PMA

Titles of individual prints:

Couverture. 41 x 33 cm.
1 *Avenue du bois.* 31.5 x 46 cm.
2 *Coin de rue.* 27.5 x 35 cm.
3 *Maison dans la cour.* 34.5 x 25.6 cm.
4 *Rue vue d'en haut.* 37 x 22 cm.
5 *Boulevard.* 17.5 x 43 cm.
6 *Place, le soir.* 28 x 39 cm.
7 *Marchand des quatre-saisons.* 29 x 34 cm.
8 *Le Pont.* 26 x 40.9 cm.
9 *Au théâtre.* 20 x 40 cm.
10 *Rue, le soir, sous la pluie.* 25 x 35.5 cm.
11 *Arc de Triomphe.* 32 x 47 cm.
12 *Coin de rue vu d'en haut.* 36.5 x 21.5 cm.

Note: *Maison dans la cour* (pl. 3) exists in an undescribed trial proof, retouched by hand; *Boulevard* (pl. 5) exists in a trial proof in orange, brown, yellow, gray-blue, with retouching in red and black crayon. (both, AIC collection). A sketch for *Place, le soir* (pl. 6) in watercolor, pastel, and chinese ink is dated 1899 (Peter Deitsch Catalogue 3, 1969, reproduced in color). This date and the fact that Vollard did not exhibit the Bonnard album until 1899 lead to the conclusion that the series was completed and issued in 1899, although the cover date is 1895.

11. La Blanchisseuse*

From *L'Album des peintres-graveurs,* 1896

Lithograph in red, gray, yellow-brown, and black. 29.5 x 20 cm. (image), 57.2 x 42.3 cm. (sheet)

100 numbered impressions on loose china paper; several trial proofs. Signed "P. Bonnard" lower right margin in pencil. Printed by Auguste Clot

Ref.: *L'Estampe et l'affiche,* 1898, vol. 2, p. 20; Roger-Marx, no. 42; Rewald, *Pierre Bonnard,* p. 31; Terrasse, no. 25; Gheerbrant, 1896; Blum, no. 17

Colls.: Brooklyn, LC, MMA, MFA, MoMA, NGA, PMA, Clark

Note: A fairly complete study in lithographic pencil is in the Gerard-Ayrton collection (31 x 21 cm.). A number of other studies are known.

12. Les Peintres-Graveurs*

Poster for "Exposition des Peintres-Graveurs" du 15 au 20 juillet 1896, Galerie Vollard, 6 rue Laffitte, Paris

Lithograph in brown, yellow, and green. 64 x 47 cm. (image), 64.8 x 48 cm. (sheet)

Edition not noted; impressions on wove paper. Signed "P. Bonnard" lower left of image on stone only; a few impressions signed in manuscript. Printed by Auguste Clot

Ref.: Terrasse, no. 18; Roger-Marx, no. 40

Colls.: Brooklyn, MoMA, NGA, NYPL

13. Le Canotage

From *L'Album d'estampes originales de la Galerie Vollard,* 1897

Lithograph in green, yellow, blue, and brown. 27 x 47 cm. (image); 42.5 x 57 cm. (sheet)

100 numbered impressions on loose china paper; a few trial proofs. Signed "P. Bonnard" lower left margin in pencil. Printed by Auguste Clot

Ref.: *L'Estampe et l'affiche,* 1898, vol. 2, p. 19; Terrasse, no. 27; Gheerbrant, 1897; Roger-Marx, no. 44

Colls.: AIC, Brooklyn, Clark, Fogg, MFA, MMA, MoMA, NGA, NYPL

14. Couverture de L'Album d'estampes originales de la Galerie Vollard, 1897

Lithograph in brown, yellow, green, orange, and beige. 57 x 87 cm. (image); 57.5 x 88 cm. (sheet)

100 impressions on wove paper; several trial proofs. Signed "P. Bonnard" lower left margin in pencil. Printed by Auguste Clot

Ref.: *L'Estampe et l'affiche,* 1898, vol. 2, p. 19; Terrasse, no. 24; Roger-Marx, no. 41; Blum, no. 19; Laran, Adhémar, Lethève, vol. 3, p. 12

Colls.: MFA, MoMA

Note: Title on cover reads *6 rue Laffitte, 2e année, Album d'estampes originales de la Galerie Vollard 1897.* There are a number of impressions that carry the 1896 title, *L'Album des peintres-graveurs* (see Introduction, p. 20). In an early proof an attempt was made to combine the two titles. It reads *Peintres-Graveurs, 2e année, L'Album d'estampes originales de la Galerie Vollard, 6 rue Laffitte.*

15. Enfant à la lampe

For unpublished *L'Album d'estampes originales de la Galerie Vollard,* 1898-

Lithograph in blue, green, orange, red, and pink. 33 x 44.6 cm. (image), 43.4 x 57.4 cm. (sheet)

100 impressions on loose china paper. Signed "Bonnard" lower right margin in pencil; some impressions unsigned. Printed by Auguste Clot

Ref.: Terrasse, no. 26; Roger-Marx, no. 43

Colls.: AIC, Brooklyn, Clark, MMA, MoMA, NYPL

Note: Some rare proofs have no color on base of lamp.

16. Portrait d'Ambroise Vollard (holding a cat).* ca. 1914

Etching. 34.5 x 24 cm. (plate); 45 x 33.9 cm. (sheet)

Edition not noted; impressions on wove paper. Not signed. Printed by the artist

Ref.: Terrasse, no. 62

Colls.: BPL, Brooklyn, MFA, MoMA, NYPL

17. Portrait de Renoir. ca. 1914

Etching. 25.7 x 19.8 cm. (plate), 35.5 x 24 cm. (sheet)

Edition not noted; possibly 150 impressions on wove paper. Signed "Bonnard" in plate only. Printed by the artist

Ref.: Terrasse, no. 63

Colls.: BPL, Fogg, Grunwald, MFA, MoMA, NGA

18. Les Baigneuses (Deux Nus). 1924

Etching and drypoint. 16.5 x 23.3 cm. (plate)

Edition not noted; impressions on cream-colored wove paper with watermark "Vollard." Signed with monogram lower right in plate only

Ref.: Undescribed by Terrasse; Lempertz (Cologne) auct. cat. 482, no. 94

Note: For Vollard's unpublished album of nudes.

BRAQUE, Georges French, 1882–1963

19. Cavalier. 1932

Etching 27.5 x 25.5 cm. (plate), 52.5 x 38 cm. (sheet)

There exist 12 numbered impressions printed on Van Gelder paper and 9 proofs. Printed by Louis Fort?

Ref.: Engelberts, *Georges Braque,* no. 14 (questioned as a Vollard publication); Bibliothèque Nationale, *Georges Braque,* no. 16 (questioned); Hofmann, *Georges Braque,* no. 16 (questioned).

Note: The print is questioned as a Vollard publication by a number of authorities. Print not located.

CARABIN, François-Rupert French, 1862–1932

20. La Statuette

From *L'Album des peintres-graveurs,* 1896

Embossing. 22 x 11 cm. (image); 32.5 x 24.2 cm. (sheet)

100 numbered impressions on wove paper. Signed "R. Carabin." Printed by Auguste Clot

Ref.: *L'Estampe et l'affiche,* 1898, vol. 2, p. 20; Blum, no. 25; Gheerbrant, 1896

Coll.: Cracow

CARRIERE, Eugène French, 1849–1906

21. Le Sommeil (Jean-René Carrière)

From *L'Album d'estampes originales de la Galerie Vollard,* 1897

Lithograph. 33.8 x 42.7 cm. (image), 42.4 x 56 cm. (sheet)

100 numbered impressions on china paper laid down on heavy wove. Signed "Eugene Carrière" upper left of image in stone only. Printed by Auguste Clot

Ref.: Delteil, vol. 8, no. 36; Gheerbrant, 1897; Blum, no. 29

Colls.: MoMA, NGA, PMA

CEZANNE, Paul French, 1839–1906

22. Les Baigneurs (small plate). 1896–97

From L'Album d'estampes originales de la Galerie Vollard, 1897

Lithograph in green, yellow, pink, blue, and black (variations). 22.4 x 27.3 cm. (image), 29.5 x 36 cm. (sheet)

100 numbered impressions on china paper laid down on heavy white wove; a small number of proofs before the edition; 1 proof in black; 1 proof heightened with watercolor. A few impressions signed "P. Cézanne"; others signed by artist's son; a small number are unsigned. Printed by Auguste Clot

Ref.: Venturi, Cézanne, no. 1156; Druick, pp. 14, 18; Roger-Marx, French Original Engravings, pl. IX; Melot, C 8; Gheerbrant, 1897; Goriany, "Cézanne's lithograph The Small Bathers," Gazette des Beaux-Arts, 1943, vol. 23, pp. 123-124

Colls.: Achenbach, AIC, Barnes, Fogg, Grunwald, MoMA, MFA, NGA

Note: A first state, slightly larger and printed on loose china paper, was formerly in the Vollard collection. The second state with composition slightly cut was issued in the 1897 album.

23. Les Baigneurs (large plate).* 1896–97

For unpublished L'Album d'estampes originales de la Galerie Vollard, 1898–

Lithograph in green, blue, yellow, and black (color variations notably in blues and blacks). 41 x 50.3 cm. (image), 48.7 x 63.3 cm. (sheet)

100 impressions in first state on Arches Ingres paper, which have inscription and signature "Tirage a cent exemplaires no. . . P. Cézanne" printed in transfer lithography lower right margin; green color accented. In excess of 100 impressions in second state on Arches Ingres paper; blue tone is accented; no inscription or signature; some impressions printed in black. The Arches paper usually carries the watermark "M B M (France) Ingres Arches." Not signed in manuscript. Printed by Auguste Clot

Ref.: Venturi, Cézanne, no. 1157; Druick, pp. 10, 16, 18, 33-34; Gheerbrant, 1897

Colls.: AIC (also impression retouched in crayon, watercolor, and india ink by an unknown hand), BPL, Brook-

lyn (black), Clarke (black and also in color), Cleveland, Detroit, Fogg, Grunwald, Minneapolis, MFA, MoMA (in color), NGA, NYPL, Ottawa (black heightened with watercolor), San Francisco, Yale (black)

Note: Druick points out that the color forms in the second state are from a different set of color stones and are less precise or more generalized. He also records 4 known proofs or maquettes heightened with watercolor. The composition of the above lithograph is based on Cézanne's earlier painting Baigneurs au repos, 1875-76 (80 x 90 cm.), now in the collection of the Barnes Foundation, Merion, Pa.

24. Portrait de Cézanne.* ca. 1896–97

For unpublished L'Album d'estampes originales de la Galerie Vollard, 1898–

Lithograph in black and in gray. 32.3 x 27.8 cm. (image), 63.5 x 46 cm. (sheet)

In excess of 300 impressions in black, and in excess of 200 impressions in gray on Arches Ingres paper; also an unknown number of impressions on smooth-textured imitation japan paper (Druick, f.n. 83, p. 28). Not signed. Printed by Auguste Clot

Ref.: Venturi, Cézanne, no. 1158; Druick, pp. 14, 15-16, 28, f.n. 83; Melot, C 7

Colls.: BPL, Clark, Fogg, Grunwald, MFA, MoMA, NYPL, PMA, Winterthur

Note: There is some disagreement concerning the number of impressions in the black and the gray printings of the Cézanne portrait. The Vollard estate held most of the impressions in gray and in the early 1940s sold them to a Paris dealer, A.C. Mazo. Both the gray and the black impressions were printed from the same stone. Melot notes that an edition in color was made. According to Druick only one color proof was printed. To date no example in color has been located. An impression in black heightened with watercolor was in the Vollard holdings.

CHAGALL, Marc French, born in Russia, 1887

25. L'Acrobate au violon.* 1924

Etching and drypoint. 41.8 x 31.8 cm. (plate), 57.5 x 45 cm. (sheet)

150 impressions on wove paper; several trial proofs Signed "Marc Chagall" lower right margin in pencil. Not all of edition signed. Printed by Louis Fort

Ref.: Salmon, Chagall, p. 22; Meyer, no. 63; Kornfeld, no. 40, 3rd state; Bibliothèque Nationale, Chagall, no. 57

Colls.: AIC (impression printed in black with color added and inscribed "Essai" in artist's hand), Fogg, Grunwald, MoMA, MFA, NYPL

COTTET, Charles French, 1863–1925

26. Un Enterrement en Bretagne

From *L'Album d'estampes originales de la Galerie Vollard*, 1897

Lithograph in blue, yellow, and olive-green (variations). 33.4 x 49 cm. (image), 43 x 49 cm. (sheet)

100 numbered impressions on china paper; several trial proofs, one with a dedication. Signed "Ch. Cottet" lower right margin in crayon. Printed by Auguste Clot

Ref.: *L'Estampe et l'affiche*, 1898, vol. 2, p. 19; Blum, no. 32

Colls.: MFA, Cracow

CROSS, Henri-Edmond French, 1856–1910

27. La Promenade (Les Cypresses)

From *L'Album d'estampes originales de la Galerie Vollard*, 1897

Lithograph in blue, green, yellow, pink, and dark blue. 28.4 x 41.1 cm. (image), 42.2 x 56.3 cm. (sheet)

100 numbered impressions on china paper laid down; several trial proofs. Signed "H. E. Cross" lower right margin in pencil; a few impressions not signed

Ref.: *L'Estampe et l'affiche*, 1898, vol. 2, p. 19; Blum, no. 34

Colls.: MFA, MoMA, NGA

DEGAS, Edgar French, 1834–1917

28. [A Collection of Etchings]

Printed from Degas's canceled plates, ca. 1919–20

Etchings. 32.3 x 25 cm. (sheet)

An edition of 150 impressions from the canceled plates was printed for Vollard, who planned to utilize them as part of a book on Degas. Delteil learned of this Vollard project as his own catalogue on the graphic oeuvre of Degas was at press. Printed on japan paper, the 21 etchings were released without cover or title page

Ref.: Delteil, vol. 9 nos. 1, 4, 7, 9-10, 14–16, 20, 26–30, 32, 34, 37, 39-40, 43, 45

Note: The plates were originally completed by Degas in 1855–84. The somewhat pale impressions of the Vollard printing may have caused him to abandon his project.

DENIS, Maurice French, 1870–1943

29. Jeune Fille à la fontaine. 1895

Lithograph in beige, green, pink, and tones of yellow. 52.5 x 32.5 cm. (image), 64 x 45 cm. (sheet)

100 impressions on wove paper. Signed "Maurice Denis" lower left margin in pencil

Ref.: Cailler, no. 87; Keller, no. 46

Coll.: Winterthur

Note: Cailler records this title as published by Sagot in an edition of 50.

30. La Visitation à la villa Montrouge

From *L'Album des peintres-graveurs*, 1896

Lithograph in blue, yellow, beige, and green (variations). 36.7 x 31.4 cm. (image), 57 x 43 cm. (sheet)

100 numbered impressions on toned wove paper. Several trial proofs. Signed "Maurice Denis" lower left margin in pencil. Printed by Auguste Clot

Ref.: *L'Estampe et l'affiche*, 1898, vol. 2, p. 20; Cailler, no. 94, third state; Gheerbrant, 1896; Keller, no. 45

Colls.: AIC, Grunwald, MoMA, NGA

31. Le Reflet dans la fontaine*

From *L'Album d'estampes originales de la Galerie Vollard*, 1897

Lithograph in green, blue, gray, pink, and olive-green (variations). 40 x 24 cm. (image), 57.2 x 43.1 cm. (sheet)

100 numbered impressions on loose china paper. Signed "Maurice Denis" lower left margin in pencil. Printed by Auguste Clot

Ref.: *L'Estampe et l'affiche*, 1898, vol. 2, p. 19; Roger-Marx, *French Original Engravings*, pl. 11; Cailler, no. 100; Gheerbrant, 1897

Colls.: Brooklyn, MoMA

32. Amour*

Douze lithographies en couleurs de Maurice Denis. Ambroise Vollard, éditeur, 6 rue Laffitte, Paris, 1898 [1899]

Album of 12 lithographs and a cover printed in color. 60 x 44.5 cm. (sheet)

100 albums on wove paper with cover printed on loose china wove paper; trial proofs of each print. Signed "Maurice Denis" lower left or right margin in pencil with the exception of plates 1 and 9. Title page also signed. Printed by Maurice Denis and Auguste Clot

Ref.: *L'Estampe et l'affiche*, 1899, vol. 3, p. 102; Cailler, nos. 107-119; Gheerbrant, 1898

Colls.: Brooklyn, Clark, MMA, MFA, MoMA, NGA, NYPL

Titles of individual prints:
Couverture. 52.6 x 41.3 cm.
1 *Allégorie* 26.7 x 41 cm.
2 *Les Attitudes sont faciles et chastes.* 38.5 x 27.5 cm.
3 *Le Bouquet matinal, les larmes.* 38 x 28 cm.
4 *Ce fût un religieux mystère.* 41.3 x 29.2 cm.

5 *Le Chevalier n'est mort à la croisade.* 38.6 x 27.6 cm.
6 *Les crépuscules ont une douceur d'ancienne peinture.* 39.8 x 29.5 cm.
7 *Elle était plus belle que les rêves.* 40.4 x 29.6 cm.
8 *Et c'est la caresse de ses mains.* 39 x 28.7 cm.
9 *Nos âmes en des gestes lents.* 27.9 x 40 cm.
10 *Sur la canapé d'argent pale.* 40.1 x 28.5 cm.
11 *La Vie devient précieuse, discrete.* 27.1 x 40.5 cm.
12 *Mais c'est le coeur qui bat trop vite.* 44.2 x 29.4 cm.

Note: Denis began work on the *Amour* series in 1892. Cailler dates album 1911.

33. La Madone au jardin fleuri. 1922

Etching. 34 x 25.4 cm. (plate), 58 x 45 cm. (sheet)

No edition noted; proofs on heavy wove paper. 34 x 25.4 cm. (plate); 58 x 45 cm. (sheet). Signed in plate only

Ref.: Cailler, no. 140; Keller, no. 47

Coll.: Winterthur

Note: After a 1907 painting.

DONGEN, Kees van Dutch, 1877–1968
34. Les Mouettes (Two Seagulls)

Etching. 39 x 32.5 cm. (plate), 58 x 45 cm. (sheet)

Edition not noted; proofs only on heavy wove paper. Signed in plate only

Ref.: Keller, no. 49

Coll.: Winterthur

DUFY, Raoul French, 1877–1953
35. Deux Antillaises (Deux Négresses). ca. 1930

Etching. 34 x 49.5 cm. (plate), 50 x 65.5 cm. (sheet)

Edition not noted; proofs on Van Gelder; also with "Ambroise Vollard" watermark. Not signed

Ref.: Cramer, *Catalogue 12,* no. 78; Deitsch, *Catalogue C supplement,* June 1, 1957

Coll.: BPL

36. La Havanaise (La Négresse).* ca. 1930

Etching. 34.9 x 51.3 cm. (plate), 46.4 x 61.4 cm. (sheet)

Edition not noted; impressions on Van Gelder wove paper. Not signed

Ref.: Laran, *L'Estampe,* vol. 2, pl. 402; Bibliothèque Nationale, *Dufy.* no. 50

Colls.: MoMA, NYPL

37. Nu couché aux palmiers avec fond de Côte d'Azur.* ca. 1930

Etching. 34 x 49.3 cm. (plate), 45.5 x 58 cm. (sheet)

Edition not noted; impressions on Arches wove paper. Signed "Raoul Dufy" with some impressions not signed

Ref.: Bibliothèque Nationale, *Dufy,* no. 51; Keller, no. 54; Parke Bernet, *Catalogue 936,* no. 28

Colls.: NYPL, MoMA

Note: Also known as *Odalisque nue, couchée dans un jardin.* For Vollard's unpublished album of nudes.

ELIOT, Maurice French, 1864–?
38. Tête de fillette

From *L'Album d'estampes originales de la Galerie Vollard.* 1897

Lithograph in color. 49 x 26 cm. (image), 57 x 43 cm. (sheet)

100 numbered impressions on wove paper. Signed "Maurice Eliot" lower margin. Printed by Auguste Clot

Ref.: *L'Estampe et l'affiche,* 1898, vol. 2, p. 19; Gheerbrant, 1897; Blum, no. 46

Coll.: Cracow

FANTIN-LATOUR, Ignace-Henri French, 1836–1904
39. Vénus et l'amour

From *L'Album des peintres-graveurs,* 1896

Lithograph in black. 32.5 x 41.6 cm. (image), 42.5 x 57 cm. (sheet)

105 impressions in second state on china paper laid down on heavy wove paper; 5 trial proofs. Signed "Fantin" lower left margin. Printed by Auguste Clot

Ref.: Hédiard, no. 131, second state (large plate); Blum, no. 48; Gheerbrant, 1896

Colls.: AIC, BPL, NYPL

Note: Stone substantially reworked in second state.

40. A H. Berlioz

From *L'Album d'estampes originales de la Galerie Vollard,* 1897

Lithograph in black. 46.4 x 38.4 cm. (image), 56 x 42.5 cm. (sheet)

Approximately 100 impressions in second state on china paper laid down on heavy wove paper. Signed "H. Fantin" lower left of composition on stone only. Printed by Blanchard

Ref.: Hédiard, no. 132, second state (large plate); Blum, no. 49; Gheerbrant, 1897

Colls.: BPL (also trial proofs in 2 states), LC, MFA, NYPL

41. Suite de six planches*

Ambroise Vollard, éditeur, 6 rue Laffitte, Paris, 1898

6 lithographs in black. 63 x 49 cm. (sheet, variants)

100 impressions on china paper laid down on heavy wove paper; some trial proofs on loose china paper. Signed "Fantin" or "h. Fantin" lower right or lower left margin. Printed by Blanchard

Ref.: Hédiard, nos. 138–142 and 146; Gheerbrant, 1898

Colls.: AIC, Cleveland, Grunwald, LC, MFA, NYPL

Titles of individual prints:

1 *Baigneuses.* H. 138, second state. 31 x 39 cm. (plate)
2 *La Source dans les bois.* H. 139, third state. 30 x 41.5 cm.
3 *Danses.* H. 140, third state. 44 x 32.6 cm.
4 *Götterdämmerung: Siegfried et les filles du Rhin.* H. 141, second state. 48 x 37.8 cm.
5 *Evocation de Kundry.* H. 142, only state. 41.2 x 48.3 cm.
6 *Prélude de Lohengrin.* H. 146, only state. 49 x 34.6 cm.

42. A. Rossini. 1902

Lithograph in black. 38.4 x 37.7 cm. (image), 58 x 73 cm. (sheet)

162 impressions: 12 on special japan paper (for the artist); 50 on white japan; 50 on japan tissue; 50 on wove; 8 trial proofs. Signed "H. Fantin" lower right of composition on stone only. Printed by Auguste Clot

Ref.: Hédiard, no. 160

Coll. BPL

Note: Vollard issued this edition in 1903

FEURE, Georges de　　　　French, 1868–1928

43. Dans le rêve (Allégorie)

From *L'Album d'estampes originales de la Galerie Vollard,* 1897

Lithograph printed in color. 33 x 31 cm. (image), 56.5 x 43 cm. (sheet)

100 numbered impressions on wove paper. Signed "G F" lower margin. Printed by Auguste Clot

Ref.: *L'Estampe et l'affiche,* 1898, vol. 2, p. 19; Gheerbrant, 1897; Blum, no. 51

Coll.: Cracow

FLANDRIN, Jules-Leon　　　　French, 1871–1947

44. Le Départ de Diane. 1923

Etching. 29.5 x 39.5 cm. (plate), 45 x 56.7 cm. (sheet)

Edition not noted; impressions on heavy wove paper. Signed in plate only

Ref.: Keller, no. 56

Coll.: Winterthur

45. Pâturage. n.d.

Etching. 28 x 42 cm. (plate), 45 x 55 cm. (sheet)

Edition not noted; impressions on heavy wove paper. Signed in plate only

Ref.: Keller, no. 55

Coll.: Winterthur

FORAIN, Jean-Louis　　　　French, 1852–1931

46. Femme assise, la tête dans la main droite

From *L'Album d'estampes originales de la Galerie Vollard,* 1897

Lithograph in sanguine and black. 26 x 38 cm. (image), 40 x 52 cm. (sheet)

100 numbered impressions on Arches wove paper; approximately 10 impressions unnumbered; several trial proofs. Signed "Forain" lower right of composition on stone only. Printed by Auguste Clot

Ref.: Guérin, no. 61; Blum, no. 53; Gheerbrant, 1897

Colls.: AIC, BPL, MoMA, NGA

47. En Grèce

For unpublished *L'Album d'estampes originales de la Galerie Vollard,* 1898–

Lithograph in black. 20 x 41.4 cm. (image), 37 x 50.2 cm. (sheet)

100 numbered impressions on wove paper; stone effaced after printing. Signed "f" lower right of composition on stone only. Printed by Auguste Clot

Ref.: Guérin, no. 60

Coll.: NGA

48. Etudes des femmes. n.d.

Four lithographs for a projected album of nudes

Lithographs. Approximately 32 x 44.5 cm. (sheet)

No edition issued; impressions on Arches wove paper. Not signed

Ref.: Guérin, no. 80–83; Keller, nos. 66–69

Colls.: BPL (nos. 1 and 2), Grunwald, Winterthur

Titles of individual prints:

1 *Etude de nue, de dos . . .* G. no. 80. 13.9 x 14.8 cm.
2 *Etude de femme assise se deshabillant* G. no. 81. 19.6 x 24.1 cm.
3 *Etude de nu de face.* G. no. 81. 22.6 x 16.9 cm.
4 *Etude de nu, de trois quarts.* G. no. 82. 22.4 x 14.5 cm.

49. Le Petit Déjeuner. n.d.

Lithograph in black. 27 x 31 cm. (image), 32.7 x 50.5 (sheet)

No edition issued; impressions on wove paper. Signed "f" on stone only

Ref.: Guérin, no. 22; Singer, p. 486; Keller, no. 73

Coll.: Winterthur

50. Portrait de Renoir, plate I. ca. 1905

Lithograph in black. 24.5 x 17.6 cm. (image), 34.5 x 27.6 cm. (sheet)

No edition issued; impressions on japan paper. Not signed

Ref.: Guérin, no. 76

Colls.: BPL, Grunwald, NGA

51. Portrait de Renoir, plate 2. ca. 1905

Lithograph in black. 27.3 x 20.2 cm. (image), 35 x 27.5 cm. (sheet)

No edition issued; impressions on japan paper. Not signed

Ref.: Guérin, no. 77

Colls.: BPL, MMA, NGA

52. Portrait de Renoir, plate 3. ca. 1905

Lithograph in black. 27.2 x 20.2 cm. (image), 35 x 27.5 cm. (sheet)

No edition issued; impressions on japan paper. Not signed

Ref.: Guérin, no. 78

Colls.: BPL, NGA

53. Portrait de Renoir, plate 4. 1905

Lithograph in black. 26.7 x 21.9 cm. (image), 35 x 27.4 cm. (sheet)

No edition issued; impressions on japan paper. Signed "forain, 8bre 1905" lower right of composition

Ref.: Guérin, no. 79: Keller, no. 70

Colls.: BPL, Grunwald, Winterthur

54. Portrait de Vollard. ca. 1905

Lithograph. 21.2 x 24.5 cm. (image); 50.5 x 32.5 cm. (sheet)

Edition not noted; impressions on wove paper. Signed "forain" on stone only

Ref.: Not listed in Guérin

Coll.: NGA

55. Portraits d'Ambroise Vollard. ca. 1905

Lithograph in black. 41.7 x 35 cm. (image), 57 x 65.5 cm. (sheet)

No edition issued; impressions on loose china and japan papers. Not signed

Ref.: Not listed in Guérin

Colls.: NGA, BPL

Note: Five sketches on single sheet

56. Portrait de Vollard (left frontal). ca. 1910

Lithograph in green. 26 x 25 cm. (image), 50.5 x 33.5 cm. (sheet)

No edition issued; impressions on wove paper. Signed on stone only

Ref.: Not listed in Guérin; Keller, no. 72

Coll.: Winterthur

57. Sortie de la bourse. n.d.

Lithograph in black. 29.5 x 33.5 cm. (image), 47 x 64 (sheet)

No edition issued; impressions printed on heavy wove paper. Signed "f" on stone only

Ref.: Keller, no. 74; not listed in Guérin

Coll.: Winterthur

FOUJITA, Tsugouharu
French, born in Japan, 1886–1968

58. Auto-portrait (seated at table with brushes, ink block, teapot, and scissors).* 1923

Etching. 41.5 x 31.5 cm. (plate), 50.9 x 37.6 cm. (sheet)

Edition not noted; proofs on wove paper. Signed "Foujita" in plate only

Ref.: Keller, no. 75

Colls.: MoMA, Winterthur

GAUGUIN, Paul French 1848–1903

59. Dix Zincographies.* 1889

Published by Ambroise Vollard, 39–41 rue Laffitte, Paris, 1894

Lithographs 33 x 39 cm. (sheet)

An unnumbered second edition of 10 lithographs (zinc plates) printed on imitation japan paper. Unsigned. Probably printed by Auguste Clot

Ref.: Guérin, *Gauguin,* nos. 2–11; Art Institute of Chicago, *Gauguin,* nos. 128–138 (notes); Brown, p. 244; Carl O. Schniewind, Gauguin manuscript

Coll.: MoMA (nos. 9 and 10)

Titles of individual prints:
1 *Joies de Bretagne.* G. no. 2. 20.1 x 24.1 cm.
2 *Baigneuses bretonnes.* G. no. 3. 24.5 x 19.9 cm.
3 *Bretonnes à la barrière.* G. no. 4. 16.9 x 21.5 cm.

4 *Misères humaines.* G. no. 5. 28.4 x 23.1 cm.
5 *Les Laveuses.* G. no. 6. 21.1 x 26 cm.
6 *Les Drames de la mer, Bretagne.* G. no. 7. 17.6 x 22.4 cm.
7 *Les Drames de la mer, Maelstrom.* G. no. 8. 18 x 27.5 cm.
8 *Pastorales Martinique.* G. no. 9. 18.5 x 22.4 cm.
9 *Les Cigales et les fourmis.* G. no. 10. 21.3 x 26.1 cm.
10 *Les vieilles filles d'Arles.* G. no. 11. 18.9 x 21 cm.

Note: The first edition of the 10 lithographs (on zinc plates) with an illustrated title page was printed by Ancourt on hand-colored yellow papers in 1889 and was the only edition known to Guérin. Sometime between his trips to Tahiti Gauguin gave the plates to Amédée Schuffenecker, who then sold them to Vollard. Vollard's unnumbered second edition was issued as a series of 10 zincographies without the earlier title page.

GRASSET, Eugène French, 1841–1917

60. Morphinomane*

From *L'Album d'estampes originales de la Galerie Vollard,* 1897

Lithograph in black, yellow, blue-green, and brown. 47 x 35.5 cm. (image), 56.7 x 42.5 cm. (sheet)

100 numbered impressions on wove paper. Signed "E. Grasset" lower margin. Printed by Auguste Clot

Ref.: *L'Estampe et l'affiche,* 1898, vol. 2, p. 19; Mellerio, *La Lithographie originale,* p. 17; Blum, no. 59; Gheerbrant, 1897

Coll.: Cracow

GUILLAUMIN, Jean-Baptiste-Armand
 French, 1841–1927

61. Les Rochers (La Falaise)

From *L'Album des peintres-graveurs,* 1896

Lithograph in blue, yellow, and brown (variations). 39.5 x 54 cm. (image), 42.7 x 57 cm. (sheet)

100 numbered impressions on wove paper; several unsigned proofs on china paper. Signed "Guillaumin" lower left of composition in pencil. Printed by Auguste Clot

Ref.: *L'Estampe et l'affiche,* 1898, vol. 2, p. 20; Gheerbrant, 1896; Blum, no. 62

Coll.: Cracow

62. Tête d'enfant

From *L'Album d'estampes originales de la Galerie Vollard,* 1897

Lithograph in blue, pink, olive-green, and yellow. 47 x 43.7 cm. (image), 56.4 x 43.7 cm. (sheet)

100 numbered impressions on heavy wove paper. Signed "Guillaumin" lower left of composition in pencil

Ref.: *L'Estampe et l'affiche,* 1898, vol. 2, p. 19; Keller, no. 77; Blum, no. 63

Colls.: BPL, Winterthur, Cracow

63. L'Enfant mangeant sa soupe. ca. 1920

Lithograph in blue, yellow, and red. 43 x 43 cm. (image)

100 impressions (approximately) on wove paper. Signed "Guillaumin" lower left margin in pencil. Printed by Auguste Clot

Ref.: Keller, no. 76

Colls.: Winterthur, Bibliothèque Nationale

HERMANN-PAUL
(Paul-Herman-Henri Héran)
 French, born in Germany, 1864–1940

64. Les Petites Machines à écrire

From *L'Album des peintres-graveurs,* 1896

Lithograph in green, blue-green, orange, and beige. 30.4 x 22.1 cm. (image), 57 x 42 cm. (sheet)

100 numbered impressions on wove paper. Signed "Hermann-Paul" lower left margin in pencil. Printed by Auguste Clot

Ref.: *L'Estampe et l'affiche,* 1898, vol. 2, p. 20; Blum, no. 67; Gheerbrant, 1896

Coll.: Cracow

LAPRADE, Pierre French, 1875–1931

65. Le Singe au bord de la fenêtre. 1923

Etching. Size not available.

Edition not noted

Ref.: Roger-Marx, "Catalogue sommaire de l'oeuvre gravé de Laprade" in *La Renaissance,* 1932, vol. 15, no. 3, p. 68. Print not located

66. Naples. 1932

Etching. Size not available

Edition not noted

Ref.: Roger-Marx, "Catalogue sommaire de l'oeuvre gravé de Laprade" in *La Renaissance,* 1932, vol. 15, no. 3, p. 68. Print not located

LEHEUTRE, Gustave French, 1861–1932

67. Le Duo (Jeunes Filles au piano)

From *L'Album des peintres-graveurs,* 1896

Drypoint in red, blue, and black. 25.4 x 42.3 cm. (plate), 39.7 x 52.7 cm. (sheet)

109 impressions on laid paper; plate effaced after printing. Signed "G. Leheutre" lower right margin in pencil. Printed by Auguste Clot

Ref.: Delteil, vol. 12, no. 41, sixth state; Blum, no. 86; Gheerbrant, 1896

Coll.: Cracow

68. Femme au repos (Le Repos). 1896

Lithograph in green, rose, bister, and ocher. 30.5 x 41.5 cm. (image), 37.5 x 49.5 cm. (sheet)

25 impressions on japan paper; some proofs printed in violet, black, and other colors not in the edition. Signed "Leheutre '96" lower left margin

Ref.: Delteil, vol. 12, no. 134; Keller, no. 79

Coll.: Winterthur

69. La Danseuse

From *L'Album d'estampes originales de la Galerie Vollard,* 1897

Lithograph in purple, green, yellow, blue, pink, and brown. 41 x 36 cm. (image), 56.5 x 43 cm. (sheet)

100 numbered impressions on china paper laid down on heavy wove; stones effaced after printing. Signed "G. Leheutre" lower right margin in pencil. Printed by Auguste Clot

Ref.: Delteil, vol. 12, no. 136, second state; Blum, no. 87; Gheerbrant, 1897

Coll.: Cracow

70. Danseuse à la barre. n.d.

Etching printed in two colors. 22 x 14 cm. (plate)

25 impressions on japan paper; several trial proofs. Signed "G. Leheutre" in plate only

Ref.: Delteil, vol. 12, no. 31, third state: Keller, no. 80

Coll.: Winterthur

LEWISOHN, Raphael French, 1863–1923

71. La Danse en Bretagne

From *L'Album d'estampes originales de la Galerie Vollard,* 1897

Lithograph in red, pink, yellow, and blue. 39 x 55 cm. (image), 43 x 57 cm. (sheet)

100 numbered impressions on loose china paper. Signed "Raphael Lewisohn" lower left margin in pencil. Printed by Auguste Clot

Ref.: *L'Estampe et l'affiche,* 1898, vol. 2, p. 19; Gheerbrant, 1897; Blum, no. 91

Coll.: Cracow

LUNOIS, Alexandre French, 1863–1916

72. Femme espagnole remettant son soulier (Danseuse espagnole)

From *L'Album des peintres-graveurs,* 1896

Lithograph in yellow, red, blue, and brown. 50.4 x 39 cm. (image), 54 x 43 cm. (sheet)

100 numbered impressions on heavy wove paper. Signed "Alexandre Lunois" lower right margin in pencil; a few impressions are not signed. Printed by Auguste Clot

Ref.: André, p. 221; Blum, no. 93; Gheerbrant, 1896

Colls.: MFA, Cracow

73. Départ pour la chasse

from *L'Album d'estampes originales de la Galerie Vollard,* 1897

Lithograph in colors. 29 x 43 cm. (image), 41 x 53 cm. sheet)

100 numbered impressions on wove paper; several trial proofs. Signed "Alex. Lunois" lower right margin in pencil. Printed by Auguste Clot

Ref.: André, p. 228; Blum, no. 94; Gheerbrant, 1897

Coll.: Cracow

74. Lawn Tennis

For unpublished *L'Album d'estampes originales de la Galerie Vollard,* 1898–

Lithograph in color. 37.9 x 50 cm. (image), 45 x 60.7 cm. (sheet)

100 impressions on wove paper; several trial proofs. Signed "Alex. Lunois" lower left margin in pencil. Printed by Auguste Clot

Ref.: André, p. 203; Gheerbrant, 1898

Coll.: BPL

75. La Procession de la Fête-Dieu

For unpublished *L'Album d'estampes originales de la Galerie Vollard,* 1898–

Lithograph in color. 49.5 x 36.5 cm. (image)

100 impressions on japan paper; several trial proofs. Signed "Alex. Lunois" lower margin in pencil. Printed by Auguste Clot

Ref.: André, p. 203; Klover, no. 726

76. Le Colin-Maillard.* n.d.

Lithograph in yellow, light green, and dark green 38 x 50.3 cm. (image), 46.4 x 56 cm. (sheet)

40 impressions on japan paper; several trial proofs; stones effaced after printing. Signed "Alex. Lunois" lower margin in pencil. Printed by Auguste Clot

Ref.: André, p. 228

Coll.: MMA

MAILLOL, Aristide French, 1861–1944

77. Femme agenouillée, un genou relevé (Eve). ca. 1926

Etching. 38 x 30.9 cm. (plate)

100 numbered impressions in second state on wove paper. Signed with monogram "M" in plate only; 2 or 3 proofs in first state with remarques in drypoint in upper center of composition; second state without remarques; plate exists. Printed by Louis Fort

Ref.: Guérin, *Maillol*, vol. 2, no. 330

Note: Major part of the edition issued by an anonymous Paris dealer.

MARTIN, Henri French, 1860–1943

78. Tête de femme

From *L'Album d'estampes originales de la Galerie Vollard,* 1897

Lithograph in blue, yellow, and light blue. 49 x 42 cm. (image), 56.5 x 42.3 cm. (sheet)

100 numbered impressions on loose china paper. Signed "Henri Martin" lower margin in crayon. Printed by Auguste Clot

Ref.: *L'Estampe et l'affiche,* 1898, vol. 2, p. 19; Blum, no. 97; Gheerbrant, 1897

Coll.: Cracow

MARVAL, Jacqueline-Marie French, 1866–1932

79. Nu couché. n.d.

Etching. 29 x 32.5 cm. (plate), 45.5 x 58 cm. (sheet)

Edition not noted; impressions on heavy wove paper. Not signed

Ref.: Keller, no. 85

Coll.: Winterthur

Note: Possibly for Vollard's unpublished album of nudes.

MATISSE, Henri French, 1869–1954

80. Femme nue au collier (Odalisque).* 1926–29

Etching. 19.8 x 29.8 cm. (plate), 45 x 57.6 cm. (sheet)

Edition not noted; an unknown number of proofs on Arches wove paper. Signed "Matisse" in plate only

Ref.: Cramer, cat. 7, no. 79, illus.; Keller, no. 86

Colls.: MoMA, Winterthur

MAURIN, Charles French, 1856–1914

81. Etude de femme nue

From *L'Album des peintres-graveurs,* 1896

Etching in green, yellow, violet, and gray-brown. 35 x 31 cm. (plate), 57 x 27.7 cm. (sheet)

100 numbered impressions on wove paper. Signed "Maurin" lower margin in pencil. Printed by Auguste Clot

Ref.: Rouchon, p. 97; Gheerbrant, 1896; Blum, no. 99

Coll.: Cracow

82. Eve

From *L'Album d'estampes originales de la Galerie Vollard,* 1897

Etching in blue and green. 22 x 18 cm. (plate), 32.7 x 25.1 cm. (sheet)

100 numbered impressions on wove paper. Signed "Maurin" lower margin in pencil. Printed by Auguste Clot

Ref.: Rouchon, p. 95; Gheerbrant, 1897; Blum, no. 100

Coll.: Cracow

Note: Vollard exhibited the work of Charles Maurin in September 1895.

MORISOT, Berthe French, 1840–1895

83. [Series of drypoints.] ca. 1888–90

Copper plates acquired by Vollard ca. 1900
Approximately 12 drypoints. 33 x 25 cm. (mount)

Edition not noted but probably small; printed on fine wove paper; no wrapper; a few rare, early artist's proofs exist. Printer not known

Ref.: Roger-Marx, *Graphic Art of the 19th Century,* p. 167; Bataille and Wildenstein, p. 5; Harriman Douglas collection, Parke Bernet auct. cat. 1286, no. 102, Nov. 20, 1951 (8 drypoints); Monod, *Le Prix des estampes,* vol. 5, p. 117

Colls.: BPL (7 prints), NGA (8 prints), several private colls.

Titles of individual prints:

1 *La Jeune Fille au chat.* Keller, no. 88. 15 x 12 cm.
2 *Berthe Morisot et Julie Manet* (Self-portrait with Daughter). Roger-Marx, p. 167. 18.2 x 14 cm.
3 *Portrait de Julie Manet.* 12 x 8.3 cm.
4 *Ducks and water plants.* 14 x 10 cm.
5 *Seated nude, rear view.* 14 x 10 cm.
6 *Duck, swan and head in profile.* 12 x 14.5 cm.
7 *Jardin de Mézy* (Bord du lac). 16 x 12 cm.
8 *Les Canards.* 15 x 12 cm.
9 *Bateau sur l'étang* (Le Bassin du Mesnil). 17.5 x 13 cm.
10 *L'Enfant, cygne et canard.* Keller, no. 89. 18.2 x 11.8 cm.
11 *Dessin.* Keller, no. 90. 18.2 x 13 cm.
12 *Jeune Fille au repose* (right hand to head). Keller, no. 91. 18 x 10 cm.

Note: Although authorities credit Berthe Morisot with a graphic oeuvre of only 8 prints, it would seem that Vollard held approximately 12 plates. Because of the

lightness of the images on several of the plates he may have decided to print but 8 or 9 of the plates. The Vollard archives at Winterthur contain 3 previously unlisted titles whose images are extremely light (Keller, nos. 88–91). The Vollard impressions reveal a slight puncturing of the plates a few mm. within the top and bottom center of the plate mark.

MUNCH, Edvard　　　　　Norwegian, 1863–1944

84. Le Soir (Angstgefühl or Anxiety)*

From *L'Album des peintres-graveurs,* 1896

Lithograph in black and red with variations in the black. 41.3 x 38.7 cm. (image), 57 x 43.3 cm. (sheet)

100 numbered impressions on wove paper. Signed "Edvard Munch" lower right margin in pencil. Printed by Auguste Clot

Ref.: Schiefler, no. 61–IIb; Timm, no. 29; Blum, no. 103; Gheerbrant, 1896; *L'Estampe et l'affiche,* 1898, vol. 2, p. 20

Colls.: AIC, MoMA

Note: Listed in *L'Estampe et l'affiche,* 1898, vol. 2, p. 20 as a woodcut.

PICASSO, Pablo

　　　　　Spanish, 1881–1973. Lived in France

85. Saltimbanques*

Series of 14 etchings and drypoints, without cover, issued by Ambroise Vollard in 1913. 66 x 51 cm. (sheet)

250 impressions on Van Gelder wove paper; 27 or 29 impressions on antique japan paper. Not signed nor numbered. Printed by Louis Fort from steel-faced plates; plates canceled after the edition

Ref.: Geiser, nos. 2–7, 9–12, 14, 15, 17, 18 in b states; Bloch, nos. 1–4, 6–10, 12–15; Gheerbrant, 1913

Colls.: Achenbach, AIC (complete), Brooklyn (no. 1), BPL (nos. 1, 3, 13), Fogg (no. 1), Grunwald (selected titles), MoMA (complete), MMA (selected titles), NGA (selected titles), NYPL (nos. 1, 2, 8)

Titles of individual prints:

1 *Le Repas frugal.* 1904. Etching. G. no. 2b, second state, B. no. 1. 46.3 x 37.7 cm.
2 *Tête de femme.* 1905. Etching. G. no. 3b, B. no. 2. 12.1 x 9 cm.
3 *Les Pauvres.* 1905. Etching. G. no. 4b, second state, B. no. 3. 23.6 x 18 cm.
4 *Buste d'homme.* 1905. Drypoint. G. no. 5b, B. no. 4. 12 x 9.3 cm.
5 *Les Deux Saltimbanques.* 1905. Drypoint. G. no. 6a, B. no. 5. 12.2 x 9.1 cm.
6 *Tête de femme, de profil.* 1905. Drypoint. G. no. 7b, B. no. 6. 29.2 x 25 cm.

7 *Les Saltimbanques.* 1905. Drypoint. G. no. 9b, B. no. 7. 28.8 x 32.6 cm.
8 *L'Abreuvoir.* 1905. Drypoint. G. no. 10b, B. no. 8. 12.2 x 18.8 cm.
9 *Au cirque.* 1905. Drypoint. G. no. 11b, B. no. 9. 22 x 14 cm.
10 *Le Saltimbanque au repos.* 1905. Drypoint. G. no. 12b, B. no. 10. 12 x 8.7 cm.
11 *Le Bain.* 1905. Drypoint. G. no. 14b, B. no. 12. 34.4 x 28.9 cm.
12 *La Toilette de la mère.* 1905. Etching. G. no. 15b, B. no. 13. 23.5 x 17.6 cm.
13 *Salomé.* 1905. Drypoint. G. no. 17b, B. no. 14. 40 x 34.8 cm.
14 *La Danse.* 1905. Drypoint. G. no. 18b, B. no. 15. 18.5 x 23.2 cm.

Note: *La Famille de saltimbanques au macaque,* a drypoint, was to have been included in this series but oxidation of the plate caused Vollard to destroy the impressions printed from this plate. G. no. 13b, B. no. 11.

86. L'Homme au chien. 1914

Etching. 27.8 x 21.8 cm. (plate), 32.8 x 25.1 cm. (sheet)

In excess of 102 impressions on wove issued by Vollard; some proofs on Arches wove; plate exists. Not signed. Printed by Louis Fort in 1930

Ref.: Geiser, no. 39, third state of three; Bloch, no. 28, third state

Colls.: AIC, MoMA

Note: Reverse side of plate has etching *Nature morte, trousseau de clefs* (Geiser, no. 30)

87. Taureau attaquant un cheval. 1921

Etching on zinc. 17.8 x 23.8 cm. (plate), 25.2 x 33.5 cm. (sheet)

In excess of 101 impressions on wove issued by Vollard; two known proofs on Arches wove; printed by Louis Fort in 1930; plate exists. Not signed

Ref.: Geiser, no. 60; Bloch, no. 44

Coll.: Achenbach

88. Les Trois Femmes. 1922

Etching on zinc. 17.5 x 13 cm. (plate), 45.9 x 28.5 cm. (sheet)

In excess of 103 impressions on wove paper; several proofs on Arches wove paper. Printed by Louis Fort

Ref.: Geiser, no. 68, third state; Bloch, no. 51

Colls.: Grunwald, NGA

89. Les Trois Baigneuses, no. 1. 1922–23

Drypoint on zinc. 17.5 x 130 cm. (plate)

In excess of 102 impressions on Arches wove paper; several proofs including 1 on Whatman paper; plate exists. Signed "Picasso" lower left margin in red pencil; some impressions not signed. Printed by Louis Fort

Ref.: Geiser, no. 106; Bloch, no. 60

Coll.: GKF

90. L'Atelier. 1927

Etching. 35.1 x 39.1 cm. (plate), 45.2 x 57.7 cm. (sheet)

150 numbered impressions on Arches wove and antique japan papers. Signed "Picasso" lower left margin in brown ink; a few proofs unsigned. Printed by Louis Fort from steel-faced plates in 1930

Ref.: Geiser, no. 121b; Bloch, no. 80

Colls.: AIC, Grunwald, MMA, MoMA, NGA

91. Homme et femme. 1927

Etching. 19.2 x 28 cm. (plate), 45.5 x 58 cm. (sheet)

250 numbered impressions on Arches wove. Signed "Picasso" lower right margin. Printed by Louis Fort from steel-faced plate; plate canceled by publisher

Ref.: Geiser, no. 118b; Bloch, no. 77

Colls.: MoMA, Winterthur

92. Les Trois Amies. 1927

Etching. 41.6 x 29.8 cm. (plate), 64.5 x 46.5 cm. (sheet)

150 numbered impressions: nos. 1–75 on antique japan; nos. 76–150 on Arches wove. Signed "Picasso" lower center margin in red ink. Printed by Louis Fort

Ref.: Geiser, no. 117b; Bloch, no. 76

Colls.: AIC, Grunwald, MMA, MoMA

93. Cheval mourant entouré d'une famille de saltimbanques. 1931

Etching. 22.2 x 30.8 cm. (plate), 25.2 x 33.5 cm. (sheet)

In excess of 103 impressions on Arches wove; 2 proofs in first state. Not signed. Printed by Louis Fort

Ref.: Geiser, no. 206, second state; Bloch, no. 235

Coll.: Achenbach

Note: Printed after 1933.

94. Eaux-Fortes originales pour Le Chef-d'oeuvre inconnu d'Honoré de Balzac

Ambroise Vollard, éditeur. 28 rue de Martignac, Paris, 1931

Album of 13 etchings. 50.5 x 38 cm. (sheet)

99 suites of 13 etchings with remarques on Van Gelder wove; 8 suites marked A-H hors commerce. Signed "Picasso" lower right margin. Printed by Louis Fort from steel-faced plates (except no. 13)

Ref.: Geiser, nos. 123b–135b; Bloch, no. 82–94. Horodisch, p. 107, f.n. 18; Gheerbrant, no. 23

Colls: AIC; MoMA

Titles of individual etchings:

1 *Sculpteur devant sa sculpture.* G. no. 123b, B. no. 82. 19.4 x 27.8 cm.
2 *Peintre entre deux modèles, à droite un chevalet.* G. 124b, B. 83. 19.3 x 27.9 cm.
3 *Taureau et cheval.* G. no. 125b, B. no. 84. 19.2 x 27.9 cm.
4 *Peintre et modèle tricotant.* G. no. 126b, B. no. 85. 19.4 x 28 cm.
5 *Sculpteur modèlant à droite deux de ses oeuvres.* G. no. 127b, B. no. 86. 19.3 x 27.8 cm.
6 *Peintre chauve devant son chevalet, à gauche un modèle en costume.* G. no. 128b, B. no. 87. 19.4 x 27.8 cm.
7 *Peintre ramassant son pinceau, à droite un modèle au torse nu.* G. no. 129b, B. no. 88. 19.4 x 28 cm.
8 *Peintre travaillant, observé par un modèle nu.* G. no. 130b, B. no. 89. 19.4 x 27.9 cm.
9 *Trois nus debout, à droite esquisses de têtes.* G. no. 131b, B. no. 90. 19.4 x 27.6 cm.
10 *Nu assis entouré d'esquisses de bêtes et d'hommes.* G. no. 132b, B. no. 91. 19.4 x 27.8 cm.
11 *Peintre devant son tableau.* G. no. 133b, B. no. 92. 27.8 x 19.4 cm.
12 *Peintre devant son chevalet, à droite modèle au torse nu.* G. no. 134b, B. no. 93. 19.5 x 27.7 cm.
13 *Table des eaux-fortes.* G. no. 135b, first state for portfolio; B. no. 94 (reduced for book). 37.5 x 29.8 cm.

Note: The title page, printed on tinted paper (Arches Ingres), carries a vignette that differs from the one appearing on the title page of the book. Most of the trial proofs that carry the *bon à tirer* of the artist, were printed at Vollard's shop before the ground had been removed from the plates. Plates nos. 1–12 completed by Picasso in 1927. Plate no. 13 has 4 large nude figures in remarques.

95. Suite Vollard*

Suite de 100 eaux-fortes originales. 1930–37.[Ambroise Vollard, 28 rue de Martignac, Paris, 1937.] Unpublished by Vollard

100 etchings and aquatints. No cover or title page. 44.4 x 34 cm. (sheet, slight variants)

298 (303) suites: 3 suites on wove and signed in red or black crayon by Picasso; 50 suites on Montval (76 x 50 cm. sheet) with watermark "Papeterie Montgolfier à Montval"; 245 (250) suites on Montval with watermark "Vollard" or "Picasso" (44.5 x 33.8 cm. sheet). Most of the Vollard portraits were signed by the

artist in red crayon with a few signed in black crayon.
Printed by Roger Lacourière

Ref.: Bloch, nos. 134–233; Lieberman, *The Sculptor's Studio;* Fox, ed., *Picasso for Vollard;* Rauch, no. 58; Bolliger, *Suite Vollard;* Reidemeister, *Pablo Picasso, Suite Vollard;* Los Angeles County Museum, nos. 75–174
Colls.: AIC (selected titles), Dartmouth, Fogg, MFA, MoMA (selected titles), NGA, PMA (selected titles)
Titles of individual prints: (listed chronologically)

1 *Femme nue couronnée de fleurs.* 13 septembre 1930. Etching. B. no. 134, G. no. 192 (SV 1). 31.4 x 22.3 cm.
2 *Femme nue se couronnant de fleurs.* 16 septembre 1930. Etching. B. no. 135, G. no. 195 (SV 2). 31.1 x 22.3 cm.
3 *Au Bain.* 17 octobre 1930. Etching. B. no. 136, G. no. 201 (SV 3). 31.3 x 22.3 cm.
4 *Femme nue assise devant un rideau.* 3 avril 1931. Etching. B. no. 137, G. no. 202 (SV 4). 30.8 x 22.4 cm.
5 *Homme dévoilant une femme.* 20 juin 1931. Drypoint. B. no. 138, G. no. 203, second state (SV 5). 36.6 x 29.8 cm.
6 *Femme nue devant une statue.* 4 juillet 1931. Etching. B. no. 139, G. no. 205 (SV 6). 31.2 x 22.1 cm.
7 *Deux sculpteurs devant une statue.* 9 juillet 1931. Etching. B. no. 140, G. no. 207 (SV 7). 22.2 x 31.3 cm.
8 *Femme nue à la jambe pliée.* 9 juillet 1931. Etching. B. no. 141, G. no. 208 (SV 8). 31.2 x 22.1 cm.
9 *Le Viol.* 9 juillet 1931. Etching. B. no. 142, G. no. 209 (SV 9). 22.1 x 31.2 cm.
10 *Femmes se reposant.* 19 septembre 1931. Drypoint. B. no. 143, G. no. 210 (SV 10). 30 x 36.5 cm.
11 *Flûtiste et trois femmes nues.* 21 juillet 1932. Drypoint. B. no. 144, G. no. 258, second state (SV 11). 29.8 x 36.8 cm.
12 *Trois Acteurs.* 14 mars 1933. Drypoint. B. no. 145. G. no. 296, third state (SV 77). 27.5 x 18.4 cm.
13 *Sculpteur, modèle et sculpture assise.* 15 mars 1933. Drypoint. B. no. 146, G. no. 297, seventh state (SV 40). 31.6 x 18.5 cm.
14 *Sculpteur, modèle couché et sculpture.* 17 mars 1933. Etching. B. no. 147, G. no. 298, third state (SV 37). 26.7 x 19.3 cm.
15 *Sculpteur, modèle et buste sculpté.* 17 mars 1933. Etching. B. no. 148, G. no. 300, second state (SV 38). 26.7 x 19.4 cm.
16 *Sculpteurs, modèles et sculpture.* 20 mars 1933. Etching. B. no. 149, G. no. 301, second state (SV 41). 19.4 x 26.7 cm.
17 *Deux Modèles vêtus.* 21 mars 1933. Etching. B. no. 150, G. no. 302, second state (SV 12). 26.7 x 19.3 cm.
18 *Modèle accoudé sur un tableau.* 21 mars 1933. Etching. B. no. 151, G. no. 303, second state (SV 43). 26.8 x 19.4 cm.
19 *Sculpteur avec coupe et modèle accroupi.* 21 mars 1933. Etching. B. no. 152, G. no. 304, third state (SV 44). 26.7 x 19.4 cm.
20 *Vieux Sculpteur au travail.* 23 mars 1933. Etching. B. no. 153, G. no. 305, second state (SV 47). 26.7 x 19.3 cm.
21 *Sculpteur et modèle admirant une tête sculptée.* 23 mars 1933. Etching. B. no. 154, G. no. 307, second state (SV 45). 26.7 x 19.4 cm.
22 *Sculpteur, modèle accroupi et tête sculptée.* 23 mars 1933. Etching. B. no. 155, G. no. 308, third state (SV 39). 26.9 x 19.4 cm.
23 *Jeune Sculpteur au travail.* 25 mars 1933. Etching. B. no. 156, G. no. 309, second state (SV 46). 26.7 x 19.4 cm.
24 *Sculpteur et deux têtes sculptées.* 26 mars 1933. Etching. B. no. 157, G. no. 310, second state (SV 48). 26.7 x 19.4 cm.
25 *Sculpteur à mi-corps au travail.* 26 mars 1933. Etching. B. no. 158, G. no. 311, second state (SV 49). 26.7 x 19.4 cm.
26 *Le Repos du sculpteur et le modèle au masque.* 27 mars 1933. Etching. B. no. 159, G. no. 312, second state (SV 50). 26.7 x 19.4 cm.
27 *Le Repos du sculpteur devant un nu à la draperie.* 27 mars 1933. Etching. B. no. 160, G. no. 313, second state (SV 51). 26.7 x 19.3 cm.
28 *Deux Hommes sculptés.* 27 mars 1933. Etching. B. no. 161, G. no. 314, second state (SV 52). 26.9 x 19.4 cm.
29 *Le Repos du sculpteur devant le petit torse.* 30 mars 1933. Etching. B. no. 162, G. no. 315, second state (SV 53). 19.4 x 26.7 cm.
30 *Famille de saltimbanques.* 30 mars 1933. Etching. B. no. 163, G. no. 316, second state (SV 54). 19.4 x 26.7 cm.
31 *Le Repos du sculpteur devant le jeune cavalier.* 30 mars 1933. Etching. B. no. 164, G. no. 317, second state (SV 55). 19.3 x 26.8 cm.
32 *Le Repos du sculpteur devant une bacchanale au taureau.* 30 mars 1933. Etching. B. no. 165, G. no. 318, second state (SV 56). 19.6 x 26.7 cm.
33 *Le Repos du sculpteur devant des chevaux et un taureau.* 31 mars 1933. Etching. B. no. 166, G. no. 319, second state (SV 57). 19.4 x 26.7 cm.
34 *Le Repos du sculpteur devant un centaure et une femme.* 31 mars 1933. Etching. B. no. 167, G. no. 320, second state (SV 58). 19.4 x 26.8 cm.
35 *Sculpteur et son modèle devant une fenêtre.* 31 mars 1933. Etching. B. no. 168, G. no. 321, third state (SV 59). 19.3 x 26.7 cm.
36 *Le Repos de sculpteur et la sculpture surréaliste.* 31 mars 1933. Etching. B. no. 169, G. no. 322, second state (SV 60). 19.3 x 26.7 cm.
37 *Modèle et grande tête sculptée.* 1 avril 1933. Etching. B. no. 170, G. no. 323, second state (SV 61). 26.7 x 19.3 cm.

38 *Le Repos du sculpteur, I.* 3 avril 1933. Etching. B. no. 171, G. no. 324, second state (SV 62). 19.3 x 26.7 cm.

39 *Le Repos du sculpteur, II.* 3 avril 1933. Etching. B. no. 172, G. no. 325, second state (SV 63). 19.3 x 26.7 cm.

40 *Le Repos du sculpteur, III.* 3 avril 1933. Etching. B. no. 173, G. no. 326, second state (SV 64). 19.3 x 26.7 cm.

41 *Repos du sculpteur, IV.* 4 avril 1933. Etching. B. no. 174, G. no. 327, second state (SV 65). 19.3 x 26.7 cm.

42 *Modèle contemplant un groupe sculpté.* 5 avril 1933. Etching. B. no. 175, G. no. 328, second state (SV 66). 29.7 x 36.7 cm.

43 *Trois Femmes nues près d'une fenêtre.* 6 avril 1933. Etching. B. no. 176, G. no. 329, second state (SV 67). 36.7 x 29.8 cm.

44 *Sculpteur et modèle debout.* 7 avril 1933. Etching. B. no. 177, G. no. 330, second state (SV 68). 36.8 x 29.7 cm.

45 *Sculpteur et modèle agenouillé.* 8 avril 1933. Etching. B. no. 178, G. no. 331, second state (SV 69). 36.7 x 29.8 cm.

46 *Sculpteur d'un jeune homme à la coupe.* 11 avril 1933. Etching. B. no. 179, G. no. 332, second state (SV 70). 36.7 x 29.8 cm.

47 *Le Viol, II.* 22 avril 1933. Drypoint. B. no. 180, G. no. 338, second state (SV 30). 29.7 x 36.6 cm.

48 *Le Viol, IV.* 22 avril 1933. Etching, drypoint, aquatint. B. no. 181, G. no. 340, third state (SV 29). 19.9 x 27.7 cm.

49 *Le Viol, V.* 23 avril 1933. Drypoint. B. no. 182, G. no. 341, second state (SV 31). 29.7 x 36.7 cm.

50 *Le Viol sous la fenêtre.* Avril 1933. Etching, drypoint, aquatint. B. no. 183, G. no. 342, fifteenth state (SV 28). 27.8 x 19.8 cm.

51 *Femme accoudée sculpture de dos et tête barbue.* 3 mai 1933. Etching. B. no. 184, G. no. 343, second state (SV 71). 37.7 x 29.4 cm.

52 *Modèle nu et sculptures.* 3 mai 1933. Etching. B. no. 185, G. no. 344, second state (SV 72). 37.8 x 29.7 cm.

53 *Modèle et grande sculpture de dos.* 4 mai 1933. Etching. B. no. 186, G. no. 345, fifth state (SV 73). 26.8 x 19.2 cm.

54 *Modèle et sculpture surréaliste.* 4 mai 1933. Etching. B. no. 187, G. no. 346, second state (SV 74). 26.8 x 19.3 cm.

55 *Modèle accroupi, sculpture de dos et tête barbue.* 5 mai 1933. Etching. B. no. 188, G. no. 347, second state (SV 75). 26.7 x 19.3 cm.

56 *Sculptures et vase de fleurs.* 5 mai 1933. Etching, aquatint. B. no. 189, G. no. 348, fourth state (SV 76). 26.7 x 19.3 cm.

57 *Minotaure, une coupe à la main, et jeune femme.* 17 mai 1933. Etching. B. no. 190, G. no. 349, second state (SV 83). 19.4 x 26.8 cm.

58 *Minotaure caressant une femme.* 18 mai 1933. Etching. B. no. 191, G. no. 350, second state (SV 84). 29.8 x 36.8 cm.

59 *Scène bachique au minotaure.* 18 mai 1933. Etching. B. no. 192, G. no. 351, fourth state (SV 85). 29.7 x 36.6 cm.

60 *Minotaure endormi contemplé par une femme.* 18 mai 1933. Etching. B. no. 193, G. no. 352, fifth state (SV 86). 19.4 x 26.8 cm.

61 *Les Baigneuses surprises.* 22 mai 1933. Etching, drypoint. B. no. 194, G. no. 355, third state (SV 14). 19.4 x 26.8 cm.

62 *Minotaure attaquant une Amazone.* 23 mai 1933. Etching. B. no. 195, G. no. 356, fourth state (SV 87). 19.4 x 26.8 cm.

63 *Minotaure blessé, VI.* 26 mai 1933. Etching. B. no. 196, G. no. 363, second state (SV 88). 19.2 x 26.7 cm.

64 *Minotaure vaincu.* 29 mai 1933. Etching. B. no. 197, G. no. 365, second state (SV 89). 19.3 x 26.9 cm.

65 *Minotaure mourant.* 30 mai 1933. Etching. B. no. 198, G. no. 366, second state (SV 90). 19.6 x 26.8 cm.

66 *Minotaure et femme derrière un rideau.* 16 juin 1933. Etching. B. no. 199, G. no. 367, second state (SV 91). 19.3 x 26.7 cm.

67 *Minotaure, buveur et femmes.* 18 juin 1933. Etching. B. no. 200, G. no. 368, fourth state (SV 92). 29.8 x 36.5 cm.

68 *Minotaure caressant une dormeuse.* 18 juin 1933. Drypoint. B. no. 201, G. no. 369, third state (SV 93). 30 x 37 cm.

69 *Le Viol, VII.* 2 novembre 1933. Drypoint, aquatint. B. no. 202, G. no. 378, tenth state (SV 32). 19.8 x 27.8 cm.

70 *Taureau et chevaux dans l'arène.* 7 novembre 1933. Etching. B. no. 203, G. no. 380, second state (SV 15). 19.4 x 26.9 cm.

71 *Morte au soleil, IV.* 8 novembre 1933. Drypoint. B. no. 204, G. no. 384, fifth state (SV 16). 20 x 28 cm.

72 *Le Cirque.* 11 novembre 1933. Drypoint. B. no. 205, G. no. 385, eighth state (SV 17). 19.6 x 27.7 cm.

73 *Femme assise et femme de dos.* 27 janvier 1934. Etching. B. no. 206, G. no. 404, second state (SV 78). 27.8 x 19.8 cm.

74 *Rembrandt et têtes de femmes.* 27 janvier 1934. Etching. B. no. 207, G. no. 405, second state (SV 33). 13.9 x 20.8 cm.

75 *Rembrandt à la palette.* 27 janvier 1934. Etching. B. no. 208, G. no. 406, third state (SV 34). 27.8 x 19.8 cm.

76 *Deux modèles se regardant.* 29 janvier 1934. Etching. B. no. 209, G. no. 409, second state (SV 80). 27.8 x 19.7 cm.

77 *Femme assise au chapeau et femme debout drapée.* 29

janvier 1934. Etching. B. no. 210, G. no. 408, second state (SV 79). 27.8 x 19.8 cm.

78 *Têtes et figures emmêlées.* 30 janvier 1934. Etching. B. no. 211, G. no. 410, second state (SV 18). 27.8 x 19.7 cm.

79 *Jeune couple accroupi, l'homme avec un tambourin.* 30 janvier 1934. Etching. B. no. 212, G. no. 411, second state (SV 19). 27.8 x 19.8 cm.

80 *Flûtiste et jeune fille au tambourin.* 30 janvier 1934. Etching. B. no. 213, G. no. 412, second state (SV 20). 27.8 x 19.8 cm.

81 *Rembrandt et femme au viole.* 31 janvier 1933. Etching. B. no. 214, G. no. 413, second state (SV 36). 27.8 x 19.8 cm.

82 *Rembrandt et deux femmes.* 31 janvier 1934. Etching. B. no. 215, G. no. 414, second state (SV 35). 27.7 x 19.7 cm.

83 *Femme nue assise et trois têtes barbues.* Janvier 1934. Etching, burin, aquatint. B. no. 216, G. no. 416, seventh state (SV 25). 13 x 17.9 cm.

84 *Sculpteur et trois danseuses sculptées.* 2 mars 1934. Etching. B. no. 217, G. no. 421, second state (SV 81). 22.3 x 31.3 cm.

85 *Femme nue assise, la tête appuyée sur la main.* 9 mars 1934. Engraving. B. no. 218, G. no. 423, second state (SV 21). 27.8 x 19.8 cm.

86 *Quatre Femmes nues et tête sculptée.* 10 mars 1934. Etching, engraving. B. no. 219, G. no. 424, fifth state (SV 82). 22.3 x 31.6 cm.

87 *Femme torero, II.* 20 juin 1934. Etching. B. no. 220, G. no. 426, second state (SV 22). 29.7 x 23.6 cm.

88 *Femme torero, III.* 22 juin 1934. Etching. B. no. 221, G. no. 427, second state (SV 23). 24 x 30 cm.

89 *Minotaure aveugle guidé par une fillette, I.* 22 septembre 1934. Etching, engraving. B. no. 222, G. no. 434, thirteenth state (SV 94). 25.2 x 34.8 cm.

90 *Minotaure aveugle guidé par une fillette, II.* 23 octobre 1934. Etching. B. no. 223, G. no. 435, second state (SV 96). 23.9 x 30 cm.

91 *Minotaure aveugle guidé par une fillette, III.* 4 novembre 1934. Etching, engraving. B. no. 224, G. no. 436, fifth state (SV 95). 22.6 x 31.2 cm.

92 *Minotaure aveugle guidé par une fillette dans la nuit.* Novembre 1934. Aquatint. B. no. 225, G. no. 437, fourth state (SV 97). 24.7 x 34.7 cm.

93 *Garçon et dormeuse à la chandelle.* 18 novembre 1934. Etching, aquatint. B. no. 226, G. no. 440, fourth state (SV 26). 23.7 x 30 cm.

94 *Personnages masqués et femme oiseau.* 19 novembre 1934. Etching, aquatint. B. no. 227, G. no. 441, second state (SV 24). 24.9 x 34.8 cm.

95 *Deux Buveurs catalans.* 29 novembre 1934. Etching. B. no. 228, G. no. 442, second state (SV 12). 23.7 x 29.9 cm.

96 *Taureau ailé contemplé par quatre enfants.* Decembre 1934. Etching. B. no. 229, G. no. 444, second state (SV 13). 23.8 x 29.8 cm.

97 *Faune dévoilant une femme.* 12 juin 1936. Aquatint. B. no. 230 (SV 27). 31.7 x 41.7 cm.

98 *Portrait de Vollard, II.* ca. 1937. Aquatint. B. no. 231 (SV 98). 34.8 x 24.7 cm.

99 *Portrait de Vollard, III.* ca. 1937. Aquatint. B. no. 232 (SV 99). 34.7 x 24.7 cm.

100 *Portrait de Vollard, IV.* ca. 1937. Etching. B. no. 233 (SV 100). 34.4 x 24.5 cm.

The categories or divisions within the Suite Vollard listed by Hans Bolliger and L. Reidemeister are: Introductory group of 27 prints; *Battle of Love,* 5 prints; *Rembrandt,* 4 prints; *The Sculptor's Studio,* 46 prints; *The Minotaure,* 11 prints; *The Blind Minotaure,* 4 prints; and three *Portrait(s) of Vollard.* William S. Leiberman notes 40 prints in *The Sculptor's Studio.*

Ten titles from the *Suite Vollard* were issued before Vollard's death in an edition of 15 on large sheets and signed in red crayon by Picasso. No cover or title page. Printed by Lacourière.

Titles of individual prints:

1 *Flûtiste et trois femmes nues.* 21 juillet 1932. Drypoint. B. no. 144; G. no. 258, second state (SV 11). 29.8 x 36.8 cm.

2 *Le Repos du sculpteur devant une bacchanale au taureau.* 30 mars 1933. Etching. B. no. 165; G. no. 318, second state (SV 56). 19.6 x 26.7 cm.

3 *Repos du sculpteur, IV.* 4 avril 1933. Etching. B. no. 174; G. no. 327, second state (SV 65). 19.3 x 26.7 cm.

4 *Modèle contemplant un groupe sculpté.* 5 avril 1933. Etching. B. no. 175; G. no. 328, second state (SV 66). 29.7 x 36.7 cm.

5 *Trois Femmes nues près fenêtre.* 6 avril 1933. Etching. B. no. 176; G. no. 329, second state (SV 67). 36.7 x 29.8 cm.

6 *Scène bachique au minotaure.* 18 mai 1933. Etching. B. no. 192, G. no. 351, fourth state (SV 85). 29.7 x 36.6 cm.

7 *Minotaure, buveur et femmes.* 18 juin 1933. Etching. B. no. 200, G. no. 368, fourth state (SV 92). 29.8 x 36.5 cm.

8 *Flûtiste et jeune fille au tambourin.* 30 janvier 1934. Etching. B. no. 213, G. no. 412, second state (SV 20). 27.8 x 19.8 cm.

9 *Femme torero, II.* 20 juin 1934. Etching. B. no. 220, G. no. 426, second state (SV 22). 29.7 x 23.6 cm.

10 *Femme torero, III.* 22 juin 1934. Etching. B. no. 221, G. no. 427, second state (SV 23). 24 x 30 cm.

Note: Picasso completed 97 of the plates during an extended period from September 1930 to June 1936; the 3 portraits of Vollard, added at a later date, were done in 1937. The title *Suite Vollard* has led to the erroneous assumption that the 100 etchings had been commissioned by him, as had been the procedure in most of his publi-

cations. However, Vollard acquired the 97 plates that included those for *The Sculptor's Studio* directly from the artist. They were selected by Picasso from his vast graphic oeuvre and presented to Vollard in exchange for several important paintings from Vollard's stock that Picasso wanted to acquire for his private collection. Along with his numerous unissued publications, this Suite remained in untidy stockpiles in Vollard's mysterious cellars. After Vollard's death and during World War II the well-known Paris print dealer Henri Petiet acquired the major part of the Suites from the Vollard estate. These did not include the 3 portraits of Vollard that were held by the art dealer Marcelle Lecomte. Petiet released most of his Suites to the market shortly after World War II. Bloch notes that a fourth portrait of Vollard exists in trial proofs only (Bloch, no. 1332). Individual titles from the *Suite Vollard* are in a number of public and private collections. The above listing follows that of Georges Bloch, *Pablo Picasso, Catalogue de l'oeuvre gravé et lithographié.*

PISSARRO, Lucien
English, born Paris, 1863–1944

96. Les Lavandières (Le Lavoir)

From *L'Album d'estampes originales de la Galerie Vollard*, 1897

Woodcut in green, rose, brown, and dark green. 23 x 11 cm. (image), 32 x 21.7 cm. (sheet)

100 numbered impressions on wove paper. Signed "L P 89" lower margin. Printed by Auguste Clot

Ref.: *L'Estampe et l'affiche*, 1898, vol. 2, p. 19; Blum, no. 107; Gheerbrant, 1897; Leicester Galleries, cat. 872, no. 44

Coll.: Cracow

Note: Two woodcuts by Lucien Pissarro, *Les Sarcleuses* and *Les Femmes faisant de l'herbe*, were exhibited at Vollard's gallery with his 1897 *L'Album d'estampes originales*, but no editions were issued by Vollard. Pissarro previously had issued them in his own 1893 album entitled *Les Travaux des champs.*

PITCAIRN-KNOWLES, James
Scottish, born Rotterdam, 1864–?, lived in Paris

97. Le Bain*

From *L'Album des peintres-graveurs*, 1896

Woodcut in blue, light brown, and yellow. 55.5 x 43 cm. (image), 57 x 43.5 cm. (sheet)

100 numbered impressions on gray laid paper. Signed "Pitcairn-Knowles" or "Knowles." Printed by Auguste Clot

Ref.: *L'Estampe et l'affiche*, 1898, vol. 2, p. 20; Gheerbrant, 1896; Blum, no. 84

Coll.: Cracow, NYPL

PUVIS DE CHAVANNES, Pierre
French, 1824–1898

98. Le Pauvre Pêcheur*

From *L'Album d'estampes originales de la Galerie Vollard*, 1897

Lithograph in mauve; some proofs in black. 41 x 52.5 cm. (image), 43.3 x 57 cm. (sheet)

100 numbered impressions on Arches laid paper with watermark "MBM." Signed "P. Puvis de Chavannes" on stone only. Printed by Auguste Clot

Ref.: *L'Estampe et l'affiche*, 1898, vol. 2, p. 19; Blum, no. 110; Gheerbrant, 1897

Colls.: Cleveland; MMA, MFA

PUY, Jean
French, 1876–1961

99. Scène orientale

Lithograph. 26.5 x 18.5 cm. (image)

No edition noted; an impression with pink-toned background on white wove paper. Not signed

Ref.: Keller, no. 97

Coll.: Winterthur

Note: The Vollard archives at Winterthur record a lithographic illustration for *Candide* (26 x 18 cm.). It is not known whether *Scène orientale* was an illustration for an undesignated *Candide* series.

REDON, Odilon
French, 1840–1916

100. Perversité. 1891

Etching and drypoint. 16 x 12.6 cm. (plate), 35.7 x 27.7 cm. (sheet)

30 impressions on japan paper; several trial proofs before drypoint shading. Not signed

Ref.: Mellerio, *Odilon Redon*, no. 20, illus.; Keller, no. 98; Art Institute of Chicago, *Odilon Redon*, exhib. cat. no. 20

Colls.: AIC, Winterthur

Note: Edition probably acquired by Vollard directly from artist.

101. Vieux Chevalier*

From *L'Album des peintres-graveurs*, 1896

Lithograph in black. 29.8 x 23.9 cm. (image), 41.5 x 33 cm. (sheet)

100 impressions on china paper laid down on heavy wove; several proofs before letters; stone effaced after the edition. Signed "Od. R." lower left of composition. Printed by Blanchard, Paris

Ref.: Mellerio, *Odilon Redon*, no. 158; Gheerbrant, 1896; Schab, cat. 52, no. 114

Colls.: Achenbach, AIC, BPL, Cincinnati, Cleveland, MFA, MMA, MoMA, NGA

102. Gustave Flaubert. Tentation de Saint-Antoine*

Troisième série. Texte de Gustave Flaubert. 24 dessins sur pierre, dont un frontispice par Odilon Redon. Ambroise Vollard, éditeur, Paris, 1896

Album of 24 lithographs in black. 44.5 x 33.5 cm. (sheet)

50 albums with 24 lithographs each on china paper laid down on heavy wove paper; frontispiece on japan paper; wrapper red toned with title printed in gold letters: "Tentation de Saint-Antoine, 1896." Initialed by artist inside wrapper. Printed by Auguste Clot and Blanchard

Ref.: Mellerio, *Odilon Redon*, nos. 134–157; Kornfeld & Klipstein, cat. 152, no. 165; Skira, no. 307; Gheerbrant, 1896; MoMA, *Odilon Redon / Gustave Moreau / Rodolphe Bresdin*, p. 96 and nos. 161–162, 164–165

Colls.: AIC (2 complete series, proofs before letters, nos. 2, 3, and 23 with retouching in india ink), MoMA, NGA

Titles of individual prints:

1 *Frontispice.* Printed by Clot. M. no. 134. 24 x 16.5 cm.

2 *Saint-Antoine: Au secours mon Dieu!* Printed by Blanchard. M. no. 135. 21.5 x 13 cm.

3 *Et partout ce sont des colonnes de basalte, . . . La lumière tombe des voûtes.* Printed by Clot. M. no. 136. 24.3 x 19 cm.

4 *Mes Baisers ont le goût d'un fruit qui se fondrait dans ton coeur! . . . Tu me dédaignes! Adieu!* Printed by Blanchard. M. no. 137. 20.3 x 16.6 cm.

5 *Des fleurs tombent, et la tête d'un python parait.* Printed by Blanchard. M. no. 138. 26 x 19.8 cm.

6 *Dans l'ombre des gens pleurent et prient entourés d'autres qui les exhortent . . .* Printed by Blanchard. M. no. 139. 26.5 x 21.6 cm.

7 *. . . Et il distingué une plaine aride et mamelonneuse.* Printed by Blanchard. M. no. 140. 24.8 x 19.5 cm.

8 *Elle tire de sa poitrine une éponge toute noire, la couvre de baisers.* Printed by Clot. M. no. 141. 19.3 x 15.3 cm.

9 *. . . Je me suis enfoncé dans la solitude. J'habitais l'arbre derrière moi.* Printed by Blanchard. M. no. 142. 30 x 22.5 cm.

10 *Hélène (Ennoia).* Printed by Blanchard. M. no. 143. 9.5 x 8.5 cm.

11 *Immédiatement surgissent trois déesses.* Printed by Blanchard. M. no. 144. 17 x 13.3 cm.

12 *L'Intelligence fût à moi! Je devins le Buddha.* Printed by Blanchard. M. no. 145. 32 x 22 cm.

13 *. . . Et que des yeux sans tête flottaient comme des mollusques.* Printed by Blanchard. M. no. 146. 31 x 22.4 cm.

14 *Oannès: Moi, la première conscience du chaos, j'ai surgi de l'abîme pour durcir la matière, pour régler les formes.* Printed by Blanchard. M. no. 147. 27.9 x 21.7 cm.

15 *Voici la bonne-déesse, l'idéenne des montagnes.* Printed by Clot. M. no. 148. 14.8 x 13 cm.

16 *Je suis toujours la grande Isis! Nul n'a encore soulevé mon voile! Mon fruit est le soleil!* Printed by Blanchard. M. no. 149. 28.2 x 20.4 cm.

17 *Il tombe dans l'abîme, la tête en bas.* Printed by Blanchard. M. no. 150. 27.8 x 21.2 cm.

18 *Antoine: Quel est le but de tout cela? Le diable: Il n'y a pas de but!* Printed by Blanchard and Clot. M. no. 151. 31.1 x 25 cm.

19 *La Vieille: Que crains-tu? Un large trou noir! Il est vide peut-être?* Printed by Blanchard. M. no. 152. 16.2 x 10.8 cm.

20 *La Mort: C'est moi qui te rends sérieuse; enlaçons-nous.* Printed by Blanchard. M. no. 153. 30.3 x 21.1 cm.

21 *. . . J'ai quelquefois aperçu dans le ciel comme des formes d'esprits.* Printed by Clot. M. no. 154. 26.1 x 18.2 cm.

22 *. . . Les bêtes de la mer, rondes comme des outres.* Printed by Blanchard. M. no. 155. 22.2 x 19 cm.

23 *Des peuples divers habitent les pays de l'océan.* Printed by Blanchard. M. no. 156. 31 x 23 cm.

24 *Le Jour enfin parait . . . et dans le disque même du soleil, rayonne la face de Jésus-Christ.* Printed by Blanchard. M. no. 157. 27 x 26.3 cm.

103. Béatrice*

From *L'Album d'estampes originales de la Galerie Vollard*, 1897

Lithograph in yellow, brown, gray-blue, orange, and green. 30 x 29.5 cm. (image), 56.5 x 43 cm. (sheet)

100 numbered impressions on china paper laid down on wove; several trial proofs with color variations on loose china paper. Signed "O. R." lower right of composition. Printed by Auguste Clot

Ref.: Mellerio, *Odilon Redon*, no. 168; Roger-Marx, *French Original Engravings*, plate 6; Gheerbrant, 1897

Colls.: AIC, Cleveland, MoMA, MFA, NGA, NYPL

104. Odilon Redon. Apocalypse de Saint-Jean.*

Edité par Vollard, 6 rue Laffitte, Paris, 1899

12 lithographs and cover-frontispiece printed in black. 62.8 x 44.5 cm. (sheet)

100 albums on china paper laid down on heavy wove; some proofs before letters. Signed "Od. R." lower left on cover, verso in blue crayon. Printed by Blanchard, Paris

Ref.: Mellerio, *Odilon Redon*, nos. 173–185; Gheerbrant, 1899

Colls.: AIC (also trial proofs), Baltimore, Brooklyn, Cleveland, Fogg, MFA, NGA, NYPL, PMA

Titles of individual prints:

Couverture–frontispice printed on heavy brown japan paper. M. no. 173. 20.2 x 23.3 cm.

1 *Et il avait dans sa main droite sept étoiles, et de sa bouche, sortait une épée aiguë à deux tranchants.* M. no. 174. 29.2 x 20.9 cm.

2 *Puis je vis, dans la main droite de celui qui était assis sur le trône, un livre écrit dedans et dehors, scellé de sept sceaux.* M. no. 175. 32.2 x 24.3 cm.

3 . . . *Et celui qui était monté dessus se nommait la mort* . . . M. no. 176. 31 x 25.5 cm.

4 *Puis l'ange prit l'encensoir.* Signed "Odilon Redon" and with monogram "O.R." M. no. 177. 31 x 21.5 cm.

5 *Et il tombe du ciel une grande étoile ardente.* Signed with monogram "O.R." M. no. 178. 30.3 x 23.3 cm.

6 . . . *Une femme revêtue du soleil.* Signed with monogram "O.R." M. no. 179. 23 x 28.6 cm.

7 *Et un autre ange sortit du temple qui est au ciel, ayant lui aussi une faucille tranchante.* M. no. 180. 31.3 x 21.2 cm.

8 *Après cela je vis descendre du ciel un ange qui avait la clef de l'abîme, et une grande chaîne en sa main.* M. no. 181. 30.4 x 23.2 cm.

9 . . . *Et le lia par mille ans.* M. no. 182. 29.8 x 21 cm.

10 *Et le diable qui les séduisait, fût jeté dans l'étang de feu et de soufre, où est la bête et le faux prophète.* M. no. 183. 27.4 x 23.8 cm.

11 *Et moi, Jean, je vis la sainte cité, la nouvelle Jérusalem, qui descendait du ciel, d'auprès de Dieu.* Signed with monogram "O.R." M. no. 184. 30 x 23.7 cm.

12 *C'est moi, Jean, qui ai vu et qui ai ouï ces choses.* Signed with monogram "O.R." M. no. 185. 15.8 x 19 cm.

105. Stéphane Mallarmé. Un Coup de dés jamais n'abolira le hazard.* ca. 1898
Unpublished by Vollard

3 lithographs in black printed on china paper laid down on wove and on loose china paper

Ref.: *L'Estampe et l'affiche,* 1899, vol. 3, p. 99; Mellerio, *Odilon Redon,* nos. 186–188; MoMA, no. 167; *Signature,* 1938, no. 8, p. 43; Garvey, no. 257; MoMA, *Odilon Redon / Gustave Moreau / Rodolphe Bresdin,* p. 40; Gheerbrant, B 1

Titles of individual prints:

1 *Femme de profil vers la gauche coiffée d'un hennin.* M. no. 186. 30 x 24 cm.

2 *Tête d'enfant, de face, avec au-dessus un arc-en-ciel.* M. no. 187. 12 x 7 cm.

3 *Femme coiffée d'un toque et rejetant le buste en arrière.* M. no. 188. 26 x 24 cm.

Colls.: AIC, Austin, MoMA (nos. 1 and 3)

Note: The lithographic stone for a fourth plate was lost or damaged at the printing shop and no edition was issued.

RENOIR, Pierre-Auguste French, 1841–1919
106. Mère et enfant (Jean Renoir)

From *L'Album des peintres-graveurs,* 1896

Drypoint in brown, green, and pink. 25 x 20.7 cm. (plate), 44 x 28.5 cm. (sheet)

100 impressions on cream-toned Van Gelder laid paper. Not signed. Printed by Auguste Clot

Ref.: Delteil, vol. 17, no. 10; Gheerbrant, 1896; Melot, R 10

Colls.: Cincinnati, MFA

107. Le Chapeau épinglé. 1897 (first plate)

Lithograph in sanguine, in bister, and in black. 60 x 49.2 cm. (image), 76 x 62 cm. (sheet)

200 impressions on laid paper: 50 in sanguine; 50 in bister; 100 in black; several trial proofs; stone effaced after printing. Printed by Auguste Clot

Ref.: Delteil, vol. 17, no. 29; Roger-Marx, *Les Lithographies de Renoir,* no. 4; Melot, no. R 28

Colls.: Cleveland, MMA, MoMa, NGA

108. Le Chapeau épinglé.* 1898 (second plate)

Lithograph in yellow, red, green, orange, gray, pink, blue, brown, and black. 60 x 48.8 cm. (image), 76 x 62 cm. (sheet)

200 impressions on Arches Ingres laid paper with watermark "M B M (France)"; several trial proofs in black and in color. The trial proofs in color are from an earlier state, made before the heightening of the orange color as it appears in the published edition (see Brooklyn impression no. 41,1090). Signed "Renoir" lower right of composition on stone only. Printed by Auguste Clot

Ref.: Delteil, vol. 17, no. 30; Roger-Marx: *Les Lithographies de Renoir,* no. 5 bis.; Melot, R 29

Colls.: AIC, Brooklyn, Clark, MFA, MMA, MoMA, NGA, NYPL

Note: There exist several trial proofs in black that carry additional color in pastel and watercolor. They probably served as maquettes for the edition in color.

109. Baigneuse, debout, en pied. 1896

For unpublished *L'Album d'estampes originales de la Galerie Vollard,* 1898–

Lithograph in yellow, blue, pink, red, and black. 41 x 34.5 cm. (image); 63 x 46 cm. (sheet)

100 impressions on Arches Ingres laid paper with watermark "Arches"; some sheets with no watermark. Signed "Renoir" lower margin and "R" lower right of composition on the stone. Printed by Auguste Clot

Ref.: Delteil, vol. 17, no. 28, illus.; Roger-Marx, *Les Lithographies de Renoir,* no. 3; Gheerbrant, 1898

Colls.: AIC, BPL, MMA, MFA, NYPL, PMA

110. L'Enfant au biscuit (Jean Renoir). 1899

For unpublished *L'Album d'estampes originales de la Galerie Vollard,* 1898–

Lithograph in gray, pink, terra-cotta, green, blue, and black. 32 x 27 cm. (image), 63 x 47 cm. (sheet)

100 impressions on Arches Ingres laid paper with watermark "M B M (France)"; trial proofs in grayed black and several in pale flesh tones; stones effaced after printing. Signed "Renoir lower left margin on stone only; a few impressions signed in manuscript. Printed by Auguste Clot

Ref.: Delteil, vol. 17, no. 31; Melot, R 30; Roger-Marx, *Les Lithographies de Renoir,* no 6

Colls.: BPL, Grunwald

111. Enfants jouant à la balle.* 1900 [1898]

Lithograph in terra-cotta, yellow, blue, green, pink, and black. 60 x 51 cm. (image), 75.5 x 62 cm. (sheet)

200 impressions printed on Arches Ingres laid paper with watermark "M B M"; some trial proofs in black and in color variations; stones effaced after printing. Signed "Renoir" lower right of composition on stone only. Printed by Auguste Clot

Ref.: Delteil, vol. 17, no. 32; Melot, R 31; Roger-Marx, *Les Lithographies de Renoir,* no. 7

Colls.: Brooklyn, MMA, MFA, MoMA, NGA, NYPL

112. Le Fleuve Scamandre, plate 1. ca. 1900

Etching. 23.2 x 19 cm. (after reduction of plate), 26 x 20 cm. (plate in early state), 32.3 x 24.8 cm. (sheet)

Edition not noted; impressions on wove paper, plate exists. Signed with stamp

Ref.: Delteil, vol. 17, no. 24; Keller, no. 126; Melot, R 24

Coll.: Winterthur

Note: Melot records only one state (22.7 x 17 cm.)

113. Le Fleuve Scamandre, plate 2. ca. 1900

Etching. 25.2 x 19.3 cm. (after reduction of plate), 26 x 20 cm. (plate in early state), 32.2 x 25 cm. (sheet)

Edition not noted; impressions on wove paper; plate exists. Signed with stamp

Ref.: Delteil, vol. 17, no. 25; Keller, no. 127; Melot, R 25

Coll.: Winterthur

Note: Melot records only one state (24 x 18.5 cm.)

114. Richard Wagner. ca. 1900

Lithograph in black. 43.5 x 32 cm. (image), 65.1 x 50 cm. (sheet)

100 impressions on heavy Arches wove paper; several proofs on japan paper; stone effaced after printing. Signed "Renoir" lower right margin on stone only. Printed by Auguste Clot

Ref.: Delteil, vol. 17, no. 33; Melot, R 33; Roger-Marx, *Les Lithographies de Renoir,* no. 8

Colls.: AIC, BPL, NGA, MoMA

Note: This lithograph may have been executed from a drawing of Wagner by Renoir. As Wagner granted Renoir very little time to make the sketch, it is perhaps the least successful of the lithographic portraits by the artist.

115. Paul Cézanne. 1902

Lithograph in black. 26 x 24 cm. (image), 56.7 x 45.8 cm. (sheet)

100 impressions on china paper; several trial proofs; stone effaced after printing. Signed "Renoir" lower right of composition on stone only. Printed by Auguste Clot

Ref.: Delteil, vol. 17, no. 34; Melot R 35; Roger-Marx, *Les Lithographies de Renoir,* no. 9

Colls.: AIC, BPL, MoMA

Note: The inscription "Tête d'homme par Renoir" faintly traced in lithographic crayon on the stone appears in lower section of composition.

116. Auguste Rodin. ca. 1910–14

Lithograph in black. 40 x 38.5 cm. (image), 65.5 x 50.5 cm. (sheet)

200 impressions on Arches wove paper; a few trial proofs; stone effaced after printing. Printed by Auguste Clot

Ref.: Delteil, vol. 17, no. 49; Melot R 51; Roger-Marx, *Les Lithographies de Renoir,* no. 25

Colls.: BPL, MMA, MFA, NGA

117. Maternité. ca. 1912

Lithograph in black and gray-green or black and sepia. 54 x 48 cm. (image), 65.5 x 50 cm. (sheet)

100 impressions on Arches wove paper; some trial proofs on laid paper; stones effaced after printing. Signed "Renoir" on stone only. Printed by Auguste Clot

Ref.: Delteil, vol. 17, no. 50; Roger-Marx, *Les Lithographies de Renoir,* no. 26; Melot, no. 53; Keller, no. 130

Colls.: AIC, BPL, Grunwald, NGA, NYPL, Winterthur

118. Douze Lithographies originales de Pierre-Auguste Renoir

Aux dépens de [sic] Ambroise Vollard, 28 rue de Grammont [sic], Paris, 1919

Album of 12 lithographs in black. 37.5 x 27 cm. (sheet)

1000 copies: nos. 1–50 on antique japan paper; nos. 51–1000 on wove paper; a few rare impressions in first state; stones effaced after printing. Signed in manuscript in nos. 1–50. Printed by Auguste Clot

Ref.: Delteil, vol. 17, nos. 37–48; Roger-Marx, *Les Lithographies de Renoir*, nos. 12–23; Gheerbrant, 1919

Colls.: AIC, BPL, Grunwald, MFA, MMA, MoMA, NGA, NYPL, PMA

Titles of individual prints:

1 *Ambroise Vollard.* 1904. D. no. 37, R-M. no. 12. 23.8 x 17 cm.
2 *Louis Valtat.* 1904. D. no. 38, R-M. no. 13. 29.8 x 23.8 cm.
3 *Claude Renoir, la tête baissée.* D. no. 39, second state, R-M. no. 14. 21.5 x 18.8 cm.
4 *Claude Renoir, tourné à gauche.* D. no. 40, R-M. no. 15. 12.8 x 11.8 cm.
5 *La Pierre au trois croquis.* D. no. 41, R-M. no. 16. 20.5 x 28.9 cm.
6 *Etude de femme nue assise.* 1904. D. no. 42, R-M. no. 17. 19 x 16.3 cm.
7 *Etude de femme nue assise, variante,* 1904. D. no. 43, second state, R-M. no. 18. 16.5 x 16 cm.
8 *Femme au cep de vigne.* 1904. D. no. 44, R-M. no. 19. 17.3 x 12.5 cm.
9 *Femme au cep de vigne, variante.* 1904. D. 45, R-M. no. 20. 17.5 x 11.8 cm.
10 *Femme au cep de vigne, 2e variante.* 1904. D. no. 46, R-M. no. 21. 11.5 x 8.5 cm.
11 *Femme au cep de vigne, 3e variante.* 1904. D. no. 47, R-M. no. 22. 16.5 x 10.4 cm.
12 *Femme au cep de vigne, 4e variante,* 1904. D. 48, R-M. no. 23. 13.2 x 9.9 cm.

RIPPL-RONAI, Jozef Hungarian, 1861–1930
119. La Fête au village

From *L'Album des peintres-graveurs,* 1896

Lithograph in green, yellow, blue, pink, and black. 39.5 x 33.5 cm. (image), 57.5 x 43.5 cm. (sheet)

100 impressions on japan paper. Signed "R R" lower left margin in pencil. Printed by Auguste Clot

Ref.: *L'Estampe et l'affiche,* 1898, vol. 2, p. 20; Blum, no. 140; Gheerbrant, 1896

Coll.: Winterthur

RODIN, Auguste French, 1840–1917
120. Nu de femme

From *L'Album d'estampes originales de la Galerie Vollard,* 1897

Lithograph in sanguine. 31 x 24 cm. (image), 32 x 25 cm. (sheet)

100 impressions on heavy wove paper. Signed "A. Rodin" lower right margin in pencil. Printed by Auguste Clot

Ref.: *L'Estampe et l'affiche,* 1898, vol. 2, p. 19; Delteil, vol. 6, no. 17 (notation); Keller, no. 133; Gheerbrant, 1897

Coll.: Winterthur

Note: Lithograph is a facsimile of drawing by the artist and transferred to the stone by Auguste Clot.

ROUAULT, Georges French, 1871–1958
121. Miserere.* 1916–27

Unpublished by Vollard. Published by l'Etoile Filante, Paris, 1948

1 f., 9 pp., 58 prints in etching, aquatint, drypoint, and roulette over photogravure. 65.3 x 50.5 cm. (sheet)

450 numbered albums on Arches heavy laid paper with watermarks "Ambroise Vollard" and "Arches," nos. 1–425 and I–XXV hors commerce; early proofs before reduction of the plates; plates canceled after printing; each print is encased in a double-leaf folder with individual title in letterpress; the edition is contained in a sturdy linen covered box with a brass clasp. Signed "G R" or "Rouault" in plate; a number of individual proofs are signed "Georges Rouault" lower right margin in ink, some have inscriptions. Printed by Jacquemin, Paris

Ref.: Wheeler, no. 14; Soby, pp. 29–31; Rauch, no. 156; Blunt, *Miserere;* Kornfeld & Klipstein, *Rouault,* cat. 120, no. 50 and nos. 52–101

Colls.: AIC (two copies and a number of trial proofs), Brooklyn (with several trial proofs), BPL, Fogg, Grunwald, MMA, MoMA (with early trial proofs), NGA, PMA

Titles of individual prints and plate sizes:

1 *Miserere mei, Deus, secundum magnam misericordiam tuam.* 1922. 56.7 x 42 cm.
2 *Jésus honni . . .* 1922. 54.9 x 40.1 cm.
3 *Toujours flagellé . . .* 1922. 48.9 x 36.1 cm.
4 *Se Réfugie en ton coeur, va-nu-pieds de malheur.* 1922. 48.3 x 37.2 cm.
5 *Solitaire, en cette vie d'embûches et de malices.* 1922. 57.9 x 42 cm.
6 *Ne Sommes-nous pas forçats?* 1926. 59.3 x 43.7 cm.
7 *Nous croyant rois.* 1926. 56.9 x 43.5 cm.
8 *Qui ne se grime pas?* 1922. 56.6 x 42.9 cm.
9 *Il arrive parfois que la route soit belle . . .* 1922. 36.2 x 50.2 cm.
10 *Au vieux faubourg des Longues Peines.* 1922. 56.1 x 41.5 cm.
11 *Demain sera beau, disait le naufragé.* 1922. 50.2 x 35.4 cm.
12 *Le Dur Métier de vivre . . .* 1922. 47.7 x 35.9 cm.
13 *Il serait si doux d'aimer.* 1923. 57.7 x 41.3 cm.

14 *Fille dite de joie.* 1922. 50.5 x 35.4 cm.

15 *En bouche qui fut fraîche, goût de fiel.* 1922. 50.3 x 37.8 cm.

16 *Dame du Haut-Quartier croit prendre pour le Ciel place réservée.* 1922. 57 x 41 cm.

17 *Femme affranchie, à quatorze heures, chante midi.* 1923. 55.8 x 41.9 cm.

18 *Le Condammé s'en est allé . . .* 1922. 50.1 x 34.2 cm.

19 *Son avocat, en phrases creuses, clame sa totale inconscience . . .* 1922. 54.9 x 40.1 cm.

20 *Sous un Jésus en croix oublié là.* 1926. 48.2 x 41.8 cm.

21 *"Il a été maltraité et opprimé et il n'a pas ouvert la bouche."* 1923. 58 x 41.2 cm.

22 *En tant d'ordres divers, le beau métier d'ensemencer une terre hostile.* ca. 1926. 61 x 46.3 cm.

23 *Rue des Solitaires.* 1922. 36.2 x 50.6 cm.

24 *"Hiver lèpre de la terre."* 1922. 51.4 x 37 cm.

25 *Jean-François jamais ne chante alleluia . . .* 1923. 59 x 42.4 cm.

26 *Au pays de la soif et de la peur.* 1923. 43.5 x 60 cm.

27 *Sunt lacrimae rerum . . .* 1926. 58.1 x 41.6 cm.

28 *"Celui qui croit en moi, fût-il mort, vivra."* 1923. 57.6 x 43.5 cm.

29 *Chantez Matines, le jour renaît.* 1922. 51 x 36.5 cm.

30 *"Nous . . . c'est en sa mort que nous avons été baptisés."* 1921. 57 x 44.7 cm.

31 *"Aimez-vous les uns les autres."* 1926. 48.2 x 41.8 cm.

32 *Seigneur, c'est vous, je vous reconnais.* 1927. 57 x 44.5 cm.

33 *Et Véronique au tendre lin, passe encore sur le chemin . . .* 1921. 43.7 x 42.8 cm.

34 *"Les Ruines elles-mêmes ont péri."* 1926. 57.8 x 44.7 cm.

35 *"Jésus sera en agonie jusqu'à la fin du monde . . ."* 1926. 58 x 41.3 cm.

36 *Ce sera la dernière, petit père!* 1926. 58.1 x 41.6 cm.

37 *Homo homini lupus.* 1926. 59.2 x 41.5 cm.

38 *Chinois inventa, dit-on, la poudre à canon, nous en fit don.* ca. 1926. 59.9 x 41.5 cm.

39 *Nous sommes fous.* 1922. 57 x 41.3 cm.

40 *Face à face.* 1922. 57.3 x 43.4 cm.

41 *Augures.* 1922. 50.5 x 43.5 cm.

42 *Bella Matribus detesta.* 1927. 58.3 x 44.1 cm.

43 *"Nous devons mourir, nous et tout ce qui est nôtre."* 1922, 51.5 x 36.4 cm.

44 *Mon Doux Pays, où êtes-vous?* 1927. 42.1 x 59.7 cm.

45 *La Mort l'a pris comme il sortait du lit d'orties.* 1922. 50.8 x 29.8 cm.

46 *"Le Juste, comme le bois de santal, parfume la hache qui le frappe."* 1926. 58 x 42 cm.

47 *De profundis . . .* 1927. 43 x 59.8 cm.

48 *Au pressoir, le raisin fut foulé.* 1922. 39.2 x 48.2 cm.

49 *"Plus le coeur est noble, moins le col est roide."* 1927. 53.4 x 42.1 cm.

50 *"Des ongles et du bec."* 1926. 57.5 x 44.4 cm.

51 *Loin du sourire de Reims.* 1922. 51.1 x 38.4 cm.

52 *Dura lex sed lex.* 1926. 57.2 x 43.8 cm.

53 *Vierge aux sept glaives.* 1926. 58.3 x 41.8 cm.

54 *"Debout les morts!"* 1927. 58.4 x 44.2 cm.

55 *L'Aveugle parfois a consolé le voyant.* 1926. 58.5 x 41.9 cm.

56 *En ces temps noirs de jactance et d'incroyance, Notre-Dame de la Fin des Terres vigilante.* 1927. 58.4 x 42.3 cm.

57 *"Obéissant jusqu'à la mort et à la mort de la croix."* 1926. 58.7 x 42.5 cm.

58 *"C'est par ses meurtrissures que nous sommes guéris."* 1922. 58 x 47.2 cm.

Note: Rouault worked on the *Miserere* project from 1916 to 1918 and from 1920 to 1927. Some trial proofs include those before the reduction of the plates and have varying titles added in manuscript. There are proofs from approximately 40 canceled plates, some in photogravure only, others with preliminary handwork by the artist. These are printed on Arches wove paper and have the notations "Planches primitives hélio rayée R" or "État primitif hélios rayé nul R." There are an unknown number of gouaches by Rouault that are preliminary sketches or constitute the final compositions that appear in the published *Miserere*.

122. Portrait de Verlaine.* 1926–33

Lithograph in black. 42.5 x 32.5 cm. (image, variants), 67 x 52.5 cm. (sheet)

Approximately 300 impressions printed on laid paper in at least four editions. A proof for the first edition has the notation "Esquisse de Verlaine, premier tirage à 30 epreuves, G. Rouault, 1926." Another impression carries an inscription "Esquisse Verlaine, hors tirage, G. Rouault, 1926." A second edition carries the inscription "Verlaine, 2e tirage, 1933, Georges Rouault" and is printed on Rives laid paper with "Ambroise Vollard" watermark. Proofs in eight states in varying sizes are known. A trial proof in two colors also exists. An undesignated number of impressions are signed "Georges Rouault" in blue ink at lower right margin; others are signed and dated on the stone only; still others are unsigned. Printed by Auguste Clot

Ref.: Wheeler, no. 22 and fig. 16; Kornfeld & Klipstein, *Rouault*, cat. 120, nos 30–31; Keller, no. 139

Colls.: AIC (first edition), BPL (second edition), Brooklyn (second edition), Fogg, MoMA (fourth edition), NGA (second edition)

Note: This posthumous portrait was composed by Rouault from a cast of Verlaine's death mask. Total number of impressions not fully established by Isabelle Rouault (1977).

123. Automne.* 1927–33

Lithograph in black. 43.5 x 57.4 cm. (image), 44.2 x 59 cm. (sheet)

Approximately 350 impressions on Arches laid and Van Gelder wove papers. First edition has inscription in blue ink "premier tirage, Automne, à 30 épreuves, 1927, Georges Rouault" with watermark "Ambroise Vollard." Second edition has inscription in ink "2e tirage à 60 ex. Automne 1933, Georges Rouault" in lower margin, no watermark. Third edition has inscription in ink "3e tirage, 1933 Automne, Georges Rouault" with watermark "Ambroise Vollard" and with monogram, date, and title in the stone, edition of approximately 150. Fourth and fifth states not determined. Sixth state and edition has inscription "à 60 exemplaires" lower left margin. Seventh state has inscription in ink "7e état, Automne 1933, Georges Rouault." Eighth state not determined. Ninth state recorded with notation in blue ink "Automne, 9e état, un tirage" and in stone lower right 'G R 1933.' Printed by Auguste Clot atelier

Ref.: Wheeler, no. 19; Kornfeld & Klipstein, *Rouault*, cat. 120, nos. 36–39. Keller, no. 138

Colls.: MoMA (second and sixth states), NGA (ninth state), PMA (seventh state), Winterthur (third state)

124. Portrait de von Hindenburg. 1927–33

Lithograph in black. 45.5 x 34.5 cm. (image, variants), 58 x 49 cm. (sheet)

Approximately 350 impressions printed on Montval and Rives laid papers. This title exists in seventeen states. A first state (1927) is signed and numbered by the artist in an edition of 30 impressions. A second edition, completed in 1933, is signed and dated by the artist but not numbered. An impression in the second state carries the notation "Hindenbourg, 2e tirage, 1933, Georges Rouault" in ink on paper with "Ambroise Vollard" watermark. Other states of 1933 have various changes in the image. One has the right shoulder accentuated; another has the eyes turned left and moustache pointed rather than curled. Other examples have the title, date, and monogram on the stone only. Printed by Auguste Clot

Ref.: Wheeler, no. 21; Kornfeld & Klipstein, *Rouault*, cat. 120, no. 40; Keller, no. 140

Colls: MoMA (first state), Winterthur (second edition, 73 x 55.7 cm. sheet)

Note: Inscriptions may vary in state, edition, and date.

125. Saint Jean-Baptiste. 1927–33

Lithograph in black. 31 x 40 cm. (image), 55.2 x 56.8 cm. (sheet)

Approximately 350 impressions printed on Arches laid paper including 30 impressions with a notation "tirage à 30 epreuves du St Jean-Baptiste, Georges Rouault, 1927" (29 x 35.2 cm., image). A variant of the above image is known. In 1933 the image on the stone was somewhat

altered and two separate printings of 30 impressions each were made. The second printing has the watermark "Ambroise Vollard" and a notation "St. Jean Baptiste 2e tirage, 1933, Georges Rouault" in blue ink. This edition has date and monogram in the stone. It has not been ascertained how many editions may have been printed from states three through nine. Printed by Auguste Clot

Ref.: Wheeler, no. 20; Kornfeld & Klipstein, *Rouault*, cat. 120, nos. 28–29; Keller, no. 141

Colls.: Winterthur (second edition), MoMA (ninth state)

Note: Complete descriptions of states and editions not established at this writing.

126. Tête de Verlaine. 1927–33

Lithograph in black 28 x 32 cm. (image), 46 x 62 cm. (sheet)

Undesignated number of impressions printed on wove paper in 1927. Some impressions have "Ambroise Vollard" watermark. A preliminary state exists (Kornfeld & Klipstein, no. 33) and several states printed in 1933 with unknown editions. Printed by Auguste Clot

Ref.: Kornfeld & Klipstein, *Rouault*, cat. 120, nos. 33–35

Note: This composition was inspired by a cast of Verlaine's death mask. It has been listed under the descriptive title *Tête de Verlaine comme Saint Jean-Baptiste*.

127. Fleurs du mal. 1933

Lithograph in black. 30.3 x 21 cm. (image), 56 x 36.5 cm. (sheet)

Undesignated number of impressions printed on Van Gelder and on Vidalon papers; the latter has an "Ambroise Vollard" watermark. An unknown number of impressions have the monogram and date "G R 1933" on the stone. Probably printed by Auguste Clot

Ref.: Kornfeld & Klipstein, *Rouault*, cat. 120, no. 39 (with later corrections by Isabelle Rouault); Keller, no 137

Coll.: Winterthur

Note: Composition is a variant of the two small central figures in Rouault's lithograph *Automne*. Early research by the collector William J. Fletcher suggests three states and possibly two stones. This has not been established by Isabelle Rouault. This print has been listed under the descriptive title *Deux Filles nues*.

128. Twelve aquatints in color by Georges Rouault

Based on *Les Fleurs du mal* by Charles Baudelaire. 1936–38. Unpublished by Vollard

250 suites in color on Montval wove paper with watermark "V" or "M" or Maillol symbol, seated nude within

a circle; 50 suites in black; trial proofs of all plates. Printed by Roger Lacourière and released by him in 1945

Ref.: Kornfeld & Klipstein, *Rouault*, cat. 120, nos. 122-133

Colls.: Lacourière Archives (with trial proofs), Rouault estate (complete series). Majority of the suites in color held by an anonymous collector

Titles of individual prints:

1 *Nu de profil*. 31.2 x 21 cm.
2 *Courtisane aux yeux baissés*. 30.7 x 22 cm.
3 *Laquais* 31.1 x 21.3 cm.
4 *Danse macabre*. 30.7 x 22 cm.
5 *Femme fière*. 31.3 x 21 cm.
6 *Juges*. 31.6 x 22.2 cm.
7 *Trio*. 30.5 x 22 cm.
8 *Paysage à la tour*. 31.2 x 21.5 cm.
9 *Tête de Christ* (de face). 30 x 21.2 cm.
10 *Christ de profil*. 31.9 x 21.9 cm.
11 *Les Troix Croix* (Golgotha). 30.9 x 22.7 cm.
12 *Tombeau*. 30 x 20.6 cm.

Note: The aquatints in color differ considerably from Rouault's black and white series published by l'Etoile Filante in 1966. Vollard originally had hoped to publish this color series in an album to be titled *Dance of Death* (William J. Fletcher, manuscript notes on the graphic work of Georges Rouault).

129. Automne. 1936

Aquatint and etching in color. 44 x 58.5 cm. (plate), 51.3 x 66 cm. (sheet)

175 numbered impressions on Arches wove paper (second state); also an undetermined number of unnumbered impressions; several trial proofs. Most impressions are signed in plate only; a few are signed in ink by the artist. Printed by Roger Lacourière and released in 1946

Ref.: Cramer, cat. 5, no. 116; Kornfeld & Klipstein, *Rouault*, cat. 120, no. 43

Note: Composition similar to Rouault's lithograph of same title. The above intaglio, however, is based on a photogravure plate that was originally planned for *Miserere* but not utilized in the final edition of 58 prints. There exists a "sketch" in gouache over the photogravure image that formed the basic design for the final color plates. Various sources are inconclusive on the extent of unnumbered prints in the editions in color of *Automne*, *Le Christ en croix*, and *La Baie des trepasses*. The number may vary from 50 to an excess of 200 impressions.

130. Le Christ en croix. 1936

Aquatint and etching in color. 65 x 49 cm. (plate), 65.5 x 51 cm. (sheet)

175 numbered impressions on Arches wove paper; also an undetermined number of unnumbered impressions. Signed in plate only. Printed by Roger Lacourière and released in 1946

Ref.: Cramer, cat. 5, no. 116; Kornfeld & Klipstein, *Rouault*, cat. 120, no. 41

Colls.: Fogg, Minneapolis

Note: K. & K. list two variants, one appears as plate no. 31 in *Miserere*, the other may be a black and white proof for the above print. (K. & K., nos. 41 and 49).

131. La Baie des trepasses. ca. 1938

Aquatint and etching in color. 61.5 x 45.5 cm. (plate)

175 numbered impressions on Arches wove paper; also an undetermined number of unnumbered impressions; several trial proofs. A few impressions are signed by the artist in ink; others signed in plate only. Printed by Roger Lacourière and released in 1946

Ref.: Cramer, cat. 5, no. 116; Kornfeld & Klipstein, *Rouault*, cat. 120, no. 46

Coll.: Brooklyn (trial proof)

Note: Adaptation of a photogravure plate that was not utilized in the *Miserere* series (see K. & K., nos. 98-99).

132. Portrait de Verlaine à la Vierge. ca. 1938

Etching over photogravure. 61.4 x 45.2 cm (plate)

Only a few impressions printed on Arches paper with watermarks "Ambroise Vollard" and "Arches" are known. An impression from an earlier state and several from the canceled plate exist

Ref.: Kornfeld & Klipstein, *Rouault*, cat. 120, no. 48

Note: Rouault's painting of this subject is in the Phillips Memorial Gallery, Washington, D.C., titled *Portrait of Verlaine* and dated ca. 1938. Apparently Rouault was not satisfied with the print and requested that it be destroyed along with other uncompleted works for Ambroise Vollard

ROUSSEL, Ker-Xavier French, 1867-1944

133. Paysage avec maison

From *L'Album d'estampes originales de la Galerie Vollard*, 1897

Lithograph in green, yellow, blue, gray, pink, and light blue. 29.8 x 41.2 cm. (image), 40.5 x 53.3 cm. (sheet)

100 numbered impressions on wove paper; several trial proofs. Signed "K. X. Roussel" lower left margin in pencil. Printed by Auguste Clot

Ref.: *L'Estampe et l'affiche*, 1898, vol. 2, p. 19. Salomon, no. 13; Gheerbrant, 1897

Colls.: Brooklyn, MFA, MoMA, NGA

134. L'Album de paysage. ca. 1900

Unpublished by Vollard

Album of 12 lithographs with cover in color. 40.8 x 52.7 cm. (sheet)

100 impressions on loose china paper, plates 1–7; trial proofs only of plates 8–12. Signed "K. X. Roussel" lower margin, not all impressions signed. Printed by Auguste Clot

Ref.: Salomon, nos. 14–25; Vollard, *Recollections*, p. 248

Colls.: AIC (nos. 1–7), Brooklyn (3 titles), Clark (nos. 1–7), MFA (no. 4), MoMA (nos. 2 and 3), NGA, NYPL (no. 4)

Titles of individual prints:

1 *Personnages au bord de la mer.* (S. no. 14). Printed in mauve, beige, olive green, and yellow. 23.2 x 41 cm.
2 *Femme en rouge dans un paysage.* (S. no. 15). Printed in red, green, blue, dark green, and gray. 23.5 x 35.7 cm.
3 *Femme en robe à rayures.* (S. no. 16). Printed in blue, green, gray, rose, and light brown. 21.4 x 32.5 cm.
4 *Les Baigneuses.* (S. no. 17). Printed in bright green, dark gray, and olive green. 25.3 x 42 cm.
5 *Amours jouant après d'une nymphe.* (S. no. 18). Printed in blue, pale brown, and white. 21 x 33.7 cm.
6 *Femmes dans la campagne.* (S. no. 19). Printed in yellow, lavender, and white. 23.3 x 32.4 cm.
7 *La Source.* (S. no. 20). Printed in gray-green, yellow, red, blue, and dark green. 31.5 x 41 cm.
8 *Nymphe assis sous un arbre.* (S. no. 21). Printed in green, gray, dark green, violet, beige, and yellow (only 2 or 3 proofs known). 26 x 36 cm.
9 *Deux Femmes dans un paysage.* (S. no. 22). Printed in green, beige, brown, white, and dark blue (single proof known). 22.5 x 38.6 cm.
10 *Femme se coiffant entourée d'enfants au bord d'une rivière.* (S. no. 23). Printed in gray and yellow-green (trial proofs only). 24.5 x 44 cm.
11 *Femme et enfants assis dans l'herbe au bord d'une rivière.* (S. no. 24). Printed in blue. yellow, violet, and green (a number of proofs). 24.5 x 37.5 cm.
12 *Deux Baigneuses.* (S. no. 25). Printed in olive green, bright green, blue, and white (only one proof known to Salomon). 24.5 x 43.5 cm.

135. Leda et le cygne. ca. 1930

Lithograph 19.5 x 25.5 cm. (image), 46.5 x 57.4 cm. (sheet)

100 impressions on wove paper; trial proofs in early states. Not signed

Ref.: Salomon, no. 30, Keller, no. 144

Coll.: Winterthur

Note: For Vollard's projected album of nudes.

RYSSELBERGHE, Theo van Belgian, 1862–1926

136. Le Café-Concert

From *L'Album des peintres-graveurs*, 1896

Etching. 24 x 30 cm. (plate), 27.5 x 32 cm. (sheet)

100 numbered impressions. Signed in monogram in plate only. Printed by Auguste Clot

Ref.: *L'Estampe et l'affiche*, 1898, vol. 2, p. 20; Bourcard, p. 557; Gheerbrant, 1896; Blum, no. 152

Colls.: Cracow, MoMA

SHANNON, Charles Haselwood

English, 1863–1937

137. La Lutte enfantine (The Nursery Floor)

From *L'Album d'estampes originales de la Galerie Vollard*, 1897

Lithograph (transfer) in black. 22 x 20 cm. (image), 46 x 24.8 cm. (sheet)

100 numbered impressions on heavy wove paper; some proofs printed in red. Signed "C. H. Shannon" lower margin. Printed by Auguste Clot

Ref.: Richetts, no. 45; Blum, no. 156; Gheerbrant, 1897

Colls.: LC, MFA, Cracow

SIGNAC, Paul French, 1863–1935

138. Port de Saint-Tropez. 1897–98

For unpublished *L'Album d'estampes originales de la Galerie Vollard*, 1898–

Lithograph in yellow, blue, green, pink, gray-blue, and red. 43.5 x 33 cm. (image), 52 x 39.9 cm. (sheet)

100 numbered impressions on fine wove paper in second state; first state in five colors with variations; several trial proofs. Signed "P. Signac" lower right margin in pencil. Printed by Auguste Clot

Ref.: Kornfeld and Wick, no. 19

Colls.: MFA, MoMA, NGA

SIMON, Lucien French, 1861–1945

139. Vieille Bretonne conduisant des enfants

From *L'Album d'estampes originales de la Galerie Vollard*, 1897

Lithograph in gray, green, yellow, and red. 53 x 39 cm. (image), 57.5 x 43.5 cm. (sheet)

100 numbered impressions on china paper. Signed "L. Simon" on stone only. Printed by Auguste Clot

Ref.: *L'Estampe et l'affiche*, 1898, vol. 2, p. 19; Keller, no. 147; Gheerbrant, 1897; Blum, no. 158

Colls.: Cracow, Winterthur

140. Chevaux à la campagne. n.d.

Etching. 29.5 x 37 cm. (plate), 44 x 57.5 cm. (sheet)

Edition not noted; impressions on heavy wove paper; a remarque appears in lower right of plate. Signed in plate only

Ref.: Keller, no. 148

Coll.: Winterthur

SISLEY, Alfred French, 1839–1899

141. Les Bords de rivière (Les Oies)

From *L'Album d'estampes originales de la Galerie Vollard*, 1897

Lithograph in blue, yellow, pink, green, orange, and light blue. 21.5 x 31.8 cm. (image), 43 x 57 cm. (sheet)

100 impressions on china paper laid down on heavy wove; several trial proofs on loose china paper; one proof in sanguine. Signed "Sisley" lower right margin in pencil; a few impressions signed on stone only. Printed by Auguste Clot

Ref.: Delteil, vol. 17, no. 6; Melot, S 6; Blum, no. 159; Gheerbrant, 1897

Colls.: Brooklyn, Cleveland, MMA, MFA, NGA, NYPL

TOOROP, Jan Theodoor Dutch, 1858–1928

142. La Dame aux cygnes*

From *L'Album des peintres-graveurs*, 1896

Lithograph in light brown. 22 x 33.4 cm. (image), 34.5 x 49 cm. (sheet)

100 numbered impressions on japan paper. Signed "Toorop" lower right margin in ink; a few signed in stone only. Printed by Auguste Clot

Ref.: Gutekunst & Klipstein, Sammlung Dr. Heinrich Stinnes, Auct. Cat. June 20–22, 1938, no. 1165; Gheerbrant, 1896

Coll.: MoMA

TOULOUSE-LAUTREC, Henri de
French, 1864–1901

143. Partie de campagne (Le Tonneau or La Charrette anglais)*

From *L'Album d'estampes originales de la Galerie Vollard*, 1897

Lithograph in yellow, pink, blue, beige, and green. 37 x 48.4 cm. (image), 40 x 51.4 cm. (sheet)

100 numbered impressions on loose china paper; does not include a large number of impressions in black. Signed with monogram on stone only. Printed by Auguste Clot

Ref.: Delteil, vol. 11, no. 219; Adhémar, no. 322; Gheerbrant, 1897

Colls.: AIC, Minneapolis, MFA, NGA

VALADON, Suzanne French, 1867–1938

144. Les Baigneuses (Femmes s'essuyant).

From *L'Album des peintres-graveurs*, 1896

Etching in brown. 28.5 x 31.5 cm. (plate), 42.7 x 57.4 cm. (sheet)

100 numbered impressions on Arches cream-toned wove paper. Signed "Suzanne Valadon" in reverse in plate only. Printed by Auguste Clot

Ref.: *L'Estampe et l'affiche*, 1898, vol. 2, p. 20; Blum, no. 178; Gheerbrant, 1896

Coll.: AIC

Note: A small number of prints by Suzanne Valadon were reported by Vollard in *La Rêvue et l'idée* (Roger-Marx, "L'Oeuvre gravée de Suzanne Valadon" in *L'Art Vivant*, 1932. no. 164, pp. 433–435). These have not been located.

VALLOTTON, Félix-Edouard Swiss, 1865–1925

145. Le Premier Janvier

From *L'Album des peintres-graveurs*, 1896

Woodcut. 17.9 x 22 cm. (image), 42 x 56.5 cm. (sheet)

100 numbered impressions on wove and japan paper; a small number of proofs on colored papers. Signed "F. Vallotton" lower right margin in blue crayon, pencil, or ink. Printed by Auguste Clot

Ref.: Godefroy, no. 165; Hahnloser-Bühler, no. 285; Vallotton and Georg, no. 167; Blum, no. 179; Gheerbrant, 1896.

Coll.: Cracow

146. Le Gagnant.* 1898

For unpublished *L'Album d'estampes originales de la Galerie Vollard*, 1898–

Woodcut. 22.4 x 17.8 cm. (image), 33 x 25 cm. (sheet)

100 impressions on fine wove paper; a few impressions on japan paper. Signed "F. V." in block only. Printed by Auguste Clot

Ref.: Godefroy, no. 200; Hahnloser-Bühler, no. 402; Vallotton and Georg, no. 201

Coll.: NGA

VALTAT, Louis French, 1869–1952

147. L'Homme à la pipe. n.d.

Woodcut in red and black. 32.5 x 26 cm. (image)

Edition not noted; impressions on wove paper. Not signed

Ref.: Keller, no. 151

Coll.: Winterthur

148. Paulette et Margot. n.d.

Woodcut in orange, yellow, mauve, and blue. 31.5 x 26 cm. (image)

Edition not noted; impressions on wove paper. Not signed

Ref.: Keller, no. 150

Coll.: Winterthur

149. Trois Femmes. n.d.

Woodcut in black. 27 x 16.5 cm. (image)

Edition not noted; impression on wove paper. Not signed

Ref.: Keller, no. 152

Coll.: Winterthur

VLAMINCK, Maurice de French, 1876–1958

150. La Plaine de Boissy-les-Perches (Paysage).* 1923–25

Etching. 30 x 40 cm. (plate), 45.5 x 57.6 cm. (sheet)

275 impressions on wove paper, of which approximately 25 are signed; a few artist's proofs exist. Signed lower right margin in pencil on an unknown number of impressions. Printed by Louis Fort

Ref.: Walterskirchen, no. 145; Keller, no. 153

Colls.: Berne, MoMA, Winterthur

Note: A small undesignated number of impressions are inscribed "21 decembre '33—2ᵉ tirage." These impressions are signed. J. C. Romand states in a letter that Vollard's project of an album of etchings by various artists was never assembled. A few plates by Puy, van Dongen, Matisse, and Vlaminck were printed. The letter also states that in 1956, at M. Petiet's request, Vlaminck signed a number of impressions of this print (see Walterskirchen, p. 275).

VUILLARD, Edouard French, 1868–1940

151. L'Intérieur au paravent. ca. 1893

Lithograph in black. 25 x 31 cm. (image), 28 x 38 cm. (sheet)

Approximately 20 impressions on wove paper; some trial proofs. Not signed. Printed by Ancourt, Paris

Ref.: Marguéry, no. 14; Roger-Marx, *L'Oeuvre gravé de Vuillard*, no. 8.; Keller, no. 155

Coll.: Winterthur

152. Le Pliage du linge. 1893

Lithograph printed in black. 24 x 32 cm. (image), 31.9 x 43.6 cm. (sheet)

Approximately 20 impressions on wove paper in second state; first state with date but without monogram, very rare; second state with date and monogram. Signed with monogram "E V" on stone only. Printed by Ancourt, Paris

Ref.: Marguéry, no. 10; Roger-Marx, *L'Oeuvre gravé de Vuillard*, no 6; Keller. no. 154

Coll.: Winterthur

153. Le Jardin des Tuileries*

From *L'Album des peintres-graveurs*, 1896

Lithograph in green, yellow, and blue (variations). 28 x 43 cm. (image), 42.8 x 57.3 cm. (sheet)

100 numbered impressions on loose china paper in second state; two or three proofs in first state (nurse's cloak in white and touches of yellow at extreme left of plate; in second state nurse's cloak is checkered and yellow touches discarded). Signed "E. Vuillard" upper right margin in pencil. Printed by Auguste Clot

Ref.: Marguéry, no. 30; Roger-Marx, *L'Oeuvre gravé de Vuillard*, no. 28, second state; Blum, no. 185; Gheerbrant, 1896

Colls.: Achenbach, AIC, MMA, MFA, PMA, NGA

Note: Several preparatory studies in pastel and in watercolor exist.

154. Jeux d'enfants*

From *L'Album d'estampes originales de la Galerie Vollard*, 1897

Lithograph in green, yellow, blue, and beige. 26 x 44.7 cm. (image), 42.7 x 57.3 cm. (sheet)

100 numbered impressions on loose china paper; trial proofs in three states; a few proofs in single colors. Signed "E. Vuillard" lower right margin in pencil or in crayon. Printed by Auguste Clot

Ref.: Marguéry, no. 31; Roger-Marx, *L'Oeuvre gravé de Vuillard*, no. 29, third state; Blum, n. 186; Gheerbrant, 1897

Colls.: AIC, Cracow, Brooklyn, MFA, MMA, MoMA, NYPL

Note: According to Roger-Marx, first-state proofs printed in black; second-state proofs printed in color; third-state proofs with scraper marks cleared from costume of the child; some rare proofs with beige tone omitted.

155. Paysages et intérieurs*

Douze lithographies en couleurs par Edouard Vuillard, éditées par Vollard, 6 rue Laffitte, Paris, 1899

Album of 12 lithographs with cover in color. 59.5 x 45 cm. (cover)

100 albums on loose china paper; trial proofs in various states of each title; Signed "E Vuillard" lower right of cover in pencil; some individual titles are signed. Printed by the artist in Auguste Clot's printing shop. Stones effaced after printing

Ref.: Marguéry, nos. 33–45; Roger-Marx, *L'Oeuvre gravé de Vuillard*, nos. 31–43; Gheerbrant, 1899

Colls.: Achenbach (5 titles), AIC, Brooklyn, Clark, MFA, MMA, MoMA, NGA, NYPL, PMA

Titles of individual prints:

Couverture. M. no. 33, R-M. no. 31. 51 x 40 cm.

1 *La Partie de dames.* M. no. 34, R-M. no. 32, third state. 34 x 26.5 cm.

2 *L'Avenue.* M. no. 35, R-M. no. 33, third state. 31.2 x 41.2 cm.

3 *A travers champs.* M. no. 36, R-M. no. 34, third state. 26.5 x 34 cm.

4 *Intérieur à la suspension.* M. no. 37, R-M. no. 34, third state. 35.5 x 28.2 cm.

5 *Intérieur aux tentures roses, I.* M. no. 38, R-M. no. 36, 4th state. 34.7 x 27.2 cm.

6 *Intérieur aux tentures roses, II.* M. no. 39, R-M. no. 37, second state. 36 x 27.2 cm.

7 *Intérieur aux tentures roses, III.* M. no. 40, R-M. no. 38, second state. 34.3 x 27.2 cm.

8 *L'Âtre.* M. no. 41, R-M. no. 39, second state. 34 x 27 cm.

9 *Les Deux Fillettes sur le Pont de l'Europe.* M. no. 42, R-M. no. 40, second state. 31 x 35 cm.

10 *Terrasse de café, la nuit (La patisserie).* M. no. 43, R-M. no. 41. 36 x 28 cm.

11 *La Cuisinière.* M. no. 44, R-M. no. 42, second state. 36 x 27.2 cm.

12 *Les Deux Belles-Soeurs.* M. no. 45, R-M. no. 43, second state. 35 x 29 cm.

Note: Size of sheet varies with each title.

156. Couverture pour L'Album d'estampes originales
Edité par A. Vollard, 6 rue Laffitte, Paris [ca. 1899.] For unpublished *L'Album d'estampes originales de la Galerie Vollard.* 1898–

Lithograph in green, blue, brown, grayed purple, and beige (variations). 58.8 x 47.5 cm. (image), 64.4 x 47.5 cm. (sheet)

Edition not noted; impressions on loose china paper; "first state" before words "Album" and "originales," in three or four proofs; second state with text "edité par A. Vollard, 6 rue Laffitte, Paris," three or four proofs; third state with added touches of green around name of editor, three or four proofs. Not signed. Printed by Auguste Clot and Vuillard

Ref.: Marguéry, no 49; Roger-Marx, *L'Oeuvre gravé de Vuillard*, no. 47

Colls.: AIC, Clark, MoMA

Note: There exists a gouache study for this lithograph.

157. La Naissance d'Annette (La Jeune Mère). ca. 1899–1900

Lithograph in blue, yellow, green, beige, rose, and gray-green. 34 x 40 cm. (image), 40.8 x 51.5 cm. (sheet)

100 impressions on loose china paper (in third state); first state in black only (rare); second state, area at right of screen has been clarified and flowers on quilt are in soft red (rare); third state, image measures .6 cm. less on left and .2 cm. less in height, red in flowers is intensified. Not signed. Printed by Auguste Clot

Ref.: Marguéry, no. 49; Roger-Marx, *L'Oeuvre gravé de Vuillard*, no. 44

Colls.: Brooklyn, NGA

WAGNER, T. P. French, n.d.

158. La Loge des clowns

From *L'Album d'estampes originales de la Galerie Vollard*, 1897

Lithograph in red, blue, and yellow. 33 x 48 cm. (image), 43 x 57 cm. (sheet)

100 numbered impressions on loose china paper. Signed "T. P. Wagner" lower right margin in pencil. Printed by Auguste Clot

Ref.: *L'Estampe et l'affiche*, 1898, vol. 2, p. 19; Gheerbrant, 1897

Coll.: BPL

WALTER, Henri C. n.d.

159. Au cirque. ca. 1896–98

Lithograph in red, yellow, blue, and orange. 40.5 x 55 cm. (image), 43.2 x 57 cm. (sheet)

Edition not noted; impressions on loose china paper. Not signed

Ref.: Keller, no. 156

Coll.: Winterthur

WHISTLER, James McNeill
 American, 1834–1903

160. La Conversation (Afternoon Tea)

From *L'Album d'estampes originales de la Galerie Vollard*, 1897

Lithograph in black. 18.5 x 15.8 cm. (image), 39.5 x 49.5 cm. (sheet)

100 numbered impressions on japan paper; several trial proofs. Printed by Auguste Clot

Ref.: Way, no. 147; Gheerbrant, 1897

Colls.: MMA, NGA

Editions de luxe

BERNARD, Emile French, 1868–1941

161. Pierre de Ronsard. Les Amours de Pierre de Ronsard

Cinquante sonnets de Pierre de Ronsard Vandomois. Bois et cuivres dessinés et gravés par Emile Bernard. Ambroise Vollard, éditeur, 6 rue Laffitte, Paris, 1915

114f., 50 sections. 16 etchings, 157 woodcuts in black and sienna. 32.5 x 25 cm.

250 numbered copies: nos 1–25 on japan Shidzuoka with double suite of etchings on japan and holland papers; watermark "Ronsard Amour"; nos. 26–50 on holland with watermark "Ronsard Amour" and a suite of etchings printed in sienna on japan paper; nos. 51–250 on holland with watermark "Ronsard Amour"; additional etching on cover printed in sienna; woodcut text executed by the artist after his own handwriting and printed in sienna; some of the woodcuts are repeated throughout the text

Etchings, woodcuts, and text printed by Emile Bernard on handpresses of Emile Féquet

Ref.: *Signature*, 1938, no. VIII, p. 39; Wartmann, no. 15; Wheeler, no. 14; Skira, no. 15; Arts Council, no. 17; Vollard, *Catalogue complet*, p. 38; Cailler, *Documents*, no. 4; Garvey, no. 24; Gheerbrant, no. 11

Colls.: AIC, HCL, MoMA

162. Charles Baudelaire. Les Fleurs du mal

Illustrations dessinées et gravées sur bois par Emile Bernard. Ambroise Vollard, éditeur, 6 rue Laffitte, Paris, 1916

2 vols., 543 pp. 36 woodcuts with 317 within text, printed in brown and black. 32.5 x 25 cm.

250 numbered copies: nos. 1–50 on japan Shidzuoka in 1 vol.; nos. 51–250 on Arches wove with watermark "Les Fleurs du mal" in 2 vols.; woodcuts destroyed after printing

Woodcuts printed by Emile Bernard; text printed by L'Imprimerie Nationale

Ref.: Mahé, vol. 1, p. 174; *Signature*, 1938, no. 8, p. 40; Wartmann, no. 8; Vollard, *Catalogue complet*, p. 42; Gheerbrant, no. 12

Coll.: BPL

Note: Mahé records a 1905 edition of *Les Fleurs du mal* with 36 illustrations by Emile Bernard, published by Vollard in an edition of 300 on japan and on holland papers. Vollard in his *Catalogue complet* mentions only the 1916 edition. Perhaps Mahé had in hand an earlier prospectus or an "exemplaire d'exposition" with the 1905 date (Keller, no. 3). No completed copy bearing the 1905 date has been located

Vollard's address in 1916 was 28 rue de Gramont; the imprint on the above *Les Fleurs du mal* is 6 rue Laffitte. This would indicate that the title page had been printed several years earlier.

163. François Villon. Oeuvres de maistre François Villon*

Bois dessinés et gravés par Emile Bernard. Chez Ambroise Vollard, 28 rue de Gramont, Paris, 1919 [1918]

432 [8] pp. 312 woodcuts. 32.5 x 25 cm.

254 numbered copies: nos. 1–25 on japan Shidzuoka paper; nos. 26–250 on vat paper giving title of the work; 2 copies marked A and B on holland paper, each with an original gouache; 2 copies marked C and D, hand-colored by the artist; the edition printed in black and red-brown; 20 additional suites of the woodcuts on wove paper; woodblocks destroyed after printing

Woodcuts and text printed by Emile Bernard on the hand presses of Emile Féquet

Ref.: Mahé, vol. 3, p. 683; *Signature*, 1938, no. VIII, p. 40; Wartmann, no. 9; Vollard, *Catalogue complet*, p. 43; Gheerbrant, no. 14.

Coll.: Brooklyn

164. Saint-François. Les Petites Fleurs de Saint-François

Traduites de l'italien par Maurice Beaufreton, illustrées de bois dessinés et gravés par Emile Bernard. Ambroise Vollard, éditeur, 28 rue de Martignac, Paris, 1928

412 [12] pp. 300 woodcuts, full-page and within text. 32.5 x 25.5 cm.

350 numbered copies on Arches laid paper, nos. 1, 2, and 3 hand-colored by the artist; 25 copies marked A–Y hors commerce; 45 suites of the woodcuts not utilized in the edition are printed on japan nacré paper

Woodcuts and text printed by Marthe Féquet

Ref.: *Signature*, 1938, no. 8, p. 41; Wartmann, no. 13; Vollard, *Catalogue complet*, p. 50; Keller, no. 8; Gheerbrant, no. 18

Coll.: MoMA

165. Homère. L'Odyssée

Ouvrage en deux volumes, traduction de Madame Dacier, illustré par Emile Bernard de quatre-vingt-seize

bois originaux et cinquante et un hors-texte. Ambroise Vollard, éditeur, 28 rue de Martignac, Paris, 1930

2 vols, 308 pp. 51 woodcuts hors-texte, 96 within text. 35 x 27.5 cm.

178 numbered copies: nos. 1–25 on japan supernacré paper with suite of 51 woodcuts printed in black; nos. 25–165 on Arches laid paper; nos. A–J hors commerce; 3 additional copies designated "exemplaires d'exposition"; blocks destroyed after printing

Printed at Aimé Jourde press; illustrations hand-colored in sepia by the artist

Ref.: Signature, 1938, no. VIII, p. 41; Wartmann, no. 15; Morand, Emile Bernard, no. 41; Vollard, Catalogue complet, p. 57–58; Keller, no. 2; Gheerbrant, no. 21

Coll.: MoMA

BONNARD, Pierre　　　　　French, 1867–1947

166. Paul Verlaine. Parallèlement*

Lithographies originales de Pierre Bonnard. Ambroise Vollard, éditeur, 6 rue Laffitte, Paris, 1900

3f., 139 pp., 1f., 109 lithographs in rose-sanguine, 9 wood-engravings in black. 30 x 24 cm.

223 numbered copies: nos. 1–10 on china paper with a suite of lithographs without text; nos. 11–30 on china paper; nos. 31–200 on Van Gelder wove with watermark "Parallèlement"; 21 copies on Van Gelder wove signed by Vollard and marked a–u; 2 copies on Van Gelder wove with a suite of all the published plates plus 12 lithographs not utilized in the edition; a few copies are printed in blue; all plates effaced after the edition

Lithographs printed by Auguste Clot; engravings cut and printed by Tony Beltrand; text printed by l'Imprimerie Nationale

Ref.: Mahé, vol. 3, p. 652; Signature, 1938, no. 8, p. 38; Rauch, no. 21; Terrasse, no. 40; Vollard, Catalogue complet, p. 59; Skira, no. 21; Garvey, no. 27; Stern, no. 9; Rewald, Pierre Bonnard, no. 144 and p. 151; French Art of the Book, no. 143

Colls.: AIC, LC, MMA, MoMA, NYPL

Note: A very small number of copies present a notable peculiarity. These rare copies carry both the typographical mark (a small nude torso), the special mark of the Imprimerie Nationale, and its customary imprint, "Imprimé par décision spéciale de M. le Garde des Sceaux Ministre de la Justice." After the Imprimerie Nationale had printed the edition for Vollard, the director became concerned with what was termed the questionable contents of Verlaine's text and demanded that the entire edition be returned. This Vollard did, save for the small number of copies that had already been distributed. The pages carrying the typographical mark and the imprint notation were removed from all the copies and another signature carrying a different typographical mark with half-title and title page were substituted in most of the copies. There exists an extensive maquette that includes 80 proof sheets, 67 original drawings and some 40 leaves; also several printer's proof sheets of the illustrations are known.

167. Almanach illustré du Père Ubu*

(XXᵉ siècle), 1ᵉʳ janvier 1901. en vente partout. [Ambroise Vollard, Paris, 1901.]

56 pp. 79 illus. in red, blue, and black. 29 x 21 cm.

1000 (approximately) copies: nos. 1–25 on japan imperial with an additional suite of illustrations printed in black; nos. 26–50 on Van Gelder paper; nos. 51–1000 on beige-toned wove paper

Ref.: Keller, no. 9; Parke Bernet, Modern French Illustrated Books, cat. 1285, no. 19; Gheerbrant, no. 2, and p. 211

Colls.: Brooklyn, MoMA (2 copies, 1 before letters), Winterthur (suite of illustrations in black)

Note: First issued by Vollard as a jest and intended for private circulation only. One of a series of small pamphlets privately printed for Vollard between 1900 and 1930 but not under Vollard's imprint.

168. Longus. Les Pastorales de Longus ou Daphnis et Chloé*

Traduction de Messire J. Amyot, en son vivant Évêque d'Auxerre et Grand Aumônier de France. Revue, corrigée, complétée de nouveau, refaite en grande partie par Paul-Louis Courier, Vigneron, Membre de la Légion d'Honneur, ci-devant canonnier à cheval. Lithographies originales de P. Bonnard. Ambroise Vollard, éditeur, 6 rue Laffitte, Paris, 1902

x, 294, pp. 2f., 151 lithographs in black. 30 x 24 cm.

250 numbered copies: nos. 1–10 on antique japan with a double suite of lithographs without text and printed in rose-sanguine; nos. 11–50 on china with a double suite of lithographs without text and printed in a blue tone; nos. 51–250 on Van Gelder with watermark "Daphnis et Chloé"; stones effaced after the edition

Lithographs printed by Auguste Clot; text printed by l'Imprimerie Nationale

Ref.: Mahé, vol. 2, p. 695; Signature, 1938, no. 8, p. 38; Terrasse, no. 42; Skira, no. 22; MoMA, no. 22; Vollard, Catalogue complet, p. 29; Rauch, no. 22; Garvey, no. 28; Klipstein and Kornfeld, Dokumentations Bibliothek, cat. 88, no. 581; Roger-Marx, Bonnard lithographe, no. 95; Rewald, Pierre Bonnard, no. 145, p. 151

Colls.: AIC, BPL, HCL, LC, MMA, MoMA, NYPL

Note: Some rare lithographic proofs retouched by hand exist; also a number of studies in lithographic crayon are known.

169. Octave Mirbeau. Dingo

Ambroise Vollard, éditeur, 28 rue de Martignac, Paris, 1924

193 [1] pp., 2f. 14 etchings hors-texte, 41 etchings in text including illustrated initial letters, additional etching on cover; all illustrations printed in black. 38 x 28.5 cm.

350 numbered copies: nos. 1–30 on antique japan with second suite of etchings; nos. 31–70 on japan Shidzuoka; nos. 71–350 on Arches wove; nos. A–T on Arches wove hors commerce. 50 suites of the etchings printed separately and issued in album with title page signed by the artist; all plates canceled after printing

Ref.: Mahé, vol. 2, p. 955; *Signature*, 1938, no. 8, p. 41; Terrasse, no. 56; Vollard, *Catalogue complet*, p. 48; Rauch, no. 26; Garvey, no. 30; Skira, no. 26; Stern, no. 7; Rewald, *Pierre Bonnard*, no. 147 and p. 151; *French Art of the Book*, no. 145

Colls.: MoMA, MMA, NYPL

170. Ambroise Vollard. La Vie de Sainte-Monique

Illustrations de Pierre Bonnard. Ambroise Vollard, éditeur, 28 rue de Martignac, Paris, 1930

224, xv pp. 17 etchings, 29 lithographs, 178 wood-engravings. 32.8 x 25.5 cm.

385 numbered copies: nos. 1–8 on antique japan; nos. 9–33 on imperial japan; nos. 34–83 on Arches wove; nos. 1–83 have a suite of the etchings and lithographs on Arches wove initialed by artist and author; nos. 84–340 on Arches wove; nos. I–XXX and A–O hors commerce; all plates canceled after printing

Illustrations and text printed by Aimé Jourde

Ref.: *Signature*, 1938, no. 8, p. 41; Terrasse, no. 64; Rauch, no. 27; Vollard, *Catalogue complet*, p. 59; Stern, no. 11; Gheerbrant, no. 22

Colls.: AIC, Baltimore, BPL, MoMA, NYPL

BRAQUE, Georges French, 1882–1963

171. Hésiode. La Théogonie*

Texte grec. Unpublished by Ambroise Vollard. Published by A. Maeght, éditeur, Paris, 1955

77 [1] pp., 2f. 20 etchings with frontispiece in two tones, 16 etchings hors-texte, 2 vignettes, and etched cover printed in black and varnished in yellow. 44.5 x 32.5 cm.

150 numbered copies printed on Auvergne paper with the 16 etchings blind stamped with monogram "G B" in circle on page margin, frontispiece printed in black and brown. In 1932 Vollard had released 50 suites of the 16 etchings with remarques and before the reduction of the plates; 15 were printed on wove paper and 1 printed on laid paper with the "Vollard" watermark. Ten of these

etchings are numbered and signed in brown crayon by the artist in the lower right margin. The signed etchings are the same compositions that appear in the published *edition de luxe* on pp. 9, 15, 21, 25, 29, 35, 41, 45, 49, 65. The 6 remaining etchings of the suites are unsigned. However, 3 suites are known to have the 6 remaining etchings signed in brown crayon by Braque in the lower left margin. Some trial proofs exist. A few of the 150 copies of the edition have been signed by Braque in pencil

Etchings and text printed by Marthe Féquet and Pierre Baudier

Ref.: Wheeler, no. 28; Rauch, no. 108; Stern, no. 14; Limbour, *La Théogonie;* Bibliothèque Nationale, *Georges Braque,* no. 17; Kornfeld & Klipstein, *Les Peintres et le livre,* cat. 152, no. 24; Garvey, no. 38

Colls.: AIC (including extra suite of etchings), HCL, MoMA (including extra suite of etchings), LC

Note: The first title in the Suites *Eros et Eurybia* was Braque's original composition. However, in the 1955 published *edition de luxe* a new plate was made. It carried the same title as the first one. The second etching printed in black and brown served as a frontispiece and was completed by the artist in 1953, at which time he also added 2 vignettes, a table of contents, and a cover. The 1955 *edition de luxe* contains 3 photo-engraved plates after the original etchings that appear on pp. 5, 74, and 75 (information recorded by MoMA).

CEZANNE, Paul French, 1839–1906

172. Ambroise Vollard. Paul Cézanne

Galerie Ambroise Vollard, 6 rue Laffitte, Paris, 1914

192 pp. 1 etching (frontispiece), 56 illustrations. 32.3 x 25.2 cm.

1000 numbered copies: nos. 1–150 on japan Shidzuoka; nos. 151–350 on Arches wove with watermark "Paul Cézanne"; nos. 351–1000 on beige-toned paper; also some unnumbered copies

Photogravures printed by Louis Fort; text printed by Frazier-Soye

Ref.: Mahé, vol. 3, p. 697; *Signature*, 1938, no. 8, p. 40; Venturi, *Cézanne,* no. 1160; Vollard, *Catalogue complet*, pp. 40–41; Gheerbrant no. 10

Colls.: LC, MMA, NYPL

CHAGALL, Marc French, born in Russia, 1887

173. Nicolas Gogol. Les Ames mortes*

Traduction de Henri Mongault. Eaux-fortes originales de Marc Chagall. Ambroise Vollard, éditeur, 28 rue de Martignac, Paris, 1927. Unpublished by Vollard. Published by Tériade, éditeur, Paris, 1948

2 vols., 308 pp. 107 mixed etchings, 11 etched initial letters. 38 x 28 cm.

Vol. I: 3f., 160 pp., 1f. 6 etchings and 6 initial letters; 51 etchings hors-texte; 41 signed in the plate.

Vol. II: 3f., 165–308 pp., 16f. 5 etchings and 5 initial letters; 45 etchings hors-texte; 41 signed in the plate; illustrated table of the etchings

368 numbered copies on Arches wove, watermark "Les Ames Mortes," nos. 1–50 with extra suite of etchings on japan nacré paper; nos. 51–335 without extra suite of etchings; nos. I–XXXIII hors commerce. All copies signed by the artist with a number signed with special dedication on the preliminary leaf

Etchings hors-texte printed by Louis Fort; etchings within text printed by Raymond Haasen, 1948; text printed by L'Imprimerie Nationale

Ref.: MoMA, no. 30; Salmon, p. 19; *Signature*, 1938, no. 8, p. 43; Garvey, no. 50; Rauch, no. 146; Stern, no. 15; Meyer, no. 14; Klipstein & Kornfeld, *Tériade*, no. 38

Colls.: AIC, Baltimore, MoMA, NYPL

Note: The 100 full-page etchings, Chagall's first for Vollard, were executed between 1923 and 1937; 96 were utilized in the Tériade publication. Originally the entire edition was changed several times by Vollard; once he found better paper, and at another time he decided on a different typeface.

174. La Fontaine. Les Fables*

Eaux-fortes originales de Marc Chagall. Ambroise Vollard, éditeur, 28 rue de Martignac, Paris, 1927. Unpublished by Vollard. Published by Tériade, éditeur, Paris, 1952

2 vols. 100 mixed etchings with 1 etching on each cover. 39 x 30.5 cm.

200 numbered and signed copies on Rives wove: nos. 1–40 hand-colored by the artist with 1 suite of etchings on japan nacré paper and a suite on Montval paper; nos. 41–85 hand-colored by the artist with suite of etchings on Montval; nos. 86–185 with etchings printed in black; nos. 1–15 hors commerce. In addition to the 200 copies of the text volumes, there were printed 100 portfolios of 100 etchings on Montval laid paper in large format, 42 x 34 cm. (sheet). Each print signed by the artist

Etchings printed by Maurice Potin, 1927–30; text printed by L'Imprimerie Nationale

Ref.: MoMA, no. 32; Garvey, no. 52; Rauch, no. 147; Bibliothèque Nationale, nos. 98–147; Meyer, no. 17; Stern, no. 17; Klipstein & Kornfeld, *Tériade*, no. 42; Gheerbrant, no. A 9

Colls.: AIC, Baltimore, MoMA, NYPL

175. La Bible. L'Ancien Testament*

Text from French Geneva translation of 1638. Unpub-

lished by Vollard. Published by Tériade, éditeur, Paris, 1956

2 vols. 105 etchings. 44 x 34 cm.

Vol. I: 62f. 57 etchings hors-texte (32 signed in the plate)

Vol. II: 54f. 48 etchings hors-texte (45 signed in the plate)

295 numbered and signed copies on Montval wove paper: nos. 1–275; nos. I–XX hors commerce. In addition 100 numbered albums of the 105 etchings were printed on Arches wove paper, hand-colored and signed by the artist; a few copies with dedication on the preliminary leaf; trial proofs exist in 4 for some, as many as 14 for others

66 etchings printed by Maurice Potin (1931–39); 39 etchings printed by Raymond Haasen (1952–56); text printed by L'Imprimerie Nationale

Ref.: MoMA, no. 32; Rauch, no. 148; Garvey, no. 53; Meyer, no. 24; Bibliothèque Nationale, *Marc Chagall*, nos. 126–167; Stern, no. 16; Klipstein & Kornfeld, *Tériade*, no. 45; Gheerbrant, A 12

Colls.: AIC, BPL, Brooklyn, MoMA

Note: Chagall had completed 105 etchings in 1939. Vollard originally had planned to have twice as many. Sixty-six of the etchings were printed by Potin in collaboration with the artist. Later, when Tériade took over the project, Chagall reworked the remaining plates in collaboration with Raymond Haasen, who printed them.

DEGAS, Edgar French, 1834–1917

176. Degas

Quatre-vingt-dix-huit reproductions signées par Degas (peintures, pastels, dessins et estampes). Galerie A. Vollard, 6 rue Laffitte, Paris, 1914. Published by Bernheim-Jeune et cie. Editions, 25 Boulevard de la Madeleine, Paris, 1918

[3] pp. 98 reproductions (pls. I–XCVIII). 37.5 x 27 cm.

800 numbered copies: nos. 1–275 on japan Shizuoka paper; nos. 276–375 on laid paper; nos. 376–800 on tinted wove paper. Printed by Frazier-Soye, Paris

Note: This work was assembled and printed for Vollard whose name appears on the title page imprint. However the entire edition was taken over and issued by Bernhein-Jeune et cie, Editions, in 1918. Their imprint appears on the cover. No text is included but a table of the plates appears at the end of the volume.

177. Guy de Maupassant. La Maison Tellier*

Illustrations d'Edgar Degas. Ambroise Vollard, éditeur, 28 rue de Martignac, Paris, 1934

65 pp. 19 aquatint-etchings, 17 wood-engravings. 32.5 x 25.5 cm.

325 numbered copies: nos. 1–305 on Rives wove; nos. A–T hors commerce

Wood-engravings by Georges Aubert printed by Henri Jourde at L'Imprimerie Aux Deux Ours; aquatint-etchings by Maurice Potin; table de hors-texte by Auguste Clot; text printed by L'Imprimerie Nationale; illustrations are after original compositions by Degas

Ref.: *Signature*, 1938, no. 8, p. 42; Wartmann, no. 20; Vollard, *Catalogue complet*, p. 67; Stern, no. 26; Gheerbrant, no. 25

Colls.: BPL, MoMA, NYPL

178. Pierre Louÿs. Mimes des courtisanes de Lucien

Illustrations d'Edgar Degas. Ambroise Vollard, éditeur, 28 rue de Martignac, Paris, 1935

84 pp. 22 aquatint-etchings, 12 photogravures. 32.5 x 25.5 cm.

324 numbered copies: nos. 1–305 on Rives wove; nos. A–T hors commerce; plates canceled after printing

Illustrations in text and table de hors-texte by Auguste Clot; photogravures by Maurice Potin; text printed by Aimé Jourde; all illustrations are after original compositions by Degas

Ref.: *Signature*, 1938, no. 8, p. 42; Wartmann, no. 21; Vollard, *Catalogue complet*, p. 21; Stern, no 27; Gheerbrant, no. 26

Colls.: MMA, MoMA, NYPL

179. Paul Valéry. Degas/Danse/Dessin

Illustrations d'Edgar Degas. Ambroise Vollard, éditeur, 28 rue de Martignac, Paris, 1936

161 pp. 26 aquatint-etchings, 25 photogravures. 32.5 x 25.5 cm.

320 numbered copies: nos. 1–305 on Rives wove; nos. A–T hors commerce; plates canceled after printing

Text with wood-engravings within text by Georges Aubert printed by Aimé Jourde; photogravures by Maurice Potin; illustrations after original compositions by Degas

Ref.: *Signature*, 1938, no. 8, p. 43; Wartmann, no. 22; Vollard, *Catalogue complet*, p. 67; Stern, no. 24; Gheerbrant, no. 27

Coll.: MoMA

DENIS, Maurice French, 1870–1943

180. Thomas à Kempis. L'Imitation de Jésus-Christ

Traduction anonyme du XVIII^e siècle. Honorée d'un bref de Notre Saint-Père le Pape Pie IX. Bois dessinés par Maurice Denis. Ambroise Vollard, éditeur, 6 rue Laffitte, Paris, 1903

xii, 456 pp. 216 wood-engravings. 30 x 25 cm.

400 numbered copies: nos. 1–5 on antique japan with a double suite of engravings without text; nos. 6–30 on china paper with double suite of engravings without text; nos. 31–120 on china paper; nos. 121–400 on Marais wove with watermark "L'Imitation de Jésus-Christ"; wood-engraving blocks effaced after printing

Wood-engravings by Tony Beltrand and printed at the Syndicat des Graveurs under supervision of artist; text by L'Imprimerie Nationale

Ref.: Mahé, vol. 2, p. 429; *Signature*, 1938, no. 8, p. 38; Wartmann, no. 4; Vollard, *Cataloque complet*, p. 31; Kornfeld & Klipstein, *Les Peintres et le livre*, cat. 152, no. 51; Gheerbrant, no. 5

Colls.: LC, MMA, MoMA, NYPL

Note: Copy no. 1 printed for Pope Leo XIII

181. Paul Verlaine. Sagesse

Images en couleurs de Maurice Denis. Gravées sur bois par Beltrand. Ambroise Vollard, éditeur, 6 rue Laffitte, Paris, 1911

4f., 100 pp., 1f. 72 wood-engravings in brown, black, gray, or green, title page in gray and black, 1 vignette in red and black. 28.5 x 23.5 cm. (variable)

250 numbered copies: nos. 1–40 on antique japan paper with extra suite of engravings on Van Gelder paper and hand-colored by the artist; nos. 41–250 on Van Gelder paper with watermark "Sagesse"

Printed by Jacques Beltrand, who also executed the wood-engravings

Ref.: Mahé, vol. 3, p. 655; Vollard, *Catalogue complet*, p. 36–37; *Signature*, 1938, no. 8, p. 39; Cailler, *Maurice Denis*, nos. 11–28; Rauch, no. 12; Guignard, p. 70; Garvey, no. 77

Colls.: LC, HCL, MoMA, NYPL

Note: The illustrations were completed by the artist in 1889 and hand-colored by him in 1910. Cailler notes that *La Voie étroite* (Cailler, no. 1, 23.5 x 18 cm.) appears as the frontispiece for *Sagesse*.

182. Francis Thompson. Poèmes

Traduit par Elizabeth M. Denis-Graterolle. Lithographies originales de Maurice Denis. Ambroise Vollard, éditeur, 28 rue de Martignac, Paris, 1939. Unpublished by Vollard. Published by Martin Fabiani and Lucien Vollard, Paris, 1942

130 [12] pp. 13 lithographs in color; 56 within text. 38.5 x 28.5 cm.

260 numbered copies: nos. 1–35 on imperial japan paper with extra suite of lithographs without text and 1 original gouache; nos. 36–240 on Van Gelder paper; nos. I–XX hors commerce; stones effaced after printing

Lithographs printed by Auguste Clot; text printed by Aimé Jourde

Ref.: Cailler, *Documents,* nos. 162–228; *Signature,* 1938, no. 8, p. 43; Rauch, no. 13; Keller, no. 42; Gheerbrant, no. A3

Coll.: MoMA

DERAIN, André French, 1880–1954

183. Jean de La Fontaine. Les Contes et nouvelles, en vers

Lithographies originales d'André Derain. Unpublished by Vollard. Published by Aux Dépens d'un Amateur, Paris, 1950

2 vols. 67 lithographs. 25 x 18 cm.
Vol. I: 5, 6–270 pp., 2f. with 28 lithographs
Vol. II: 7, 271–417 pp., 2f. with 39 lithographs

200 numbered copies on Montval wove: nos. 1–10 with a suite of the lithographs on japan laid paper and a suite of 15 lithographs not utilized in the edition printed on japan nacré; nos. 11–20 with 1 suite on china and 1 suite on japan laid; nos. 21–40 with a suite of lithographs on china; nos. 41–200 without the lithographic suites. Lithographs printed by Mourlot Frères; text printed by Féquet et Baudier

Ref.: *Signature,* 1938, no. 8, p. 43; MoMA, no. 58; Rauch, no. 39; Cailler, *Documents,* no. 13, pp. 14–17; Strachan, p. 330; Gheerbrant, no. A 7

Coll.: LC

Note: Publication of the 1950 edition was realized through the efforts of Daniel Sickles. Copy no. 1 (unique), assembled especially for Colonel Sickles, had 3 suites of the lithographs, printed on wove, on china, and on antique japan papers. Also an additional suite of 15 lithographs not utilized in the edition are printed on various papers. A series of 20 original drawings executed by Derain for the lithographs in the edition was also included. The suites of lithographs and the drawings accompanying this copy have been dispersed.

184. Petronius Arbitor. Le Satyricon*

Cuivres gravés par André Derain. [1934.] Unpublished by Vollard. Published by Aux Dépens d'un Amateur, Paris, 1951

[3] 291 [5] pp. 36 line engravings, 33 woodcuts. 44.5 x 33.4 cm.

326 numbered copies on Arches wove: nos. 1–33 each with 2 original drawings, 1 suite of 36 engravings including 3 not utilized in the edition printed on antique laid paper, 1 suite of the engravings on Richard de Bas wove, 1 suite of the woodcuts on Malacca white, and 1 suite on tinted Malacca paper; nos. 34–70 with 1 original drawing, 1 suite of engravings on antique laid, 1 suite of

engravings on Richard de Bas wove, 1 suite of the woodcuts on white Malacca, 1 suite of woodcuts on gray-tinted Malacca paper; nos. 71–120 with 1 suite of engravings on Richard de Bas wove, 1 suite of woodcuts on tinted Malacca paper; nos. 121–150 with 1 suite of engravings on Arches wove; nos. 151–280 without the suites; nos. A–Z and nos. I–XX (first 5 include a suite of illustrations) reserved for Vollard estate

Ref.: *Signature,* 1938, no. 8, p. 43; MoMA, no. 57; Rauch, no. 40; Strachan, p. 330; Cailler, *Documents,* no. 13, pp. 14–17; Kornfeld & Klipstein, *Les Peintres et le livre,* cat. 152, no. 54; Stern, no. 33; Gheerbrant, no. 8A: Bibliothèque Nationale, *L'Oeuvre gravé de Derain,* no. 98

Coll.: MoMA

Note: There are 4 recorded copies to which original drawings have been added. These include a special copy for the artist and an elaborate copy with original drawings and numerous special suites of the illustrations for the publisher and bibliophile Colonel Daniel Sickles. The latter copy has been dispersed. The 1951 edition was realized through the efforts of Daniel Sickles and René Gas.

DUFY, Raoul French, 1877–1953

185. Eugène Montfort. La Belle Enfant, ou L'Amour à quarante ans*

Ambroise Vollard, éditeur, 28 rue de Martignac, Paris, 1930

2f., 249 [1] pp., 4f. 16 etchings hors-texte, 77 etchings within text, and an etched cover. 32.5 x 25 cm.

390 numbered copies: nos. 1–30 on antique japan paper with extra suite of etchings on Montval laid; nos. 31–60 on japan supernacré with an extra suite of etchings on Montval laid; nos. 61–95 on japan supernacré; 96–340 on Arches wove; 35 copies hors commerce, numbered I–XXXV and 15 copies numbered A–O; plates canceled after printing

Etchings printed by Louis Fort; text printed by L'Imprimerie Nationale

Ref.: *Signature,* 1938, no. 8, p. 42; MoMA, no. 63; Vollard, *Catalogue complet,* pp. 61–62; Rauch, no. 47; Garvey, no. 93; Stern, no. 38; Courthion, *Raoul Dufy,* no. 39; Kornfeld & Klipstein, *Les Peintres et le livre,* cat. 152, no. 62; Gheerbrant, no. 20

Colls.: AIC, Baltimore, Brooklyn, LC, MoMA, NYPL

186. Ambroise Vollard. Catalogue complet des éditions Ambroise Vollard

Exposition du 15 decembre au 15 janvier, 1931 au Portique. Le Portique éditeur, Paris, 1930

69 [3] pp. 1 etching by Raoul Dufy. 20 x 23 cm.

625 numbered copies: nos. 1-125 on Montval with portrait of Vollard by Dufy (etching) printed in sanguine and signed in the plate; nos. 126-625 on Rives laid with etching printed in black; all copies also have a portrait of Vollard by Auguste Renoir (facsimile of a lithograph); 50 numbered impressions of the Dufy etching were printed: 15 in sanguine marked A-O and 35 in black marked 1-35; plate canceled after printing

Etching printed by Louis Fort; text printed by L'Imprimerie Lecram, Paris

Ref.: Libraire Nicaise S.A., cat. 11, no. 412

Colls.: Brooklyn, LC, MoMA, NYPL

Note: Catalogue lists 19 published editions of Vollard to 1930, and 14 unpublished; also an undesignated number of bronzes by Maillol, Renoir, and Picasso, and unlisted prints. Vollard's Introduction was reprinted from his essay in *L'Art vivant*, December 15, 1929.

A second portrait of Vollard (in bow tie and seated with left arm resting on an imaginary table) was etched by Dufy ca. 1930, but was not selected by Vollard as a frontispiece for his catalogue (Bridel et Cailler, *L'Exposition Raoul Dufy oeuvre gravé*, du mardi 5 au samedi 30 janvier, 1954).

GOGH, Vincent van Dutch, 1853-1890

187. Lettres de Vincent van Gogh à Emile Bernard

Ambroise Vollard, éditeur, 6 rue Laffitte, Paris, 1911

152 pp. 100 reproductions. 26 x 20.5 cm.

40 copies printed on japan paper; also a trade edition

Text printed by M. Puyfagès at Tonnerre (Yonne); reproductions from *La Revue illustrée*, 6 rue de Savoie, Paris; Color reproductions from La Maison Sadag

Ref.: Vollard, *Catalogue complet*, p. 35; *Signature*, 1938, no. 8, p. 39; Gheerbrant, no. 9

Colls.: MoMA, MMA

LAPRADE, Pierre French, 1875-1931

188. Paul Verlaine. Fêtes galantes*

Illustrations de Pierre Laprade. Ambroise Vollard, éditeur, 28 rue de Martignac, Paris, 1928

[6] 52 pp. 14 etchings, 42 illustrations in color within text. 32.5 x 25 cm.

375 numbered copies: nos. 1-55 printed on japan paper with a suite of etchings on Rives wove and a suite of the illustrations in color; nos. 56-375 on Rives wove; nos. I-XXIV hors commerce. Plates canceled after the edition. Etchings in black executed by Maurice Potin and printed at the Louis Fort presses; compositions in color executed by Maurice Potin and printed by the artist include table of the etchings; text printed by L'Imprimerie Nationale

Ref.: Roger-Marx, "Catalogue sommaire de l'oeuvre gravé" (de Laprade), no. 3, p. 67; *Signature*, 1938, no. 8, p. 41; Vollard, *Catalogue complet*, pp. 56-57; Rauch, no. 112; Keller, no. 81; Gheerbrant, no. 19

Colls.: BPL, NYPL, Winterthur

189. Gérard de Nerval. Sylvie

Illustrations de Pierre Laprade. Ambroise Vollard, éditeur, 28 rue de Martignac, Paris, 1938

97 pp. 39 etchings and aquatints. 33.7 x 26 cm.

250 numbered copies: nos. 1-10 on japan nacré with extra suite of etchings printed in black; nos. 11-30 on japan imperial with a suite of etchings in black; nos. 31-250 on Arches laid with watermark "Sylvie"; an unknown number of copies designated in Roman numerals, hors commerce

Etchings executed by Roger Lacourière and printed by Philippe Molinié; text printed by Féquet et Baudier

Ref.: Roger-Marx, "Catalogue sommaire de l'oeuvre gravé" (de Laprade), no. 3, p. 67; Gheerbrant, no. A 1; Keller, no. 82

Coll.: MoMA

Note: Released by Lucien Vollard and Martin Fabiani in 1940.

MAILLOL, Aristide French, 1861-1944

190. Pierre de Ronsard. Livret des folastries à Janot Parisien*

Plvs. quelques épigrammes grec et des dythyrambes chantes au bouc de E. Iodëlle, poëte tragiq, avec les eaux-fortes originales d'Aristide Maillol. Ambroise Vollard, éditeur, 28 rue de Martignac, Paris, 1939

190 pp. 43 etchings including 16 hors-texe. 24.2 x 18.4 cm.

230 numbered copies: nos. 1-30 on japan imperial paper, signed by the artist; nos. 31-200 on Montval laid; nos. I-V on japan imperial; nos. VI-XXX on Montval laid, hors commerce. Plates canceled after printing

Etchings printed by Roger Lacourière; text printed by Aimé Jourde; table of etchings printed by Henri Jourde from wood-engravings by Georges Aubert

Ref.: Vollard, *Catalogue complet*, p. 68; MoMA, no. 129; *Signature*, 1938, no. 8, p. 43; Rauch, no. 143; Guérin, *Aristide Maillol*, vol. 2, nos. 332-375; Gheerbrant, no. A 2; Keller, no. 83

Colls.: MFA, MoMA, NYPL, Winterthur

Note: Released by Lucien Vollard and Martin Fabiani, Paris, 1940. Cover has 1938 date, title page has 1939 date. The etchings, on zinc plates, were completed by Maillol during May to October 1927; 5 known etchings were not utilized in the edition. A title page bearing an imprint date of 1939 is in Winterthur.

PICASSO, Pablo

Spanish, 1881–1973, lived in France

191. Honoré de Balzac. Le Chef-d'oeuvre inconnu*

Eaux-fortes originales et dessins gravés sur bois de Pablo Picasso. Ambroise Vollard, éditeur, 28 rue de Martignac, Paris, 1931

xiv, llf., 92 pp. 13 etchings, 67 wood-engravings. 32.5 x 25.5 cm.

340 numbered copies: nos. 1–65 on japan imperial with extra suite of etchings on Rives, these copies carry signature of Picasso and Vollard; nos. 66–305 on Rives; nos. I–XXXV hors commerce. In addition there are 99 suites of the etchings with remarques and one etched plate serving as an illustrated table of contents (see cat. no. 94)

Etchings printed by Louis Fort; text and wood-engravings printed by Aimé Jourde; wood-engravings executed by Georges Aubert

Ref.: *Signature,* 1938, no. 8, p. 42; Vollard, *Catalogue complet,* p. 68; Garvey, no. 225; Skira, no. 293; Bloch, *livres,* no. 19; MoMA, no. 163; Klipstein & Kornfeld, *Dokumentations Bibliothek,* cat. 88, no. 600; Los Angeles, no. 70; Philadelphia Museum, no. 10; Stern no. 86; Horodisch, p. 72; Geiser, nos. 123–135; Gheerbrant, no. 23

Colls: AIC, Baltimore, Fogg, Grunwald, LC, MFA, MoMA, NYPL

Note: In 1945 Albert Skira (Geneva, Petite Collection Labyrinthe) published *Le-Chef-d'oeuvre inconnu* with reproductions of drawings made by Picasso on the margins of the Vollard 1931 edition (see Garvey, p. 225).

192. Comte de Buffon (Georges Louis Leclerc). **Eaux-fortes originales pour des texts de Buffon. [Histoire naturelle]***

Unpublished by Vollard. Published by Martin Fabiani, Paris, 1942

134 pp. 11f. 31 etchings and aquatints in black and gray (unsigned). 37.5 x 28.5 cm.

226 numbered copies: nos. 1–5 on japan supernacré paper with extra suite of etchings on china with remarques and before reduction of plates; nos. 6–35 on japan imperial with extra suite of etchings on china; nos. 36–90 on Montval wove; nos. 91–225 on Vidalon wove; 1 unique copy with extra suite of etchings on blue tinted paper

Etchings printed by Roger Lacourière; text printed by Marthe Féquet and Pierre Baudier

Ref.: *Signature,* 1938, no. 8, p. 43; Bloch, nos. 328–58 and Livres, no. 36; Rauch, no. 61; Stern, no. 83; Barr, pp. 210, 278; Philadelphia Museum of Art, no. 18; *French Art of the Book,* no. 109; Matarasso, no. 34; Horodisch, p. 73;

Garvey, no. 231; Los Angeles, no. 193; Klipstein and Kornfeld, *Dokumentations Bibliothek,* cat. 88, no. 608; Skira no. 298; Gheerbrant, no. A 4

Colls.: Fogg, Grunwald, MoMA, NGA, NYPL

Note: Commissioned by Vollard in 1931 and completed by Picasso in 1936. Some proofs printed on laid paper with large margins, their titles are: *Le Singe, La Chat, Le Toureau, Le Belier, L'Ane, La Puce, La Guêpe, Le Crepaud.* The dimensions are 33 x 23 cm. (image), 44.2 x 33.5 (sheet). One copy in the edition of 5 contains a full-page drawing in watercolor of a ram's head and signed by Picasso (see Rauch, frontispiece). In 1957 Jonquières in Paris published a series of 40 drawings executed by Picasso in 1942 on the margins of Dora Maar's copy of the Buffon (see Garvey, no. 231, f.n.).

193. André Suarès. Hélène chez Archimède

Unpublished by Vollard. Published by Nouveau Cercle Parisien du Livre, 1955

199 pp. 3 full-page ornaments, 22 wood-engravings. 44 x 33 cm.

240 numbered copies: nos. 1–140 reserved for members of the Cercle; nos. I-C, one hundred copies for sale; also 30 suites of the illustrations printed on blue-tinted paper and 30 on yellow-tinted paper (20 copies have a double suite on blue-tinted paper and also in yellow; 10 copies have a suite on blue and 10 copies have a suite on yellow paper)

Engravings and text printed by Marthe Féquet and Pierre Baudier; wood-engravings executed by Georges Aubert

Ref.: Rauch, no. 80; Horodisch, pp. 39–42 and B 22; Matarasso, no. 67; Gheerbrant, no. A 10

Coll.: MoMA

Note: The 1955 edition is considerably different from what is known of Vollard's original plan. The single etching and one of the wood-engravings have been eliminated. Vollard had expected to use as an Introduction some of the line drawings from a 1926 Picasso sketchbook. It is not known how Vollard hoped to incorporate the three ornamental designs. Colonel Daniel Sickles and Maxime Denesle were commissioners of the 1955 edition. There exist a few rare early proofs on japan paper.

PUY, Jean

French, 1876–1961

194. Ambroise Vollard. Le Père Ubu à la guerre*

Illustrations de Jean Puy. Ambroise Vollard, éditeur, 28 rue de Martignac, Paris, 1923

126 [8] pp. 8 etchings, 1 lithograph, 109 wood-engravings. 38 x 28 cm.

375 numbered copies: nos. 1–30 on antique japan paper; nos. 31–60 on japan imperial; nos. 61–375 on Arches

wove; plates canceled and stone effaced after printing

Printed on Ambroise Vollard's hand press

Ref.: Mahé, vol. 3, p. 697; *Signature,* 1938, no. 8, p. 40; Wartmann, no. 11; Vollard, *Catalogue complet,* p. 47; Gheerbrant, no. 16

Colls.: AIC, Brooklyn, MoMA

REDON, Odilon French, 1840–1916

195. Gustave Flaubert. La Tentation de Saint-Antoine

Illustrations d'Odilon Redon. Ambroise Vollard, editeur, Paris, [1933] 1938

[4] 208 [12] pp. 22 lithographs in black, 14 wood-engravings with table of illustrations. 45 x 33.5 cm.

220 numbered copies: nos. 1–25 on Marias wove with watermark "Tentation de Saint-Antoine"; nos. 26–210 on Arches wove; nos. I–X on Arches wove, hors commerce

Lithographs printed by Auguste Clot and Blanchard (1896); text and wood-engravings printed by Henri Jourde; wood-engravings executed by Georges Aubert after drawings by Redon

Ref.: Mellerio, *Odilon Redon,* nos. 134–140 and 142–157; *Signature,* 1938, no. 8, p. 43; Vollard, *Catalogue complet,* p. 65; Rauch, no. 10; Stern, no. 96; Gheerbrant, no. 29

Colls.: AIC, BPL, Grunwald, MoMA, NYPL

Note: The lithographs were completed and printed in 1896 and the illustrations within the text were executed ca. 1910. Due to the reluctance of Flaubert's heirs and to Vollard's mislaying of the illustrations the book did not appear until 1938. The album of 1896 has 24 lithographs. However, only 22 lithographs appear in the book released in 1938. The editions of the title page (M. no. 134) and plate no. 7 (M. no. 140) were not retrieved until after the war. There exist 14 original drawings by Redon for the wood-engravings that appear in the above edition (Kornfeld & Klipstein, cat. 152, nos. 1086–1099).

RENOIR, Auguste French, 1841–1919

196. Ambroise Vollard. Tableaux, pastels et dessins de Pierre-Auguste Renoir*

Précédé d'une lettre de Renoir. Chez Ambroise Vollard, 28 rue de Gramont, Paris, 1918. [1919]

xii pp. 1 etching, one drypoint, 700 photogravures. 32.5 x 25 cm.

1000 numbered copies: nos. 1–100 on japan Shidzuoka paper; nos. 101–1000 on tinted wove (La Fuma) paper.

Text printed by Emile Féquet; photogravures printed by Maison Barroud

Ref.: Delteil, vol. 17, nos. 16 and 25; Melot, R 16; Gheerbrant, no. 13

Coll.: LC

Note: A further statement in the above volume notes that Ambroise Vollard's work on Renoir includes three independent parts:
1) The above volume
2) *La Vie et l'oeuvre de Pierre-Auguste Renoir*
3) An album of approximately 1400 reproductions of paintings, pastels, and drawings with two original etchings

It seems doubtful that the third volume was ever issued by Vollard. The Vollard archives at Winterthur contain two proof titles with the date of 1919 and a slightly different description of the edition: 1000 copies: nos. 1–55 on japan Shidzuoka paper; nos. 56–380 on Arches laid; 381–1000 on wove (La Fuma) paper. A 2-vol. edition of Vollard's *Tableaux, pastels et dessins* without the Renoir etchings was published in 1954 (Libraire Nicaise, cat. 11, no. 430).

197. Ambroise Vollard. La Vie et l'oeuvre de Pierre-Auguste Renoir

Chez Ambroise Vollard, 28 rue de Martignac, Paris, 1919

261 [19] pp. 1 etching, 51 photogravures, 175 drawings within text. 32.4 x 25 cm.

1000 numbered copies: 1–100 on japan imperial paper with double suite of photogravures, hors-texte; nos. 101–475 on Arches wove; nos. 476–1000 on tinted wove paper

Illustrations and text printed by Emile Féquet on hand presses

Ref.: Mahé, vol. 3, p. 697; *Signature,* 1938, no. 8, p. 40; Delteil, vol. 17, no. 11; Wartmann, no. 10; Vollard, *Catalogue complet,* pp. 45–46; Melot, no. 12; Gheerbrandt, no. 15

Colls.: LC, MMA, MoMA

Note: Title of Renoir etching is "Baigneuse assise," 1905 (Delteil, no. 11).

RODIN, Auguste French, 1840–1917

198. Octave Mirbeau. Le Jardin des supplices

Vingt compositions originales de A. Rodin, Ambroise Vollard, éditeur, 6 rue Laffitte, Paris, 1902

2f., 167 pp. 20 lithographs (18 in color, 2 in black). 33 x 25 cm.

200 numbered copies: nos. 1–15 on japan imperial paper with double suite of illustrations; nos. 16–45 on china with double suite of illustrations; nos. 46–200 on Masure et Periot wove with watermark "Le Jardin des supplices"; stones effaced after printing

Lithographs composed after compositions of the artist and printed by Auguste Clot; text printed by Philippe Renouard

Ref.: MoMA, no. 172; Delteil, vol. 6, nos. 13–17; Vollard, *Catalogue complet,* pp. 14–16 and 27; Skira no. 308; Rauch, no. 28; Garvey, no. 261; *Signature,* 1938, no. 8, p. 38; Stern, no. 97; Gheerbrant, no. 4; Thorson, sect. 3, nos. 109–133a

Colls.: HCL, MMA, MoMA, NYPL, PMA

Note: The Mirbeau text with Rodin illustrations was commissioned by Vollard in 1899, printed in 1899–1900, and issued in 1902. The Rodin drawings for the above lithographs are in the collection of the Rodin museum in Paris. Thorson records Vollard's contract with Mirbeau and Rodin, also a letter from Vollard to Rodin (p. 108 and Appendix B, p. 140).

ROUAULT, Georges French, 1871–1958

199. Ambroise Vollard. Les Réincarnations du Père Ubu*

Eaux-fortes et dessins sur bois de Georges Rouault. Ambroise Vollard, éditeur, 28 rue de Martignac, Paris, 1932

2f., vii [1] 211 [1] pp. 22 etchings, some with roulette over photogravure, 105 wood-engravings. 44 x 33.7 cm.

335 numbered copies: nos. 1–55 on Montval paper with double suites of etchings on Arches and Rives papers, each copy signed by author and artist; nos. 56–305 on Vidalon paper with a suite of etchings; nos. I–XXX copies hors commerce. Wood-engravings by Georges Aubert after drawings by Rouault. In addition 225 numbered albums with 22 etchings were printed: 50 on japan nacré paper with large margins; 175 on Van Gelder paper; 15 copies hors commerce. All albums signed "G. Rouault" in ink, lower right margin of prints. Each album encased in heavy gray paper wrapper with title and imprint in black. There are trial proofs for a number of the etchings

Etchings printed by Henri Jourde; text and wood-engravings in book printed by Aux Deux Ours. Wood-engravings by Georges Aubert after gouaches by Rouault

Ref.: Vollard, *Catalogue complet,* p. 65; Wheeler, no. 13; Soby, pp. 24–25; *Signature,* 1938, no. 8, p. 42; Rauch, no. 152; Skira, no. 101; Garvey, no. 270; Stern, no. 101; Gheerbrant, no. 24; Kornfeld & Klipstein, *Rouault,* cat. 120, no. 152

Colls.: Achenbach (album), AIC, Baltimore, BPL, Grunwald, LC (2 copies), MMA (with album), MoMA (with album), MFA, NYPL

Note: Rouault began work on the Ubu series in 1913 and completed the illustrations in 1928. Kornfeld & Klipstein record 4 etchings that were not utilized in the edition. Trial proofs exist in various states printed in 1916–19 and dated in plates. The final states have the 1928 date in the plates. The Ubu series marks Rouault's

first employment of photogravure to secure the basic image on the plate. An 8-page prospectus with 5 wood-engravings by Aubert was issued by Vollard.

An extensive maquette contains various title pages and the text printed in Vidalon paper, folded but uncut with numerous correction and variations of the general format by Henri Jourde. This maquette also includes an inventory of the original gouaches noted by Jourde; also complete itemized notes by Georges Aubert record the purchase of the engraving blocks in 1929, including the number of blocks and their sizes and Aubert's account for the cutting of the individual blocks (maquette in collection of William J. Fletcher).

200. Georges Rouault. Cirque de l'étoile filante*

Eaux-fortes originales et dessins gravés sur bois de Georges Rouault. Ambroise Vollard, éditeur, 28 rue de Martignac, Paris, 1938

2f., 168 pp., 3f. 17 aquatints in color, 82 wood-engravings. 44 x 34 cm.

280 numbered copies: nos. 1–35 on japan imperial with extra suite of aquatints in black and white, signed and numbered 1–35; nos. 36–250 on Montval laid; nos. I–XXX hors commerce of which I–V are on japan imperial and VI–XXX on Montval laid

Aquatints printed by Roger Lacourière; text and wood engravings printed by Aux Deux Ours; wood-engravings by Georges Aubert after gouaches by Rouault

Ref.: Wheeler, no. 15; Wartmann, no. 23; *French Art of the Book,* no. 118; Rauch, no. 154; Stern, no. 99; Kornfeld & Klipstein, *Rouault,* nos. 145–151; Garvey, no. 271; Gheerbrant, no. 28

Colls.: AIC, HCL, Grunwald, MFA, MoMA, LC, NGA, NYPL, PMA, Portland

Titles of individual prints:

1 *Frontispice—Parade*
2 *Pierrot noir*
3 *Amer Citron*
4 *Le Petit Nain*
5 *Jongleur*
6 *La Petite Écuyère*
7 *Madame Louison*
8 *Triste Os*
9 *Madame Carmencita*
10 *Enfant de la balle*
11 *Master Arthur*
12 *Douce Amère*
13 *Le Renchéri*
14 *Pierrot*
15 *Les Ballerines*
16 *Auguste*
17 *Dors, mon amour*

Note: When the Suarès text for *Cirque* was abandoned by Vollard as being too controversial, Rouault began work on a new version with his own text entitled *Cirque de l'étoile filante*, with 200 wood-engravings from the earlier *Cirque* augmented by 62 additional ones and 17 new aquatints in color. One of the aquatints entitled "Auguste" was to have been included in the full edition. However it appears only in the copies printed on japan imperial paper, nos. 1–35 and I–V (Schab, cat. 33, no. 188). A number of proofs were printed before the reduction of the copper plates. Also there exists a series of illustrations in color in reduced size (31 x 21 cm.) that differ somewhat in the colors and in the blacks from the formal edition. They have an inscription in ink by Rouault: "essai Cirque de l'Etoile filante G R" They lack the title "Master Arthur," pl. XI (Cramer, cat. 5, no. 112).

A maquette with title pages and text for *Cirque de l'étoile filante* records a preliminary title page dated 1931 with a small square-shaped gouache in red freely rendered with the initials "G R" within the form. This design was later discarded for a wood-engraving by Georges Aubert in a title page dated in manuscript, *Mars 1933*. The heavy paper is folded to the size of the book and the text shows few corrections (maquette in collection of William J. Fletcher).

There exists a rare group of trial proofs for 3 of the color aquatints in *Cirque de l'étoile filante* consisting of different color combinations printed before the final state. These are printed on china paper mounted on heavy japan wove with large margins (Schab, cat. 33, no. 188).

201. André Suarès. Passion*

Eaux-fortes originales en couleurs et bois dessinés par Georges Rouault. Ambroise Vollard, éditeur, 28 rue Martignac, Paris, 1939

2f, 143 pp., 5f. 17 aquatints in color, 82 wood-engravings. 44 x 34 cm.

270 numbered copies: nos. 1–245 on Montval laid (nos. 1–40 have extra suite of aquatints in black and white and are signed by the artist); nos. I–XXV hors commerce, on Montval laid

Aquatints printed by Roger Lacourière; text and wood engravings by Henri Jourde; wood engravings by Georges Aubert after paintings by Rouault

Ref.: Wheeler, no. 17; Wartmann, no. 24; Arts Council, no. 128; Stern, no. 100; *French Art of the Book,* no. 119; Rauch, no. 155; Garvey, no. 272; Gheerbrant, no. 30; Kornfeld & Klipstein, *Rouault,* no. 172

Colls.: AIC, HCL, BPL, MoMA, NGA, NYPL, PMA, Portland

Note: This was the last Vollard book to be published and issued in his lifetime. There is a well-documented record that shows the printing procedure for the Suarès *Passion*. It records that Rouault began work on the illustrations in August 1929. A series of title pages with changes and corrections are dated January 1933; 1934; 1936; March 15, 1938; and a final title page dated February 1939. The corrected title pages and text with instances of realignments are signed by the printer Henri Jourde and form a comprehensive record of the progress of the work (maquette in collection of William J. Fletcher). The large series of paintings created by Rouault for the wood-engravings for *Passion* are in the Idemitsu Museum, Tokyo.

202. André Suarès. Cirque*

Eaux-fortes en couleurs et en noir de Georges Rouault. Ambroise Vollard, éditeur, 28 rue de Martignac, Paris, [1931, 1933, 1939]. (Maquettes.) Unpublished by Vollard

[240] pp. 8 aquatints in color, 20 wood-engravings hors-texte and within the text. 44.5 x 33.5 cm.

An unusual number of maquettes exist due, in part, to the changes in both text and illustrations dating from 1931 to 1939. A first version of the Suarès text that Vollard belatedly decided was too controversial for publication is in the collection of Mlle Rouault. It consists of a trial layout assembled in 1931 and probably is a unique copy of the original text, with some early illustrations by Rouault. In 1933 Vollard asked Suarès to revise part of his text in a somewhat less controversial version. It is this version that makes up the 3-part maquette in the Bibliothéque Nationale, Paris. Section I. has the title page "André Suarès, Cirque [title printed in red], Eaux-fortes en couleurs et dessins sur bois de Georges Rouault, Ambroise Vollard, éditeur, 28 rue de Martignac, Paris, MCMXXXIII." It has 240 pages of text printed on wove paper with the watermark "BFK Rives." The wood-engravings by Aubert are printed on Rives with a few on proof paper. It also contains photographs of Rouault's gouaches; although signed, they probably are not his final versions. No justification of the edition appears. Section II has a title page as above with 225 pages of text and lightly printed proofs of 17 full-page wood-engravings and numerous vignettes pasted down in sequence. In Section III, the incomplete text printed on Rives paper closely follows the text in Section I but contains no illustrations. Proofs of text were corrected by Maurice Heine, Vollard's assistant, and apparently approved by Suarès. Interspersed are blank pages with designated spaces and measurements for the illustrations. Wofsy records several less detailed maquettes. One has 4 title pages, one dated 1931, and 3 dated 1939 all have the subtitle "Eaux-fortes en couleurs et en noir de Georges Rouault." A 1939 title page has a

correction dated July 27, 1938 and two have varying layouts. Another maquette has a table of contents through chapter "Parade" and 78 pages of text with numerous corrections dating from 1936 and from March through September 1937

Ref.: Rauch, no. 153; Kornfeld & Klipstein, *Rouault,* cat. 120, nos. 134–144: Gheerbrant no. B 4. Soby, pp. 110 and 120

Colls.: Grunwald (black), LC (8 aquatints in color and 6 in black), MoMA (7 in black and a title page), Lacourière Archives (with trial proofs), Rouault estate

Titles of the eight aquatints in color:

1 *Ballerine.* 30.6 x 20.1 cm.
2 *Clown et enfant.* 31.2 x 21.2 cm.
3 *Le Clown jaune.* 35.1 x 25.2 cm.
4 *Le Vieux Clown.* 32.6 x 33.8 cm.
5 *Clown à la grosse caisse.* 31.3 x 21.2 cm.
6 *Amazone.* 29.7 x 22.7 cm.
7 *Parade.* 30.4 x 26.8 cm.
8 *Jongleur.* 31.1 x 21.5 cm.

Note: According to Isabelle Rouault, the 8 aquatints in color (without text) were printed on Montval and Rives papers in an edition of 500. A number of early proofs in black exist. Vollard also issued a prospectus with a title page and corrections. All but *Parade* are dated 1930 in black plate.

203. [Charles Baudelaire.] Quatorze planches gravées pour Les Fleurs du mal*
Unpublished by Vollard. Published by L'Etoile Filante, Paris, 1966

5f., 97 pp. 14 etchings in black. 45 x 34.5 cm.

450 numbered copies printed on Arches paper: nos. 1–425; I–XXV hors commerce. Etchings individually numbered 1–14 (verso). Etchings printed for Vollard by Jacquemin in 1927; text later printed by Féquet et Baudier

Ref.: Kornfeld & Klipstein, *Rouault,* cat. 120, nos. 102–115 (corrections by Isabelle Rouault); Garvey, no. 267; Wheeler, no. 18; Gheerbrant, no. B 2

Coll.: MoMA

Note: Due to deterioration during World War II, some of the etchings in the Vollard printing of 500 could not be used. Also a few impressions, not individually numbered (verso), had been distributed by Vollard before his death, accounting for the reduction of the edition from 500 to 450 copies. In the above edition only 13 of Baudelaire's poems are utilized rather that the 30 that were to be in Vollard's original project. There exist several of the Vollard title pages (maquettes). A title page apparently for a planned publication in 1940 reads "Charles Baudelaire, Les Fleurs du Mal, Eaux-fortes originales de Georges Rouault, Paris, Ambroise Vollard, éditeur, 28

rue de Martignac, MCMXL." An earlier title page dated 1930 mentions wood-engravings. According to Isabelle Rouault, there were 36 photogravure plates made for *Les Fleurs du mal* that were rejected by Rouault and all 36 plates were canceled. Proofs from the canceled plates have the notation "Etat primitif hélio rayé nul G R." These make up a section of the Colonel Daniel Sickles maquette and are not to be considered a part of the *Les Fleurs du mal* series. There also exist 4 rare proofs with descriptive titles *Nu de profil au gauche* and *Le Roi* in etching and aquatint, and *Femme nue* and *Femme nue II* in etching. These proofs are possibly Rouault's early studies for his later compositions for *Les Fleurs du mal.*

SEGONZAC, André Dunoyer de

French, 1884–1974

204. Virgile. Georgica (Les Géorgiques)*

Traduites par Michel de Marolles. Illustrées d'eaux-fortes par Dunoyer de Segonzac. Chez l'artiste, Paris, 1944 [1947]

2 vols. 119 etchings and drypoints. 46 x 34.4 cm
Vol. I: 201 [1] pp. 58 etchings
Vol. II: 213 [1] pp., 4f. 61 etchings

250 numbered copies on Arches wove with watermark (spear and bee): nos. 1–50 with extra suite of etchings on Rives wove with watermark (cluster of grapes with ox head), signed by artist; nos. 51–225 with unsigned suite of etchings; nos. I–XXV hors commerce; plates canceled after the edition

Etchings printed by Roger Lacourière and Jacques Frélaut; text printed by L'Imprimerie Nationale

Ref.: MoMA, no. 189; Rauch, no. 122; *French Art of the Book,* no. 55; Bibliothèque Nationale, *Dunoyer de Segonzac,* nos. 143–166; Lioré and Cailler, nos. 837–862, preliminary studies, and nos. 863–1103; Garvey, no. 281; Vollard, *Catalogue complet,* p. 66; *Signature,* 1938, no. 8, p. 43; Stern, no. 105; Gheerbrant, no. A 5; Kornfeld & Klipstein, *Les Peintres et le livre,* cat. 152, June 12, 1974, no. 68

Colls.: AIC, HCL, LC, MoMA, NYPL

Note: Segonzac worked on this Vollard project for more than 15 years in Provence and in L'Ile de France. The plates, most of which were completed in 1927, were designed directly from nature and etched in a single biting of the acid with additional drypoint. The plates were evenly inked and cleanly wiped for clarity of impression and were printed at Lacourière's Atelier during 1937, 1939, and 1940. Most of the titles exist in 2 or 3 early proofs.

At the end of Vol. II appears the notation: "We wish to pay tribute here to the memory of Ambroise Vollard, who contributed to the choice of type face and the first typographic tryouts for this volume."

SEGUIN, Armand French, 1869–1904

205. Louis Bertrand. Gaspard de la nuit*

Fantaisies à la manière de Rembrandt et de Callot. Illustrations d'Armand Séguin. Ambroise Vollard, editeur, 6 rue Laffitte, Paris, 1904

xxx, 312 pp. 213 wood-engravings. 31 x 25 cm.

350 numbered copies: nos. 1–20 on antique japan paper, with a double suite of wood-engravings without text printed on china paper; nos. 21–120 on china paper; nos. 121–350 on Van Gelder wove with watermark: "Gaspard de la nuit"; also 26 suites of the engravings without text marked A–Z; engraved blocks destroyed after printing

Text and wood-engravings printed by L'Imprimerie Nationale; blocks engraved by Tony, Jacques, and Camille Beltrand after drawings by Séguin

Ref.: Mahé, vol. 1, p. 244; *Signature*, 1938, no. 8, p. 39; Vollard, *Catalogue complet*, pp. 33–34; Wartmann, no. 5; Gheerbrant, no. 6

Coll.: NYPL

Note: Frontispiece printed in black with red lettering.

Editions de luxe—Uncompleted

CHAGALL, Marc

206. André Suarès. Cirque

Unpublished by Vollard

19 gouaches completed by Chagall in 1927

Ref.: Salmon, p. 19; Marc Chagall in *Sélection*, no. 6, 1929, pp. 60–62; Mourlot, nos. 490–527 (refers to Vollard's earlier project)

Note: In 1927 Vollard had requested that Chagall illustrate the Suarès *Cirque*. After completing 19 gouaches, he abandoned the project in favor of illustrations for the Bible.

DERAIN, André

207. Le Roman de la rose

Illustrated with original etchings by André Derain. Unpublished by Vollard

Ref.: *Signature*, 1938, no. 8, p. 43; Gheerbrant, C., p. 362

DUFY, Raoul

208. Edouard Herriot. La Forêt Normande

Ambroise Vollard, éditeur, 28 rue de Martignac, Paris, 1939. Unpublished by Vollard. 43 x 32.2 cm.

Edition never completed. A maquette of proofs, layout, and printing instructions in the Library of Congress contains 2 title pages, 16 plates printed on Arches wove

and with text for pages 11–14. One title page has 1933 date and title "La Normandie. Eaux-fortes et lithographies originales de Raoul Dufy." A second title page designates the work as "La Forêt Normande" with date 1939 and the Vollard imprint as noted above. The Vollard archives at Winterthur contain 1 lithograph in color, a still life in a landscape; several etchings also exist. Lithographs are in 4 to 6 colors

Ref.: Vollard, *Catalogue complet*, p. 66; MoMA, no. 64; *Signature*, 1938, no. 8, p. 43; Gheerbrant, no. B 3

Coll.: LC

HAYTER, Stanley William

British, b. 1901, lives in Paris

209. Cervantes. Numancia

A play with engravings by Stanley William Hayter. Unpublished by Vollard

The tentative plan agreed upon by Vollard and the artist was to issue *Numancia* in Spanish and French printed on a two-column page. Hayter had completed two of the proposed engravings: *Douro*, 1938 and *Runner*, 1939. The two titles were printed later in small editions and issued separately by the artist (Reynolds, p. 6, pls. 6–7).

PUY, Jean

210. Ambroise Vollard. Le Pot de fleurs de la mère Ubu

Illustré par Puy. Ambroise Vollard, éditeur, 28 rue de Martignac, Paris. n.d. Unpublished by Vollard

Only a few exhibition copies known with 10 lithographs by Jean Puy on Arches wove. 44.5 x 33 cm.

Printed by Auguste Clot

Ref.: Petit Palais de Beaux-Arts, *Salon International du Livre d'Art*, 1931, p. 105; *Signature*, 1938, no. 8, p. 43; Vollard, *Catalogue complet*, p. 67; Vollard, *Recollections of a Picture Dealer*, facing p. 249, illus.; Keller, no. 95

Coll.: Winterthur (10 lithographs, no text)

Note: Jean Puy was working on the lithographs for the above text during 1923–25.

ROUSSEL, Ker-Xavier French, 1867–1944

211. Maurice de Guérin. Le Centaure and La Bacchante

Ambroise Vollard, éditeur, 28 rue de Martignac, Paris, (1932–33). Unpublished by Vollard

49 pp. Approximately 50 lithographs. 32 x 25 cm.

Only 2 of the lithographs were printed on japan paper in an edition of 240 by Auguste Clot, ca. 1931–32. According to Salomon, Roussel completed more than 50 illustrations in lithographic crayon over an extended period of time. Other titles illustrating specific lines from

Guérin's poems exist in various early proofs. A table of contents lists: *Le Centaure*, p. 1; *La Bacchante*, p. 19; *Glaucus*, p. 43. The two completed titles are *Les Centaures dans la caverne* (S. no. 32); *Les Aigles* (S. no. 33). 20 x 15 cm.

Auguste Clot remembered that Vollard had envisioned an album of "Variations" composed of those lithographs that had not been retained for *Le Centaure* and *La Bacchante*. Six of these illustrations, destined for the "Variations," were exhibited under this title at the Bibliothèque Nationale in 1934 (S. no. 33)

Titles of the individual prints:

Bacchante (S. no. 57). 10.5 x 17 cm.
Pan (S. no. 62). 13 x 11.5 cm.
Faune enlacant une nymphe (S. no. 64). 11 x 18 cm.
Dieu marin sur une rive rocheuse au clair de lune (S. no. 67). 20 x 15 cm.
Femmes assises au bord d'un étang (S. no. 76). 12.5 x 21.5 cm.
Couple se reposant sous un arbre (S. no. 80). 11.5 x 8.5 cm

Note: The above titles differ from the ones listed under "Variations" in the Bremen Kunsthalle exhibition catalogue of Roussel's oeuvre, September–November 1965. To add to the complications, 11 of the printed lithographs originally destined for the Vollard projects were utilized in a preliminary treatise on the work of Roussel entitled *Vingt-huit études dessinées au crayon lithographie* (to illustrate a text by Alain with an essay and catalogue by Jacques Salomon). Issued in a limited edition of 500, with nos. I–XXX each containing 11 original lithographs by Roussel. Published by Daniel Jacomet, Paris, 1968.

VUILLARD, Edouard French, 1868–1940

212. Stéphane Mallarmé. Hérodiade

With proposed illustrations by Édouard Vuillard. Unpublished by Vollard

Note: Vollard hoped "someday" to publish Mallarmé's late poem and had received the approval of both author and artist. However the death of Mallarmé ended this somewhat vague project. The poet's heirs considered the work unfinished and inappropriate for publication. (Vollard, *Recollections*, pp. 256–57).

MISCELLANEOUS

213. Album of 100 etchings by Painters

An uncompleted Vollard project begun in the 1920s

Marc Chagall's notes to MoMA state that his etching *L'Acrobate au violon* was executed specifically for this grandiose project (cat. no. 25). Other etchings completed by various artists in the 1920s and printed on wove paper of uniform size sheets may be part of this projected album. They include the following artists:

Chagall, Marc. *L'Acrobate au violon* (noted above)
Denis, Maurice. *La Madone au jardin Fleuri*
Dongen, Kees van. *Les Mouettes*
Flandrin, Jules-Jean. *Le Depart de Diane* and *Pâturage*
Foujita, Tsugouharu. *Auto-portrait*
Picasso, Pablo. *L'Atelier* and *Homme et femme*
Simon, Lucien. *Chevaux à la campagne*
Vlaminck, Maurice de. *La Plaine de Boissy-les-Perches*

Note: Most of the above examples appear in the Winterthur Archives.

214. L'Album des nus

Series of etchings and lithographs by various artists. Uncompleted by Vollard. ca. 1902–30

6 etchings and 1 lithograph. 46 x 57 cm. (sheet, with slight variants)

Edition not noted. Impressions printed on wove paper

Note: See catalogue listing under individual artists:

Bonnard, Pierre. *Les Baigneuses (Deux Nus)*
Dufy, Raoul. *Nu couché aux palmiers (Odalisque nue, couchée dans un jardin)*
Maillol, Artistide. *Femme agenouillée, un genou relevé (Eve)*
Marvel, Jacqueline-Marie. *Nu couché*
Matisse, Henri. *Femme nue au collier (Odalisque)*
Picasso, Pablo. *Homme et femme*
Roussel, Ker-Xavier. *Leda et le cygne*

Bronzes

BONNARD, Pierre French, 1867–1947

215. Surtout de table. ca. 1902
Bronze. 15 x 50 x 83 cm. (oval)

No cast no.; hand-tooled by artist

Ref.: Vollard, *Recollections*, pp. 249–250; Rewald, *Pierre Bonnard*, p. 58, f.n. 34; Russoli, no. 95 (illus.)

Coll.: Musée National d'Art Moderne

Note: Exhibited at Vollard's gallery in 1902.

GAUGUIN, Paul French, 1848–1903

216. Femme debout (La Petite Parisienne). ca. 1881
Bronze. h. 27.1 cm.

Unknown number of casts

Ref.: Gray, *Gauguin*, no. 4–II

Note: Cast from an original modeled in wax over wood. According to Christopher Gray, Vollard apparently ordered the bronze cast shortly before his death.

217. Le Masque. ca. 1891–95.

Bronze. h. 25 cm.

Three casts known

Ref.: Gray, *Gauguin*, no. 110

MAILLOL, Aristide French, 1861–1946

218. Baigneuse se coiffant. ca. 1898

Bronze. h. 27.3 cm.

No cast no

Ref.: Galerie d'Estampe, *Maillol*, pl. 4; Rewald, *Maillol*, no. 70

Coll.: Hirshhorn

219. Les Deux Soeurs (design for a clock). 1899

Bronze. 51.5 x 43 x 19 cm.

6 numbered casts. Signed with monogram; inscribed "Alexis Rudier, Fondeur, Paris"

Ref.: Cladel, *Maillol*, pl. 2; Rewald, *Maillol*, no. 97; Guggenheim Museum, cat. no. 23

220. Les Deux Lutteuses. 1900

Bronze. h. 18.4 cm.

6 numbered casts. Signed with monogram; inscribed "J. Godard Fondeur, Paris"

Ref.: Rewald, *Maillol*, no. 99; Guggenheim Museum, cat. no. 36

221. Baigneuse debout. ca. 1900

Bronze. 67 x 18.5 x 15.3 cm.

Unknown cast number in an edition of 6. Signed "Aristide Maillol"; inscribed "Alexis Rudier Fondeur, Paris"

Ref.: Galerie d'Estampe, *Maillol*, pl. 3; Rewald, *Maillol*, no. 72; Guggenheim Museum, cat. no. 35

Coll.: PMA

222. Jeune Fille assise, tenant la jambe. ca. 1900

Bronze. 23 x 9.3 x 12.5 cm.

6 casts. Signed with monogram; inscribed "Cire C. Valsuani perdue"

Ref.: Rewald, *Maillol*, no. 114; Guggenheim Museum, cat. no. 38

223. Jeune Fille accroupie. ca. 1900

Bronze. 19.6 x 8.3 x 9.3 cm.

No cast no. Signed with monogram; inscribed "Alexis Rudier Fondeur, Paris"

Ref.: Rewald, *Maillol*, no. 104; Guggenheim Museum, cat. no. 27

Colls.: Detroit, AIC

224. Leda.* ca. 1900

Bronze. 29.2 x 13.5 x 13.5 cm.

6 numbered casts. Signed with monogram; inscribed "Alexis Rudier Fondeur, Paris"

Ref.: Galerie d'Estampe, *Maillol*, pl. 5; Rewald, *Maillol*, no. 110; Guggenheim Museum, cat., 40

Colls.: AIC, Williams, MMA, PMA

225. Jeune Fille agenouillée. 1902

Bronze. 17.5 x 7.5 x 10 cm.

No cast no. Not signed

Ref.: Cladel, *Maillol*, pl. 15; Rewald, *Maillol*, no. 102; Guggenheim Museum, cat. no. 42

Coll.: Hirshhorn

226. Buste d'Auguste Renoir (Tête de Renoir). 1907

Bronze. 41 x 25.5 x 28 cm.

No cast no. Signed with monogram; inscribed "Alexis Rudier, Fondeur, Paris"

Ref.: Rewald, *Maillol*, no. 146; MoMA, *Art of our Time*, no. 264; Guggenheim Museum, cat. no. 60

Coll.: MoMA

Note: Also issued in terra cotta.

PICASSO, Pablo

Spanish, 1881–1973, lived in France

227. Arlequin (Head of a Jester).* 1905

Bronze. 38.2 x 36.5 x 21.6 cm.

No cast no. Signed "Picasso"

Ref.: Barr, no. 32; Zervos, vol. 1. no. 322; MoMA, *The Sculpture of Picasso*, no. 5 and p. 52

Colls.: Hirshhorn, Phillips, PMA

228. Fernande (Buste de femme). 1905–06

Bronze. 34 x 25 x 26.5 cm.

9 numbered casts. Signed "Picasso"

Ref.: Zervos, vol. 1, no. 313; MoMA, *The Sculpture of Picasso*, no. 6 and p. 53

Colls.: Hirshhorn, Oberlin

229. Femme se coiffant. 1905–06

Bronze. 41.6 x 31.2 x 29.2 cm.

No cast no. Signed "Picasso"

Ref.: Barr, no. 59; Zervos, vol. 1, no. 320; MoMA, *The Sculpture of Picasso*, no. 7

Colls.: Baltimore, Hirshhorn

230. Tête de femme (Cubist Head).* 1909

Bronze. 41.3 x 26.2 x 27.2 cm.

No cast no. Signed "Picasso"

Ref.: Barr, no. 83; Zervos, vol. 2, no. 573; MoMA, no. 13

Coll.: MoMA

231. Tête d'homme. ca. 1909

Bronze. h 1.6 cm.

No cast. no.

Ref.: Zervos, vol. 1, no. 380; Georges Petit Galleries, *Exposition Picasso*, 1932, no. 226

RENOIR, Auguste French, 1841–1919

232. La Vénus triomphante (small standing Venus).* 1913

Bronze. 58.5 x 60 cm.

No cast no. Signed "Renoir" on base. Executed by Richard Guino under guidance of Renoir

Ref.: Haesaerts, no. 3; George, *L'Oeuvre sculpté de Renoir*, pp. 334–35

Coll.: Baltimore

233. La Vénus triomphante (large standing Venus). 1915–16

Bronze. 188 x 110 cm. Vollard edition, 1919

No cast no. Signed "Renoir" on flat of base. Executed by Richard Guino under guidance of Renoir

Ref.: Haesaerts, no. 6; Meier-Graefe, *Renoir*, pp. 404–05; fig. 407–08

234. Pâris (beardless) (Tête de la république). 1915

Bronze. 65 x 55 cm.

No cast no. Executed by Richard Guino under guidance of Renoir and based on an early drawing by the artist

Ref.: Haesaerts, no. 8; George, *L'Oeuvre sculpté de Renoir*, p. 330

Note: There is a variant: Pâris (bearded). Haesaerts, no. 9.

235. Le Forgeron (Le Jeune Berger). 1916

Bronze. 35 x 26 cm.

No cast no. Signed "Renoir" lower left side of base; no date. Executed by Richard Guino under guidance of Renoir

Ref.: Haesaerts, no. 19; Vollard, *Tableaux, pastels et dessins de Pierre-Auguste Renoir*, no. 112; Meier-Graefe, *Renoir*, pp. 406–407, figs. 409–410

236. Le Jugement de Pâris (high relief). 1916

Bronze. 73 x 91 cm.

No cast no. Signed "Renoir" lower left. Executed by Richard Guino under guidance of Renoir

Ref.: Haesaerts, no. 7; George, *L'Oeuvre sculpté de Renoir*. pp. 333–335; Meier-Graefe, *Renoir*, p. 409, fig. 412

237. La Laveuse (Washerwoman or La Baigneuse, small version). 1916

Bronze. h 33.7 cm.

No cast no. Signed "Renoir" on right side of base, no date. Executed by Richard Guino under direction of Renoir

Ref.: Haesaerts, no. 20; George, *L'Oeuvre sculpté de Renoir*, p. 329; Meier-Graefe, *Renoir*, p. 408, fig. 411; Vollard, *Tableaux, pastels et dessins de Pierre-Auguste Renoir*, no. 105

Coll.: Baltimore

238. La Laveuse (Washerwoman or La Baigneuse, large version).* 1917

Bronze. 123 x 135 x 55 cm.

No cast no. Signed "Renoir" lower left of base, no date. Executed by Richard Guino under guidance of Renoir. Early casts signed "F. Godard Fondeur." A number of later casts probably made by Alexis Rudier Fondeur, Paris

Ref.: Haesaerts, no. 31; George, *L'Oeuvre sculpté de Renoir*, p. 329

Coll.: MoMA

239. Paul Cézanne. Medallion. 1915–17

Bronze. d. 80 cm.

No cast no. Signed "Renoir" on sleeve of subject; no date. Executed by Richard Guino under Renoir's direction

Ref.: Haesaerts, no. 16; George, *L'Oeuvre sculpté de Renoir*, p. 332

Note: A bronze cast of this medallion was placed on a fountain wall in Aix-en-Provence as a memorial to Cézanne.

240. Camille Corot. medallion. 1915–17

Bronze. d. 80 cm.

No cast no. Signed "Renoir" lower left, no date. Executed by Richard Guino after a photograph of Corot. Approved by Renoir

Ref.: Haesaerts, no. 13; George, *L'Oeuvre sculpté de Renoir*, p. 332

241. Eugene Delacroix. Medallion. 1915–17
Bronze. d. 80 cm.

No cast no. Signed "Renoir" on left sleeve of subject, no date. Executed by Richard Guino after reproduction of a self-portrait by Delacroix. Approved by Renoir

Ref.: Haesaerts, no. 14; George, *L'Oeuvre sculpté de Renoir*, p. 332

242. Dominique Ingres. Medallion. 1915–17
Bronze. d. 80 cm.

No cast no. Signed "Renoir" lower left, no date. Executed by Richard Guino after a photograph of Ingres. Approved by Renoir

Ref.: Haesaerts, no. 11; George, *L'Oeuvre sculpté de Renoir*, p. 332

243. Claude Monet. Medallion. 1915–17
Bronze. d. 80 cm.

No cast no. Signed "Renoir" lower left, no date. Executed by Richard Guino after a portrait drawing of Monet by Renoir. Approved by Renoir

Ref.: Haesaerts, no. 15; George, *L'Oeuvre sculpté de Renoir*, p. 332

244. Auguste Rodin. Medallion. 1915–17
Bronze. d. 80 cm.

No cast no. Signed "Renoir" lower left, no date. Executed by Richard Guino after a portrait drawing of Rodin by Renoir. Approved by Renoir

Ref.: Haesaerts, no. 12; George, *L'Oeuvre sculpté de Renoir*, p. 332

Epilogue

THE STORY of Ambroise Vollard's extensive publications and projects may never be fully complete. This would be to Vollard's liking because it continues the ironies and anecdotes he was so fond of observing. A case in point involves the long and complicated problems concerning the Rouault-Vollard achievements. The absence of a recognized catalogue raisonné of this artist's graphic oeuvre makes meaningful research difficult, if not impossible. Rouault's vast creative energies, his involved development of a chosen theme, and his quest for perfection are not easily charted. To Vollard, who thought only of his publishing ventures and ideas, and to Rouault, who was concerned with the development of his ideas through eloquent visual means, such matters were of little concern. Perhaps Vollard's unceasing query "Dites moi, dites moi—tell me, tell me" will encourage future research.

U.E.J.

BIBLIOGRAPHY

Adhémar, Jean. *Toulouse Lautrec. His Complete Lithographs and Drypoints.* New York: Abrams, 1965.

Agustoni, Fabrizio. "The Graphic Work of Georges Rouault." *Print Collector* (Milan), Autumn–Winter 1972, pp. 14–35.

André, Edouard. *Alexandre Lunois, peintre, graveur et lithographe.* Paris: H. Floury, 1914.

Art Institute of Chicago. *The Etchings and Lithographs of Odilon Redon.* Exhibition catalogue no. 20. Chicago: Art Institute of Chicago, 1929.

————. *Gauguin: Paintings, Drawings, Prints, Sculpture.* Exhibition catalogue, 1959. Chicago: Art Institute of Chicago and New York: Metropolitan Museum of Art, 1959.

Arts Council of Great Britain. *An Exhibition of French Book Illustration, 1895–1945.* London, 1945.

Auriant. "E. Bernard, graveur." *L'Amour de l'art* (Paris), October 1928.

Ayrton, Michael. "Chagall as a Book Illustrator." Bibliography by René Ben Sussan. *Signature* (London), n.s. no. 2 (November 1946), pp. 31–46.

Bacou, Roseline. *Odilon Redon.* 2 vols. Paris: Editions des Musées Nationaux, 1956.

Barr, Alfred H. Jr. *Picasso: Forty Years of his Art.* 1st ed. New York: The Museum of Modern Art, 1939.

Basler, Adolphe, and Kunstler, Charles. *Le Dessin et la gravure modernes en France.* Paris: Cres, 1930.

Bataille, M.-L., and Wildentein, Georges. *Berthe Morisot: catalogue des peintres, pastels, et aquarelles.* Paris: Les Beaux Arts, 1961.

Bénézit, Emmanuel. *Dictionaire critique et documentaire des peintres, sculpteurs, dessinateurs et graveurs.* 8 vols., new ed. Paris: Librairie Gründ, 1960.

Berggruen et cie. *Picasso: 60 ans de gravures.* Exhibition catalogue. Paris: Berggruen et cie, 1964.

Bern, Kunstmuseum. *Vlaminck,* Collection of Dr. S. Pollog (Zurich). Exhibition catalogue, February 3–April 1961.

Bibliothèque Nationale, Paris. *Georges Braque: oeuvre graphique.* Catalogue by Jean Adhémar and Jacques Lethève. Paris: Bibliothèque Nationale, 1960.

————. *Chagall, l'oeuvre gravé.* Exhibition catalogue. Paris: Bibliothèque Nationale, 1957.

————. *Derain.* Exhibition catalogue by Jean Adhémar. Paris: Bibliothèque Nationale, 1955.

————. *Dufy.* Exhibition catalogue. Paris: Bibliothèque Nationale, n.d.

————. *Inventaire du fonds français du cabinet des estampes de Paris après 1800* by Jean Laran and Jean Adhémar. Paris: Les Garres, 1930.

————. *Dunoyer de Segonzac.* Exhibition catalogue. Paris, 1958. English edition, London: Arts Council of Great Britain, 1959.

Bloch, Georges. *Pablo Picasso: catalogue de l'oeuvre gravé et lithographie, 1904–1969.* 2 vols. Bern: Kornfeld & Klipstein, 1968–71.

Blum, Helena. *Grafika Francuska: teki A Vollard z zbiorów Feliksa Jasieńskiego.* Exhibition catalogue. Cracow: Museum Narodowe w Krakowie, 1971.

Blunt, Anthony. *Miserere.* Preface by Rouault, translation by Arnold Faucus. Paris: L'Etoile Filante and Trianon Press, 1963.

Bolliger, Hans. *Picasso for Vollard.* Edited by Milton S. Fox. New York: Abrams, 1956.

Boucard, G. *A Travers cinq siècles de gravures 1350–1903: les estampes célèbres, rares ou curieuses.* Paris: G. Rapilly, 1903.

Bouyer, Raymond. "L'Estampe murale." *Art et décoration* (Paris), vol. 4 (July–December 1898), pp. 185–191.

Breeskin, Adelyn. *Mary Cassatt: A Catalogue Raisonné of Oils, Pastels, Watercolors and Drawings.* Wash. D.C.: Smithsonian Inst. Press, 1970.

Bremen, Kunsthalle. *Ker-Xavier Roussel, 1867–1944.* Exhibition catalogue, September 16–November 21, 1965. Bremen: Kunsthalle, 1965.

Brown, Milton W. *The Story of the Armory Show.* New York: The Hirshhorn Foundation, 1966.

Buckland-Wright, John. "Roger Lacourière and Modern French Engraving." *Signature* (London), n.s. no. 6 (1948), pp. 3–18.

Burroughs, Alan, "Vollard—Sensible Biography." *Arts Magazine* (New York), vol. 4 (1923), pp. 166–175.

Cailler, Pierre. *Catalogue raissoné de l'oeuvre gravé et lithographie de Maurice Denis.* Geneva: Editions P. Cailler, 1968.

————. *Documents, encyclopédie générale des beaux arts aux XIXe et XXe siècles.* Geneva: Editions P. Cailler, 1955–1958.

Castleman, Riva. *Prints of the Twentieth Century: A History.* New York: The Museum of Modern Art, 1976.

Cherpin, Jean. "L'Oeuvre gravé de Cézanne." *Arts et livres de Provence* (Marseilles), Bulletin no. 82, 1972.

Cladel, Judith. *Aristide Maillol, son oeuvre, ses idées.* Paris: B. Grasset, 1937.

Cologne, Kunsthaus Math. Lempertz. Auction catalogue 482, no. 94. Cologne, n.d.

Courthion, Pierre. *Raoul Dufy: Documentation complet sur le peintre, sa vie, son oeuvre.* Geneva: P. Cailler, 1952.

————. *Georges Rouault.* Includes a catalogue of works prepared with the collaboration of Isabelle Rouault. New York: Abrams, [1961].

Cramer, Gérald. *Catalogue de très beaux livres illustrés modernes.* Catalogue 7, no. 79. Geneva: G. Cramer, 1951.

————. *Estampes—dessins—livres illustrés—sculptures.* Catalogue 12, no. 78. Geneva: G. Cramer, 1961.

————. *Livres et estampes modernes.* Catalogue 5, no. 116 Geneva: G. Cramer, 1948.

Delteil, Loÿs. *Le Peintre-graveur illustré, XIXe et XXe siècles.* 31 vols. Paris: Delteil, 1906–26.

Dormoy, Marie. "Maillol." *Arts et métiers graphiques* (Paris), November 1936, pp. 37–41.

Druick, Douglas W. "Cézanne, Vollard and Lithography." *Bulletin* 19. Ottawa: National Gallery of Canada, 1972.

Edwards, Hugh. "Redon, Flaubert, Vollard." *Bulletin,* vol. 36, no. 1 (January 1942), pp. 4–6. Chicago: The Art Institute of Chicago, 1942.

Engelberts, Edwin. *Georges Braque: oeuvre graphique original.* Exhibition Catalogue. Geneva: Cabinet des Estampes du Musée d'Art et d'Histoire and Galerie Nicolas Rauch, 1956.

d'Espezel, P. "M. Ambroise Vollard, éditeur." *Beaux-Arts* (Paris), vol. 9 (1931), pp. 19.

L'Estampe et l'affiche (Paris). Edited by E. Pelletan. Année 1–3, 1897–98.

Fabiani, Martin. *Quand j'étais marchand de tableaux.* Paris: Julliard, 1976.

Fern, Alan, ed. *Notes on the Eragny Press, and a Letter to J. B. Manson.* Cambridge (England), 1957.

Flam, Jack D. *Matisse on Art.* London: Phaidon Press, 1973.

Flanner, Janet. *Men and Monuments.* New York: Harper & Bros., 1947.

French Art of the Book. See San Francisco, Palace of the Legion of Honor.

Fry, Roger. "Paul Cézanne by Ambroise Vollard." *Burlington Magazine,* vol. 31, pp. 52–61.

Galerie d'Estampe. *Maillol.* Exhibition catalogue. Paris, n.d.

Galerie Guiot. *Picasso: 100 estampes originales, 1930–1937.* Exhibition catalogue, November–December 1973. Paris: Galerie Guiot, 1973.

Galerie Pigalle. *Exposition Cézanne 1839–1906: Quelques souvenirs par Ambroise Vollard.* Paris: Galerie Pigalle, 1929.

Garvey, Eleanor M. *The Artist and the Book 1860–1960: In Western Europe and the United States.* 2d ed. Boston: Museum of Fine Arts and Harvard College Library, 1972.

Geiser, Bernhard. *Picasso, peintre-graveur. Catalogue illustré de l'oeuvre gravé et lithographie, 1899–1931.* 2 vols., vol. 1 published in Bern by author, vol. 2 in Bern by Kornfeld and Klipstein, 1968.

Geiger, R. *Hermann-Paul.* Paris: H. Babou, 1929.

Geneva, Musée de l'Athénée. *Maurice de Vlaminck du fauvisme à nos jours.* Exhibition catalogue. Geneva, 1958.

George, Waldemar. "L'Oeuvre sculpté de Renoir." *Amour de l'art* (Paris), vol. 5 (November 1924), pp. 329, 334–35.

Gheerbrant, Bernard, see Vollard, *Souvenirs d'un marchand de tableaux.*

Gilot, Françoise, and Lake, Carlton. *Life with Picasso.* New York: McGraw-Hill, 1964.

Glaser, Curt. *Die Graphik de Neuzeit vom Anfang des XIX Jahrhunderts bis zur Gegenwart.* Berlin: B. Cassirer, 1922.

Godéfroy, Louis. *Albert Besnard.* Paris: Chez auteur, 1926.

————. *L'Oeuvre gravé de Félix Vallotton.* Lausanne: Chez Paul Vallotton, 1932.

Goriany, Jean. "Cézanne's lithograph 'The Small Bathers.'" *Gazette des Beaux-Arts* (Paris), 6e serie, vol. 23 (1943), pp. 123–124.

Gray, Christopher. *Sculpture and Ceramics of Paul Gauguin.* Baltimore: The Johns Hopkins Press, 1963.

Guérin, Marcel. *Catalogue raisonné de l'oeuvre gravé et lithographie de Aristide Maillol.* Geneva: P. Cailler, 1948.

————. *J.-L. Forain aquafortiste.* 2 vols. Paris: H. Floury, 1912.

————. *L'Oeuvre gravé de Gauguin.* 2 vols. Paris: H. Floury, 1927.

Guggenheim Museum. *Aristide Maillol, 1861–1944.* Introduction by John Rewald. New York: Guggenheim Museum, 1976.

Guignard, Jacques. "Les Livres illustrés de Maurice Denis." *Le Portique* (Paris), no. 4 (1946), pp. 49–71.

Gutekunst and Klipstein. *Editions Vollard.* Catalogue 53 (June–November 1949). Bern: Gutekunst and Klipstein.

Haesaerts, Paul. *Renoir sculpteur.* New York: Reynal-Hitchcock, 1947.

Hahnloser-Bühler, Hedy. *Félix Vallotton et ses amis.* Paris: Editions A. Sedrowski, 1936.

Hédiard, Germain. *Fantin-Latour: catalogue de l'oeuvre lithographique du maitre.* Paris: Librairie de l'art ancient et moderne, 1906.

Heusinger, Christian von. See Bremen, Kunsthalle.

Hofmann, Werner. *Georges Braque: His Graphic Work.* New York: Abrams, 1961.

Horodisch, Abraham. *Picasso as a Book Artist.* Translation by I. Grafe. Cleveland and New York: World Publishing Co., 1962.

Jamot, Paul. "Emile Bernard, illustrateur." *Gazette Beaux-Arts* (Paris), période 4, vol. 13 (1917), pp. 108–120.

Jarry, Alfred. *Selected Works of Alfred Jarry.* Edited by Roger Shattuck and Simon Watson Taylor. New York: Grove Press, 1965.

————. *Ubu Roi.* Paris: Editions du Mercure de France, 1896.

————. *Ubu Roi: drama in 5 Acts.* Translated by Barbara Wright. New York: New Directions, 1961.

Keller, Heinz, See Winterthur Kunstmuseum, *Schenkung Vollard.*

Klipstein and Kornfeld. *Dokumentations Bibliothek zur Kunst und Literatur des 20 Jahrhunderts.* Illustrierte Bücher. Auction catalogue 88 (May 13-14, 1958). Bern: Klipstein and Kornfeld, 1958.

————. *Tériade éditeur—Revue Verve.* Exhibition, February 6–March 12, 1960. Bern: Klipstein and Kornfeld, 1960.

Klover, Marjorie B. *Forgotten Printmakers of the 19th Century.* Exhibition catalogue December 1967–January 1968. Chicago: Klover Gallery, 1967.

Kornfeld, E. W. *Verzeichnis der Kupferstiche Radierungen und Holzschnitte von Marc Chagall.* Vol. 1 (1922-1966). Bern: Kornfeld, 1970.

Kornfeld and Klipstein. *Les Peintres et le livre.* Auction catalogue 152 (June 13, 1974). Bern: Kornfeld and Klipstein, 1974.

————. *Georges Rouault.* Auction catalogue 120 (June 9, 1966). Bern: Kornfeld and Klipstein, 1966.

Kornfeld, E. W., and Wick, P. A. *Catalogue raisonné de l'oeuvre gravé et lithographie de Paul Signac.* Bern: Kornfeld and Klipstein, 1974.

Kraus, H. P. *The Illustrated Book.* Catalogue 108, no. 138. New York: H. P. Kraus Gallery, 1964.

Lamb, Lynton. "Ambroise Vollard as a Publisher." *Signature* (London), no. 8 (March 1938), pp. 38–43.

Laran, Jean. *L'Estampe.* 2 vols. Paris: Presse Universitaire, 1959.

Leicester Galleries. *Lucien Pissarro.* Memorial exhibition of Woodcuts, Engravings and Books for the Eragny Press. Part 2 (December 1947). London: Ernest Brown & Phillips Ltd., 1947.

Leymarie, Jean. *The Graphic Works of the Impressionists.* New York: Abrams, 1972.

Librairie Nicaise S. A. *Poesie—Prose: peintres-graveurs de notre temps.* Catalogue no. 11 (Paris, 1964).

Lieberman, William S. "Picasso—Redon." The Museum of Modern Art *Bulletin,* vol. 19, no. 2 (Winter), 1952.

————. *The Sculptor's Studio by Picasso.* 2d rev. ed. New York: Museum of Modern Art, 1966.

Limbour, Georges. "La Théogonie d'Hésiode et de Georges Braque." *Derrière le miroir* (Paris), nos. 71–72, 1954-55.

Lioré, Aimée, and Cailler, Pierre. *Catalogue de l'oeuvre gravé de Dunoyer de Segonzac.* 6 vols. Geneva: P. Cailler, 1958-68.

Los Angeles County Museum of Art. *Picasso—Sixty Years of Graphic Works.* Exhibition catalogue. Los Angeles: Los Angeles County Museum of Art, 1966.

Mahé, Raymond. *Bibliographie des livres de luxe de 1900–1928.* 4 vols. Paris: Editions Kieffer, 1931-43.

Marguéry, Henri. *Les Lithographies de Vuillard.* Paris: L'Amateur d'estampes, 1935.

Matarasso, H. *Bibliographie des livres illustrés par Pablo Picasso, oeuvres graphiques, 1905-06.* Nice: Galerie Matarasso, 1956.

Meier-Graefe, Julius. *Modern Art.* 2 vols. New York: G. P. Putnam's Sons, 1908.

————. *Renoir.* Leipzig: Seemann & Co. n.d.

Mellerio, André. *La Lithographie originale en couleurs.* Paris: L'Estampe et l'affiche, 1898.

————. *Odilon Redon.* Paris: Société pour l'Etude de la Gravure, 1913 and Da Capo Press, New York, 1968.

Mellow, James. *Charmed Circle—Gertrude Stein & Company.* New York: Frederick A. Praeger, 1974.

Melot, Michel. *L'Estampe impressioniste.* Paris, Bibliothèque Nationale, 1975.

Meyer, Franz. *Marc Chagall, l'oeuvre gravé.* Translated by Paul Chavasse. Stuttgart [1957] and New York: Abrams, 1957.

Monod, Lucien. *Le Prix des estampes anciennes et modernes.* 9 vols. Paris: A. Morancé, 1920-31.

Morand, Pierre. "Emile Bernard." *Artists du Livre* (Paris), no. 6, 1949.

————, and Thomé, J.R. *Vingt-deux artists du livre.* Paris [1950].

Mourlot, Fernand. *The Lithographs of Marc Chagall.* Vol. 1. New York: George Braziller, 1965.

Musée de l'Orangerie, Paris. *André Dunoyer de Segonzac.* Exhibition catalogue. Summer 1976.

Musée Rodin. Paris. *Rodin et les écrivains de son temp.* Exhibition, June 23-October 8, 1976. Paris: Musée Rodin, 1976.

The Museum of Modern Art, New York. *Art in our Time.* New York: The Museum of Modern Art. 1939.

————. *The sculpture of Picasso.* Introduction by Roland Penrose. Chronology by Alicia Legg. New York: The Museum of Modern Art, 1967.

———— and Art Institute of Chicago. *Odilon Redon/Gustave Moreau/Rodolphe Bresdin.* New York: The Museum of Modern Art, 1961.

Parke Bernet Galleries, Inc. *Modern French Prints and Drawings, Collection of Colonel Daniel Sickles.* Auction catalogue 1122 (January 31, 1950). New York: Parke Bernet Galleries, 1950.

————. *Modern French Illustrated Books.* Auction catalogue 1285 (November 19, 1951). New York: Parke Bernet Galleries, 1951.

————. *Modern Lithographs and Etchings, Collection of Curt Valentin.* Auction catalogue 936 (February 24, 1948). New York: Parke Bernet Galleries, 1948.

Parrot, J. "Ambroise Vollard et l'édition." *La Livre et ses amis* (Paris), April 1946, pp. 9-20.

Penrose, Roland. *Picasso: His Life and Work.* New York: Harper & Bros., 1958.

Petit, Georges. *Exposition Picasso.* Paris: Georges Petit Galleries, 1932.

Petit Palais des Beaux Arts, Paris. *Salon International du livre d'art.* Exhibition catalogue. Paris, 1931.

Philadelphia Museum of Art. *Picasso.* A Loan Exhibition, January 8-February 23, 1958. Philadelphia: Museum of Art, 1958.

Pia, Pascal. "A. Vollard, marchand et éditeur." *L'Oeil,* January 1955, p. 18.

Pissarro, Camille. *Letters to his Son Lucien.* Edited by John Rewald. New York: Pantheon Books, Inc., 1943.

Poutermann, J. E. "Complete Bibliography of Books Published by Ambroise Vollard." *Signature* (London), no. 8 (1938), pp. 38-43.

Rauch, Nicolas S. A. *Les Peintres et le livre.* Catalogue 6, Geneva, 1957.

Redon, Odilon. *A soi-même journal* (1867-1945). Paris, 1922 and 1961.

Reid, B. L. *The Man from New York: John Quinn and his Friends.* New York: Oxford University Press, 1968.

Reidemeister, Leopold. *Pablo Picasso: Suite Vollard: 100 Radierungen, 1930-1937.* Hamburg, 1956.

Renoir, Jean. *Renoir, my Father.* Translated by Randolph and Dorothy Weaver. Boston: Little Brown & Co., 1958.

Rewald, John. *Pierre Bonnard.* New York: Museum of Modern Art [1948].

————, ed. *Paul Cézanne: Letters.* Translated by Marguerite Kay. London: B. Cassirer, 1946.

————, ed. *Paul Gauguin: Letters to Ambroise Vollard and André Fontainas.* San Francisco: Grabhorn Press, 1943.

————. *Maillol.* London: Hyperion Press, 1939.

————. "In Memoriam Ambroise Vollard." *De Groene Amsterdammer* (Amsterdam), August 1939.

Reynolds, Graham. *The Engravings of Stanley William Hayter.* London: Victoria and Albert Museum, 1967.

Ricketts, Charles. *A Catalogue of Mr. Shannon's Lithographs.* [London, 1902].

Roger-Marx, Claude. *Bonnard lithographie.* Monte Carlo: A. Sauret, 1952.

————. "Catalogue sommaire de l'oeuvre gravé (de Laprade)." *Renaissance* (Paris), vol. 15, no. 3, 1932.

————. *French Original Engravings from Monet to the Present Time.* London: Hyperion Press, 1939.

————. *Graphic Art of the 19th Century.* New York: McGraw-Hill, 1962.

————. *Les Lithographies de Renoir.* Monte Carlo: A. Sauret, 1951.

————. "L'Oeuvre gravé de Georges Rouault." *Byblis,* 1931, pp. 93-100.

————. *L'Oeuvre gravé de Vuillard.* Monte Carlo: A. Sauret [1948].

Correspondance: Georges Rouault—André Suarès. Introduction by Marcel Arland. Paris: Librairie Gallimard, 1960.

"The Rouault Case." Reprint from *Liturgical Arts,* May 1948. Translated by Harry Lorin Binasse from *Gazette du Palais* (Paris), September 11-13, 1946.

Rouchon, Ulysse. *Charles Maurin.* Catalogue raisonné. Le Puy-en-Velay, 1922.

Russoli, Franco. *Pierre Bonnard.* Milan: Silvana Editorile d'Arte, 1955.

Sabartés, Jaime. *Picasso, an Intimate Portrait.* New York: Prentice-Hall [1948].

Salmon, André. "Chagall," *Editions de chroniques du jour* (Paris). Les Maîtres Nouveaux, vol. 4 (1928).

Salomon, Jaques. *Introduction à l'oeuvre gravé de Ker-Xavier Roussel par Alain.* Paris: Mercure de France, 1968.

San Francisco, California Palace of the Legion of Honor. *French Art of the Book.* Exhibition Catalogue. San Francisco: California Palace of the Legion of Honor, 1949.

Schab, William H. *Master Prints and Drawings*. Catalogue 52. New York: William H. Schab Gallery, 1972.

Schapiro, Meyer. "Illustrations for the Bible by Marc Chagall." *Verve* (Paris and New York), nos. 33–34, 1956.

Schiefler, Gustav. *Verzeichnis des Graphischen Werks Edvard Munchs bis 1906*. Berlin: H. Cassirer, 1907.

Shattuck, Roger. *The Banquet Years: The Origins of the Avant Garde in France, 1885 to World War I*. Rev. ed. New York: Vintage Books, 1968.

Skira, Albert. *Anthologie du livre illustré par les peintres et sculpteurs de l'école de Paris*. Geneva: A. Skira, 1946.

Soby, James Thrall. *Georges Rouault: Paintings and Prints*. Technical notes by Carl O. Schniewind. New York: The Museum of Modern Art, 1945.

Stein, Donna. *L'Estampe originale: a Catalogue Raisonné*. New York: Museum of Graphic Art, 1970.

Stein, Gertrude. *Autobiography of Alice B. Toklas*. New York: Harcourt, Brace and Co., 1933, and Vintage Books, n.d.

Stern, Louis E. *Modern Illustrated Books from the Collection of Louis E. Stern*. Exhibition catalogue. Minneapolis: Minneapolis Institute of Arts, 1959.

Strachan, W. J. *The Artist and the Book in France*. New York: Wittenborn, 1969.

Suarès, André. "Ambroise Vollard." *La Nouvelle Revue Française* (Paris), vol. 54 (1940), pp. 184–193.

Terrasse, Charles. *Bonnard*. Paris: H. Floury, 1927.

Thieme-Becker. *Kunstler—Lexikon*. 33 vols. Leipzig, 1907–39.

Thorson, Victoria. *Rodin Graphics: a Catalogue Raisonné of Drypoints and Book Illustrations*. San Francisco: The Fine Arts Museum of San Francisco, 1975.

Timm, Werner. *The Graphic Art of Edvard Munch*. London: Studio Vista, 1969.

Vallotton, M. and Georg, C. *Vallotton*. Catalogue raisonné. Geneva: Editions de Bonvent, 1972.

Venturi, Lionello. *Cézanne: son art—son oeuvre*. Catalogue raisonné, 2 vols. Paris: Rosenberg, 1936.

————. *Georges Rouault*. New York: E. Weyhe, 1940.

Vollard, Ambroise. *Catalogue complet des éditions Ambroise Vollard*. Paris: Le Portique, 1930.

————. *Degas: An Intimate Portrait*. Translated by Randolph T. Weaver. New York: Crown, 1937.

————. *En écoutant Cézanne, Degas, Renoir*. Paris: Grasset, 1938.

————. *Recollections of a Picture Dealer*. Boston: Little, Brown and Co., 1936.

————. "Renoir sculpteur." *Beaux-Arts*, Oct. 12, 1934.

————. *Souvenirs d'un marchand de tableaux*. Paris: Editions Albin Michel, 1948.

————. *Souvenirs d'un marchand de tableaux*. Bibliography edited by Bernard Gheerbrant. Paris: Club des Libraries de France, 1957.

————. *Tableaux, pastels et dessins de Pierre-Auguste Renoir*. Paris: Ambroise Vollard, 1918.

Walterskirchen, Katalin von. *Maurice Vlaminck. Verzeichnis des Graphischen Werkes: Holzschnitte, Radierungen, Lithographien*. Bern: Benteli, 1974.

Wartmann, W. *Schenkung Lucien Vollard, Bücher von Ambroise Vollard, 1900–1939*. Exhibition catalogue, January, n.d. Brussels: Palais des Beaux-Arts.

Way, T. R. *The Catalogue of Whistler's Lithographs*. New ed. New York: Kennedy and Co., 1916.

Werth, Léon. "Pierre Bonnard illustrateur." Bibliography by Bernard Thibault. *Le Portique* (Paris), no. 5 (1950), pp. 9–20.

Wheeler, Monroe. *Modern Painters and Sculptors as Illustrators*. Exhibition catalogue. New York: The Museum of Modern Art, 1936.

————. *The Prints of Georges Rouault*. New York: The Museum of Modern Art, 1945.

Wilenski, R. H. *Modern French Painters*. New York: Reynal & Hitchcock, 1940.

Winterthur, Kunstmuseum. *Schenkung Vollard*. Catalogue by Heinz Keller. April 24–May 28, 1949. Winterthur, Switzerland: Kunstmuseum, 1949.

Wofsy, Alan. *Georges Rouault. The Graphic Works*. San Francisco: Alan Wofsy Fine Arts, 1976.

Zahar, Marcel. "The Vollard Editions." *Forms*, vol. 2, January 1921.

Zervos, Christian. *Pablo Picasso: oeuvres*. Paris. Vols. 1 and 2. Paris: Cahiers d'Art [1932].